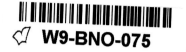
Lee Frost's

PANORAMIC

PHOTOGRAPHY

▷ SALFORD QUAYS, MANCHESTER, ENGLAND
Although it can take some time to develop an eye for great panoramic pictures, you occasionally encounter subjects that are perfectly designed for the letterbox format. Here's a good example. The sweeping supports and railings of this pedestrian suspension bridge act as powerful lines that carry the eye over the bridge to the building on the opposite bank of the river – which itself was perfectly placed for a symmetrical composition. For a variation on this image, see page 90.

Camera Hasselblad XPan Lens 30mm Filters 0.45 centre ND and polarizer Film Fujichrome Velvia 50

LEE FROST'S

PANORAMIC

PHOTOGRAPHY

David and Charles

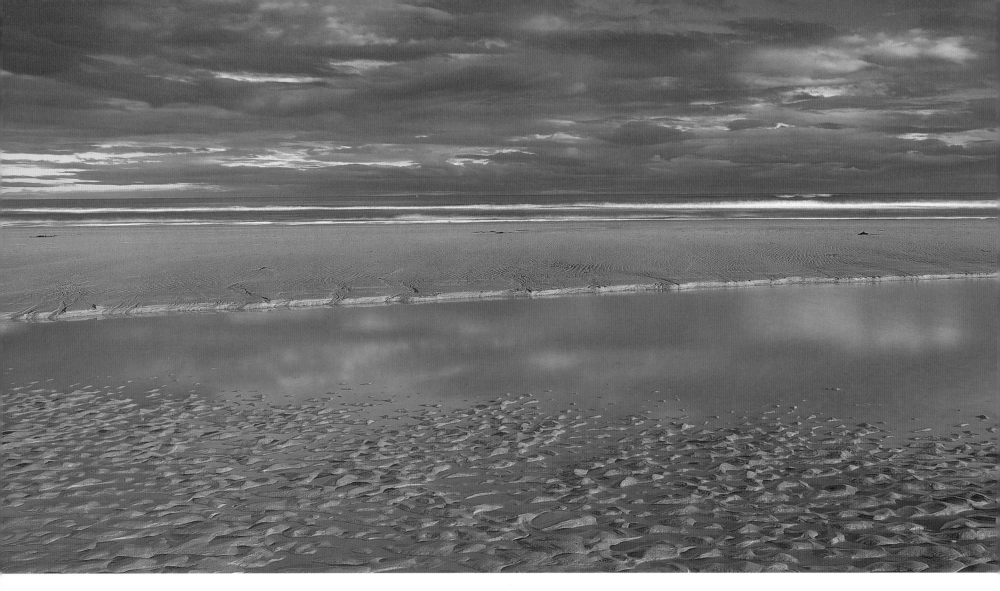

A DAVID & CHARLES BOOK
David & Charles is a subsidiary of F+W (UK) Ltd.,
an F+W Publications Inc. company

First published in the UK in 2005

Copyright © Lee Frost 2005

Distributed in North America by
F+W Publications, Inc. 4700 East Galbraith Road
Cincinnati, OH 45236
1-800-289-0963

A catalogue record for this book is available
from the British Library.

ISBN 0 7153 1962 0 hardback
ISBN 0 7153 1969 8 paperback

Printed in China by Hong Kong Graphics & Printing Ltd.
for David & Charles
Brunel House Newton Abbot Devon

Commissioning Editor Neil Baber
Editor Jennifer Proverbs
Art Editor Mike Moule
Production Controller Kelly Smith
Project Editor Nicola Hodgson

Visit our website at www.davidandcharles.co.uk

David & Charles books are available from all
good bookshops; alternatively you can contact
our Orderline on (0)1626 334555 or write to us
at FREEPOST EX2 110, David & Charles Direct,
Newton Abbot, TQ12 4ZZ (no stamp required
UK mainland).

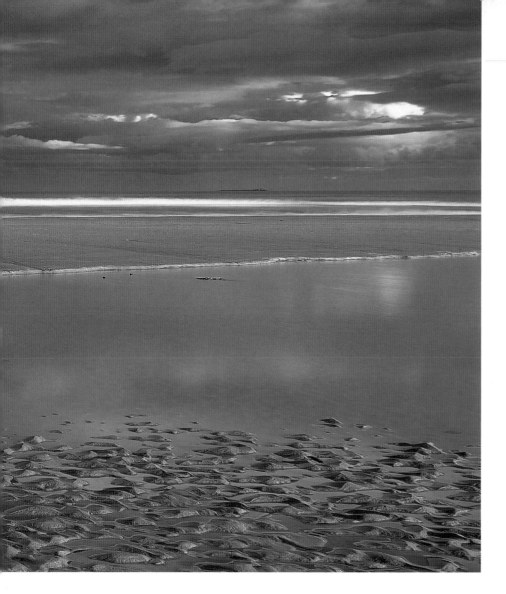

△ **ALNMOUTH BEACH, NORTHUMBERLAND, ENGLAND**
This beach is less than a minute's walk from my home, so when prevailing weather conditions suggest there may be some interesting light on its way, I can respond to it at very short notice. On this occasion, I was walking the beach with family an hour or so before sunset when the cloudy sky began to break up. Seeing the chance for some great panoramics, I bid them a fond farewell, dashed home, and returned immediately with my camera. I was just in time. Within seconds of setting up, the sun came out and lit-up the golden sand just long enough for me to make three quick exposures.

Camera Fuji GX617 Lens 90mm Filters 0.6ND hard grad and 0.45 centre ND Film Fujichrome Velvia 50

CONTENTS

INTRODUCTION

I will never forget the first time I saw a panoramic photograph. It was a revelational experience that changed my whole outlook on landscape photography in a second and filled a creative void that had often left me feeling disappointed and unfulfilled.

I had just returned from a week-long shoot in the Highlands of Scotland, where I spent every day from dawn to dusk exploring magical locations such as Rannoch Moor, Glen Etive, Loch Linnhe and Glencoe. The scenery left me stunned, but although I was generally happy with the pictures I took on that trip, there was something missing; that vital ingredient that makes a good landscape photograph great and really captures the drama and beauty of a place. I couldn't quite put my finger on it. Then I discovered a book by Scottish landscape photographer Colin Prior. The moment I opened *Highland Wilderness*, I realized that I had discovered the missing link in my photography. Page after page, magnificent panoramic photographs of the locations that I had just visited stared back at me, and I knew then that I had to have a panoramic camera.

There was just one snag – money. Back then, Colin Prior was using a Linhof Technorama 617S; a large, bulky rollfilm camera with a fixed 90mm lens that produced four shots on a roll of 120 film. In the mid-1990s, my car was worth less than one of those cameras. But I was determined, so I saved hard, scanned the secondhand market (there was no eBay then) and eventually found a used Fuji G617, a camera utilizing the same format as the Linhof but with a fixed 105mm lens. My adventures in the world of panoramic photography were about to begin.

A decade and several cameras later, my love of the panoramic format is greater than ever. It was a shaky

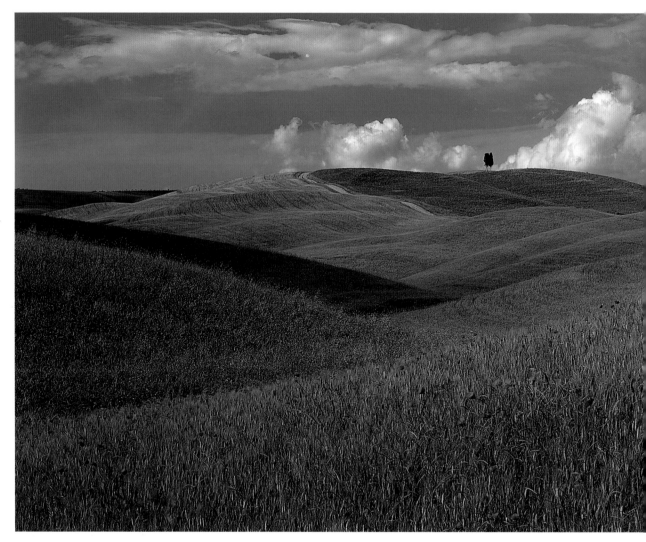

start, I'll admit, as I grappled with the strange letterbox format, having grown used to 35mm and 6x7cm cameras. However, before long I realized that the 3:1 ratio suited my natural vision far better than any other format, and I soon felt completely at ease with it. I now 'see' images in panoramic format first and foremost, and once I start working with a panoramic camera, any 'conventional' cameras in my backpack are often forgotten – to

▽ **NEAR SAN QUIRICO, TUSCANY, ITALY**

Tuscany contains some of the world's most beautiful landscape scenery, especially during the latter half of May, when poppies and other wild flowers are in full bloom and add vibrant splashes of colour to the countryside. On this occasion, I had set out to photograph a more famous scene (see page 22), but when I arrived I decided the view in the opposite direction worked better. This is one of several pictures that I took of the rolling fields and distant cypress trees against a dramatic sky.

Camera Fuji GX617 **Lens** 180mm **Filter** Polarizer **Film** Fujichrome Velvia 50

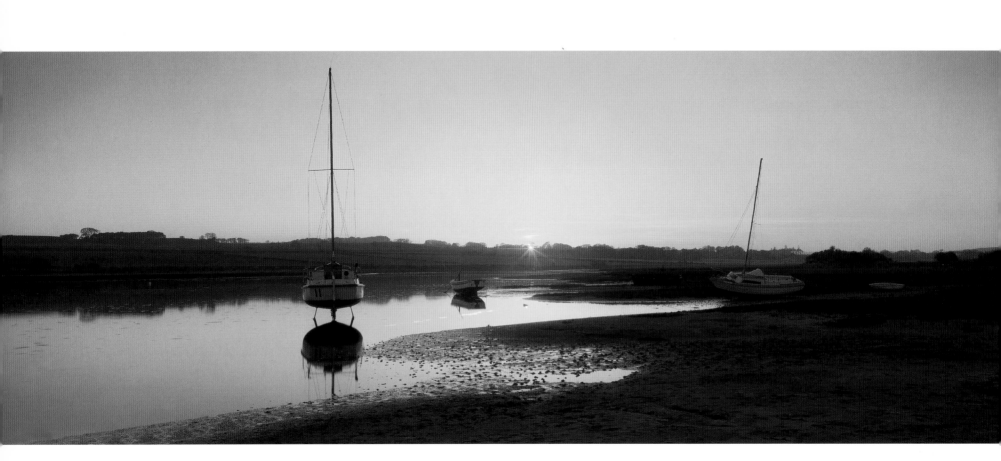

the point that I wonder why I bother carrying them around with me at all.

When I first started shooting panoramics, I was in a minority, but in the last few years the genre has experienced a huge increase in popularity, thanks mainly to the launch of the superb Hasselblad XPan camera. When I lead photographic holidays and workshops these days, it's rare for there not to be at least one member of the group toting an XPan, with several more intending to buy one by the end of the trip once they have seen the results that the camera is capable of producing.

My intention in writing this book is to pass on the experience and knowledge that I have amassed over the last ten years and help anyone discovering panoramic

△ **ALN ESTUARY AT SUNSET, ALNMOUTH, NORTHUMBERLAND, ENGLAND**

My home is less than a minute's walk from this fantastic estuary location, so when an attractive sunset seems imminent I'm in the lucky position of not having to travel any real distance to capture it – more often than not with my trusty panoramic camera. As my favourite Fuji GX617 has no integral metering system, I often use a Nikon 35mm SLR to determine correct exposure. For this shot, I used a neutral density graduated filter to tone down the bright sky and a warm-up filter to enhance the light.

Camera Fuji GX617 Lens 90mm Filters 0.6 ND hard grad and 81C warm-up Film Fujichrome Velvia 50

▷ **CHURCH AT FIROSTEPHANI, SANTORINI, GREEK ISLANDS**
▷▷ **PIAZZA DEL CAMPO, SIENA, TUSCANY, ITALY**
▷▷▷ **NAMIB RAND, NAMIBIA**

Although most suitable subjects for panoramic cameras naturally lend themselves to the horizontal format, you can also produce powerful compositions by breaking convention and turning the camera on its side. This approach works best on simple, graphic scenes and the unusual cropping adds lots of impact, as you can see from these three very different photographs. All were shot originally in 6x17cm format, but I decided that they worked better when cropped down to 6x12cm.

Camera Fuji GX617 Lens 180mm (church); 90mm (other shots)
Filter Polarizer (all three shots) Film Fujichrome Velvia 50

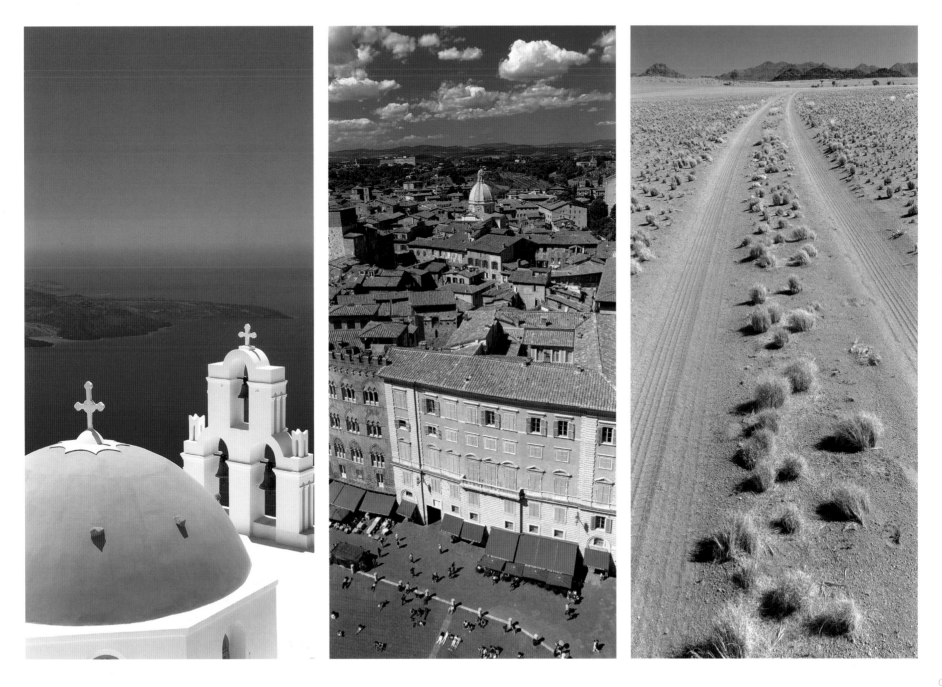

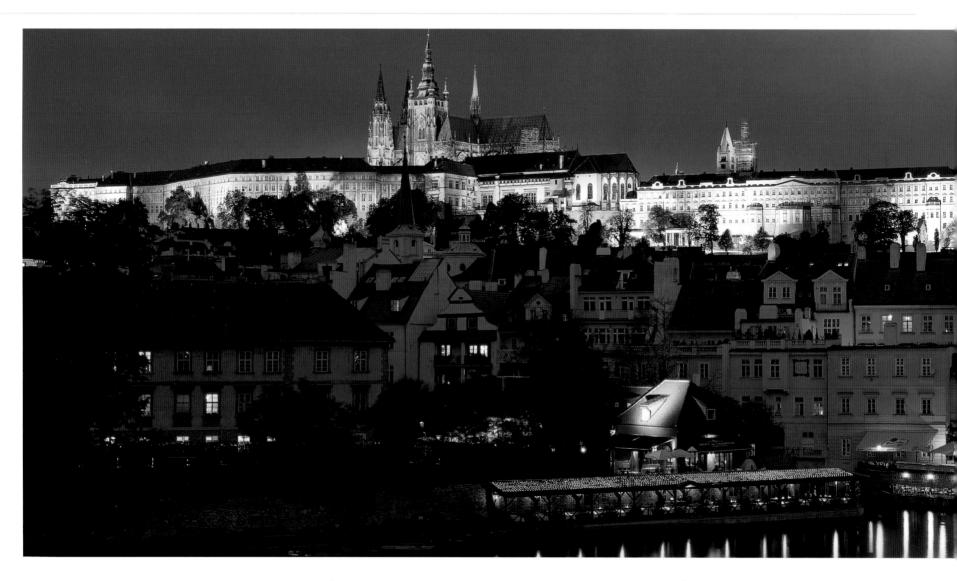

△ **PRAGUE CASTLE AT NIGHT, PRAGUE, CZECH REPUBLIC**

I spent three days and nights in Prague in October 2003. For most of that time it rained almost non-stop, making successful photography very difficult. However, past experience has taught me that no matter how dull and dismal the weather is, cities still photograph well at dawn and dusk, especially if they are lit by artificial illumination, so each morning and evening I headed out and hoped for the best. This is one of the pictures from an evening shoot looking across the Vltava River from the end of Charles Bridge. The combination of a rich blue sky and the warmer colours of artificial lighting makes the shot. The effect is completely natural. No filters were used, just a long exposure (2 minutes) and a little help from reciprocity failure.

Camera Fuji GX617 Lens 180mm Film Fujichrome Velvia 50

being a specialized subject, there are many more panoramic cameras available than you might have realized, including some fairly bizarre contraptions.

Next, I discuss the use of filters and accessories with panoramic cameras. This is something that causes a lot of confusion among photographers who have grown accustomed to the convenience of SLR cameras with through-the-lens (TTL) viewing – a luxury that panoramic cameras generally do not offer.

Composition follows; this is a very important topic because the elongated panoramic format requires special care when it comes to framing. In this chapter, you will learn how to compose great panoramics, not only in a conventional way but by breaking the rules as well.

Panoramic cameras, on the whole, lack integral metering, so it's essential to have a thorough understanding of how to use handheld meters to determine correct exposure. This subject is covered in Chapter 4, after which I take a look at some of the problems commonly associated with panoramic photography and suggest ways of overcoming them.

Chapter 6 is devoted to creative applications of the panoramic format. I, like many other photographers, tend to use a panoramic camera mainly to shoot landscapes and architecture, but the panoramic format can be far more versatile than that (see page 90 onwards).

If you can't afford a panoramic camera, don't be put off – Chapter 7 looks at alternative ways of creating panoramics, from cropping down pictures taken on conventional formats to using software to stitch a series of images together digitally.

The final chapters look at what you can do with your panoramics once you've taken them, from printing, filing, mounting and framing, to selling your work.

This book is illustrated with more than 200 photographs. They represent a fraction of the thousands of 'pans' that I have taken over the years. However, I feel that I have taken only a few steps on the long creative journey I began when I first picked up a panoramic camera. I hope that journey will last for the rest of my life, and that by reading this book and looking at my photographs you will feel inspired enough to want to join me on it.

photography to overcome the problems that I had to face head-on – there was no written advice available back then to solve them. I also hope to pass on my love and enthusiasm for an area of photography that is often overlooked and misunderstood, and show just how versatile the format can be when used creatively.

Like most 'how-to' books on photography, this one begins with a look at equipment. Despite panoramics

PANORAMIC CAMERAS

There is a surprisingly high number of panoramic cameras available today – well over 20 and counting. The best-known and most popular models come from mainstream manufacturers, including Fuji, Linhof, Horseman and Hasselblad, but there are also many small specialist manufacturers around the world producing cameras that are equally capable of producing stunning results.

Aspect ratio is the main factor that defines a panoramic camera. In my opinion, the accepted minimum that qualifies is 2:1 – such as 6x12cm. As aspect ratio increases, so the process of producing successful images tends to become more complicated and susceptible to problems – technically, because the lens has to gather so much light and expose such a broad piece of film, and also creatively, because the more elongated the image, the more limited is its use.

Panoramic cameras can be divided into three distinct groups: flatback, swing lens, and rotational. All of these differ in design, operation and versatility.

In this chapter, I will discuss in detail specific models of which I have first-hand experience, and highlight alternative models. I will also look at ways of producing panoramic images without using a purpose-made panoramic camera. Before doing that, however, let's look at the three categories of panoramic cameras.

FLATBACK CAMERAS
The main feature of flatback cameras is that, as the name implies, the film is held flat and parallel to the lens. An image is exposed in one 'hit' when you trip the shutter, as it is with conventional SLR, rangefinder and view cameras. Flatbacks are the most common and the most popular

type of panoramic camera because they are generally the most versatile and the easiest to use. Most accept a range – albeit limited – of interchangeable lenses; filters can be used with ease; they're quick to set up; distortion is minimal; and, other than the elongated format, they work in much the same way as a conventional camera, so adapting to them is fairly pain-free.

The only limitation of flatback cameras is that with wideangle lenses the image size usually extends to the very edges of the lens's image circle, so centre neutral density (ND) filters have to be used to even out exposure across the frame (see page 44).

The Hasselblad XPan is a flatback camera – it is the only 35mm model available in this category. Rollfilm models include the Fuji GX617, Linhof Technorama 612 and 617 models, Fotoman 612 and 617, Horseman 612 Pro, Gilde 66-617 MST, and Art Panorama in both 6x17cm and 6x24cm formats.

SWING LENS CAMERAS
Models in this category offer a similar aspect ratio to flatbacks – around 3:1 – but they work in a totally different way. Instead of exposing each shot in one hit, a narrow slit rotates in front of the film, which is held in a curved rather than a flat position, and exposes it gradually. Swing lens cameras also have a fixed lens (fixed in the sense that you can't remove it and attach a different lens with an alternative focal length). They typically offer a very wide field of view – around 135–140 degrees, depending on the model.

I vividly remember as a teenager seeing gatefold images in *National Geographic* that must have been shot with a swing lens camera – the curvature of the horizon

and distortion was a giveaway. Such cameras were rarely publicized, so only a lucky few even knew that they existed, and fewer still owned one. The need for panoramic images was also much smaller then, whereas today panoramics are enjoying something of a renaissance.

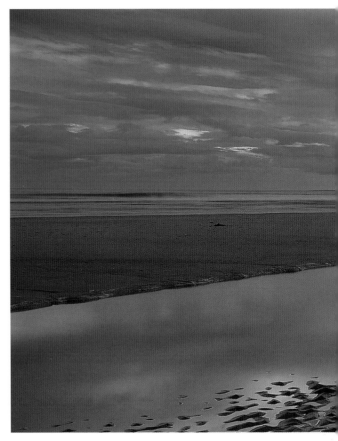

Although swing lens panoramic cameras are re-nowned for the distortion they introduce, some photographers feel that distortion is a poor choice of word to describe the effect that they produce. The way these cameras work is closer to the way the human eye works – by scanning across a scene – so the perspective they record is actually quite natural. Whether you agree with this or not, swing lens panoramic cameras definitely have something unique to offer, and are capable of truly stunning results.

Noblex is the most popular brand, with both 35mm and rollfilm models available. There's also a 6x24cm swing lens camera called the Eyescan; a 55x110mm camera from China called the Widepan 120 Pro; and, at

the budget end of the market, the 35mm Horizon, which produces 24x58mm images on 35mm film. Widelux, the best-known swing lens camera, is no longer made.

No focusing controls are available, but depth of field is so great that focusing isn't necessary, even at wide apertures. Swing lens cameras are also easy to use handheld, although distortion is quite severe if you don't keep the camera level. However, it's tricky to use most filter types due to the way the camera works, and some strange stretching occurs if a moving subject passes through your field of view while an exposure is being made. That said, swing lens cameras can be very effective when used creatively and if you accept their limitations and work with them. For more advice, see page 30.

▽ **ALNMOUTH BEACH, NORTHUMBERLAND, ENGLAND**
Flatback cameras are the most popular choice for panoramic photography: they're quick and easy to use, distortion is minimal, and image quality is high. My favourite panoramic camera is the Fuji GX617. It's hard to beat for landscape photography, and the three lenses in my kit – 90mm, 180mm and 300mm – cover all eventualities.

Camera Fuji GX617 **Lens** 90mm **Filters** 0.6ND hard grad, polarizer and 0.45 centre ND **Film** Fujichrome Velvia

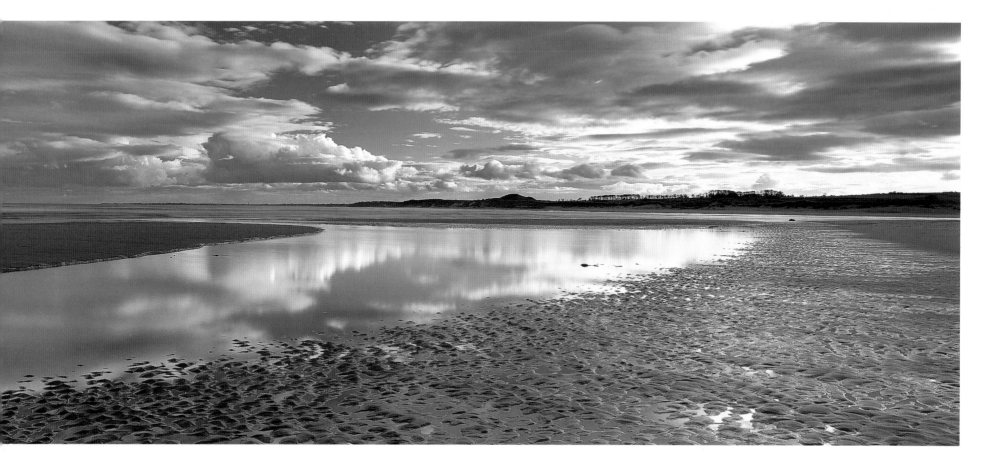

ROTATIONAL CAMERAS

This type of camera is defined by its ability to produce images up to and beyond 360 degrees. The prospect of being able to achieve this is exciting. In reality, however, rotational panoramic cameras have limited creative use: they need to be set up with great care, distortion can be extreme, and they can be used effectively only in locations where you have 360 degrees of interest, such as inside buildings or in town squares. As a result, rotational cameras are mainly used for architectural and interior photography, or for virtual reality work, such as 360-degree views of interiors on real estate websites.

One or two photographers have successfully used 360-degree cameras for travel documentary, but for pure landscape photography they have limited use unless the angle of coverage is reduced, which defeats the object.

The best-known rotational cameras are the Globuscope and the Seitz Roundshot. Models from Hulcherama and Mottweiller are highly sophisticated, as are the Spheron and Seitz digital panoramic cameras. A more affordable and fun option is the Lookaround, a handmade, mechanical rotating camera that can be used handheld or on a tripod and that accepts 35mm film (see pages 34–5).

FUJI GX617

In my opinion, the ultimate panoramic format is 6x17cm, and the ultimate 6x17cm panoramic camera is the flat-back Fuji GX617. I started out using a secondhand Fuji G617 model with a fixed 105mm lens, and then tried the Art 617 panoramic. But in my heart, I knew that only one model could satisfy my creative needs, so I decided to invest in a Fuji GX617 and three lenses: 90mm, 180mm and 300mm.

Financially, this was a big step. The GX617 kit cost more in a single outlay than all my other equipment combined (and my wife's car, as she has reminded me on more than one occasion) and I was unsure how long – if ever – it would take to recoup the costs. But once I made my mind up, there was no going back – I just had to have one! I can honestly say that I have never regretted my

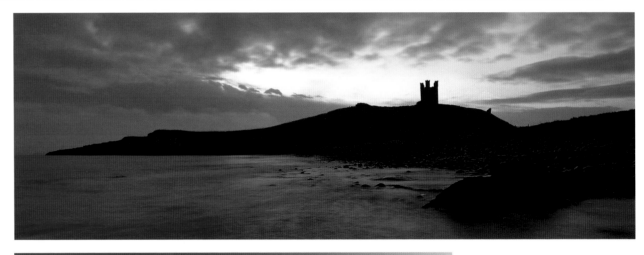

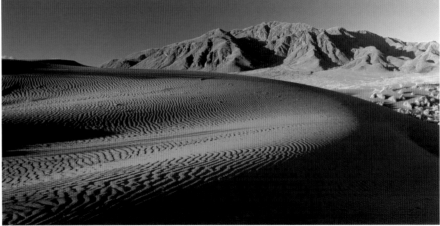

△ **DUNSTANBURGH CASTLE, NORTHUMBERLAND, ENGLAND**
◁ **NAMIB RAND, NAMIBIA**
▽ **KOLMANSKOP, NAMIBIA**

These three images are reproduced lifesize to allow a comparison of the most popular aspect ratios and film formats for panoramic photography. The biggest is 6x17cm, followed by 6x12cm, both shot on rollfilm, and finally 24x65mm, shot on 35mm film.

Camera Fuji GX617 and Hasselblad XPan Lens 90mm (GX) and 30mm (XPan) Filter Polarizer (Namib Rand and Kolmanskop) Film Fujichrome Velvia 50

Which aspect ratio?

Rotational panoramic cameras fall into a category of their own because quirks of their design, and the ability to achieve a view of up to 360 degrees, make them unsuitable for general use. The best images I have seen taken with a rotational panoramic camera covered no more than 180–200 degrees. At that level, they offer a much wider view than flatback and swing lens cameras and the results have a high 'wow' factor. But once you start shooting 360-degree pans, you really enter the realms of virtual reality rather than stills photography.

For me, the perfect aspect ratio for general panoramic photography is around 3:1. This is what can be achieved with 6x17cm cameras, the Hasselblad XPan (24x65mm), and swing lens models such as the Noblex. However, you need to compose very carefully to make full use of the image space – it's easy to end up with wasted space at either end of the photograph and find that in reality the composition works better at an aspect ratio of 2:1. This is why many photographers prefer to use 6x12cm cameras instead of 6x17cm.

I like the 6x12cm format as well, especially when working with lenses wider than 90mm, but often it just doesn't feel wide enough to qualify as panoramic for me. I think 6x17cm, or the equivalent in other formats, is the most effective format.

decision. I love using the GX617: the results are awesome, it's still my first-choice panoramic camera, and it has paid for itself several times over.

USING THE FUJI GX617

Despite being big and bulky, the Fuji GX617 is surprisingly quick and easy to use once you're familiar with it. I can have it set up and shooting in less than a minute, and that includes loading a fresh roll of film.

A tripod is essential when you're using slow film and filters, as shutter speeds become very slow even

in bright conditions once you start stopping down to increase depth of field. That said, I have used the camera handheld on a few occasions, the most memorable being from a hot air balloon over the Namib Desert at sunrise. Everything was so far below me I knew that I could focus the lens on infinity and shoot at maximum aperture to maintain a reasonable shutter speed.

The camera itself is little more than a black box into which film is loaded. There's no integral metering system, so you need a handheld meter to determine correct exposure. Both aperture and shutter speed are set on the lenses, which have leaf shutters.

◁ The Fuji GX617 is the most versatile rollfilm panoramic camera on the market today – the majority of photographs in this book were taken with it.

Alternative flatback cameras

If you want a 6x17cm flatback camera, there are various options to consider in addition to the Fuji GX617: the Linhof Technorama 617S III, the Tomiyama Art 617, the Gilde 66-617 MST and the Fotoman 617. A fifth option is to look for a secondhand Fuji G617 with a fixed 105mm lens.

By the time you read this book, there may be further options. Mike Walker of Walker Cameras in the UK is working on two panoramics models – a 6x17cm camera based on the Canham 6x17cm motorized rollfilm back designed for Canham 5x7in cameras, and a multi-format camera similar to the Gilde offering formats from 6x2.4cm (similar to the Hasselblad Xpan) to 6x14cm. See www.walkercameras.com for an update.

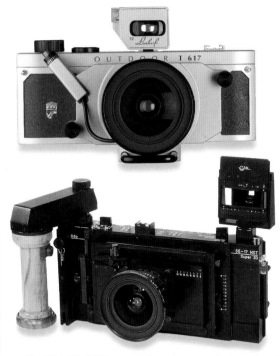

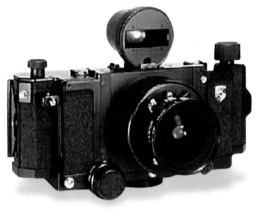

△ The Gilde 66-617 is a multi-format camera that can be set to any film format from 6x6cm to 6x17cm mid-roll. It will also accept lenses from 47–420mm. The design is very clever, but it's a big and complicated camera to use and comes with a very large price tag.

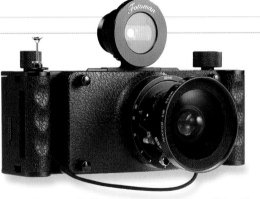

△ The Fotoman 617 is a 6x17cm camera from China. On paper it seems to offer a lot – costing around half that of the Fuji or Linhof but able to utilize a wider range of large-format lenses from 72mm to 210mm. At the time of writing I have yet to put one of these cameras to the test, but I am excited by the prospect of using one, and if image quality matches the Fuji GX617, I would seriously consider buying one for use with a 72mm lens as the widest available for my Fuji GX617 is 90mm.

◁ The Linhof Technorama 617 is the latest incarnation of the first 6x17cm camera. As well as the standard model – the 617S III – there's also a more robust Outdoor version (see above). Both will accept 72mm, 90mm, 180mm and 250mm lenses, making the Linhof the closest rival to the Fuji.

△ The Tomiyama Art 617 is designed to be used with a 90mm large-format lens. It costs about 40% less than the Fuji or Linhof but is bigger, bulkier and heavier. Build quality is also less sophisticated, though it is capable of high quality results.

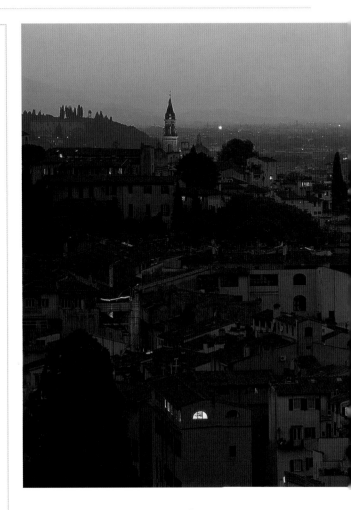

SOME QUIRKS OF THE FUJI GX617

A roll of 120 film gives four frames, so I spend as much time unloading and reloading as I do shooting. I could use 220 film, which would give me eight shots per roll, but I prefer 120 film. It's easier to get hold of, and also helps to overcome one of the GX617's quirks – namely, because the camera lacks any kind of darkslide facility, once a roll of film is loaded you can't change lenses without fogging it. The likelihood of needing to change lenses mid-roll is reduced when you have only four frames to get through.

The other feature that causes problems with the GX617 is the provision on each lens of rubber-coated

It took me a while to get used to the Fuji GX617, and for a long time it felt like an unwieldy beast compared to my Pentax 67 medium-format camera. Eventually, however, I became accustomed to its quirks and my confidence grew. I can now set it up in a matter of seconds and use it for a wide range of subjects – including night scenes that require a sturdy tripod and long exposures.

Camera Fuji GX617
Lens 180mm Film Fujichrome
Velvia 50

metal bars that protrude beyond the front element to offer protection. The idea is basically a good one, but the gap between the bars isn't wide enough to take a 100mm filter holder, so I have to attach the filter to the lens using Blu-tac (see page 41).

The third quirk I have found with the GX617 is that, when using the 90mm lens, I have to load film very carefully and ensure that it remains tight inside the camera. If not, the corners of the image come out unsharp due to lack of depth of focus at the film plane. To avoid this, a finger must be placed on the film where it winds onto the take-up spool to keep it flat, and the film advance lever held in the fully out position to maintain tightness on the film while the camera back is being closed and locked.

LENSES WITH THE FUJI GX617
With each lens, you get a separate viewfinder that fits to the top of the camera body. This handy facility means that you can use the viewfinders to help you decide which lens to use, where to place the camera, and how the picture will be composed before the camera is removed from its case. The downside is that you can pop a viewfinder on the camera but forget to change lenses – something I've done once or twice!

Because you're not actually looking through the lens, focusing must be done with the aid of the distance and depth-of-field scales on the lens, rather than by eye. This is quick and easy, however, because all the lenses for the GX617 have good depth-of-field scales. A more precise method of focusing can be achieved by using the optional ground glass screen that clips on the opened camera back and turns it into a view camera. I bought one myself, but after a year of carrying it around and never using it, I decided to sell it. The great beauty of the GX617 is that it's quick to use, and the focusing screen just slows things down too much.

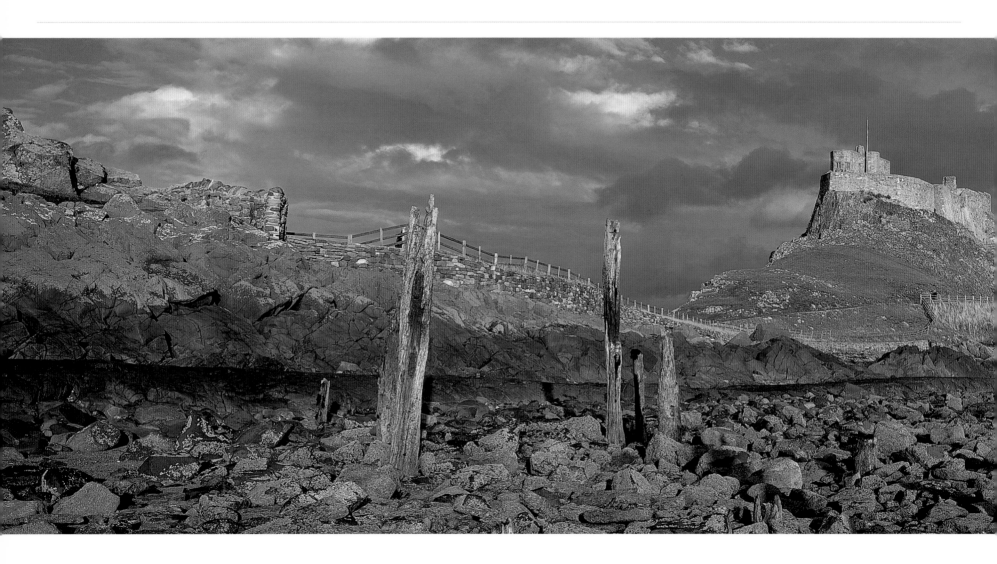

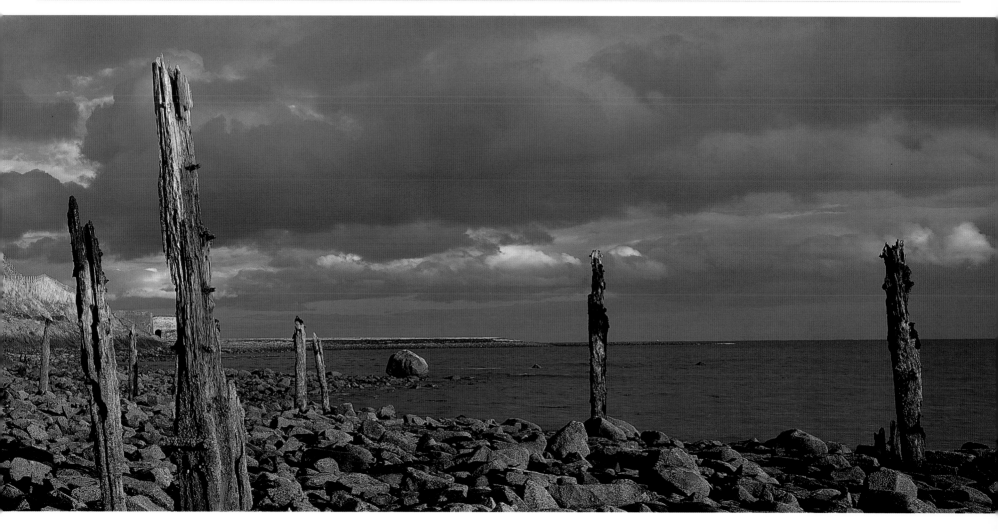

LINDISFARNE CASTLE, HOLY ISLAND, NORTHUMBERLAND, ENGLAND

This photograph of Lindisfarne Castle was taken during late afternoon in autumn. There was a lot of cloud around, but I could see that the sun would eventually drop into clear sky as it neared the horizon. Within seconds of my arrival, the castle and beach were bathed in stunning light against a stormy sky. The only problem I faced while recording this scene was trying to keep people out of the picture, as tourists were constantly walking up to the castle, most of them wearing red or yellow jackets. All I could do was wait until the scene was clear and hope that the light was still good. With the sun low and behind me, a further consideration was not getting my own shadow in the picture. But that's one benefit of the panoramic format; you can still achieve a wideangle view without including lots of foreground, so I was able to keep unwanted shadows out of the frame and make the most of the wonderful light.

Camera Fuji GX617 Lens 90mm Filter 0.45 centre ND
Film Fujichrome Velvia 50

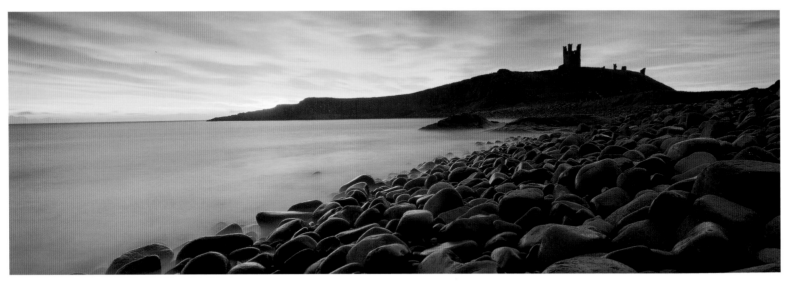

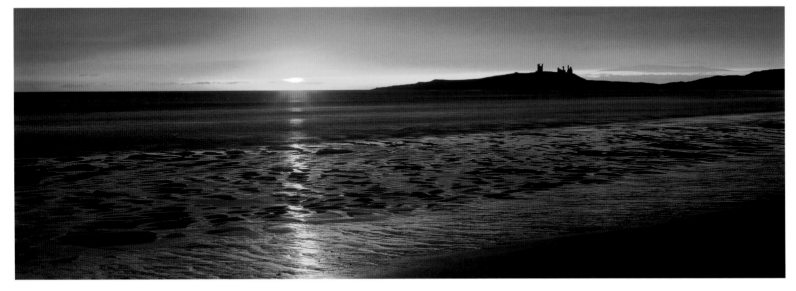

DUNSTANBURGH CASTLE, NORTHUMBERLAND, ENGLAND

This castle lies on the Northumberland coast, not far from my home, and over the years it has become a favourite subject. I have shown four images of the same subject here to illustrate how light and weather can have a dramatic impact on the atmosphere of a scene. The first three shots were taken on the beach at Embleton Bay, just north of Dunstanburgh. They reveal the castle and coastline from a similar angle, yet all are different. In the first, top left, the sun is rising over the ridge on which the medieval fortress was constructed; in the second, bottom left, the sun is rising over the sea, turning the sky orange and sending a shimmering highlight across

the wet sand. In the third view across Embleton Bay, top right, which was taken one stormy afternoon, the castle is picked out by sunlight squeezing through a crack in the sky. The final image, below right, shows an alternative view of the castle from the south side, near the village of Craster. In this image, warm light from the rising sun is illuminating the castle, while a long exposure records the graceful washing of waves against the shoreline. Which of these locations I decide to shoot from depends on the weather, but no matter how many times I visit either spot, I never tire of the beauty and drama unfolding before me.

Camera Fuji GX617
Lens 90mm, 180mm and 300mm
Film Fujichrome Velvia 50

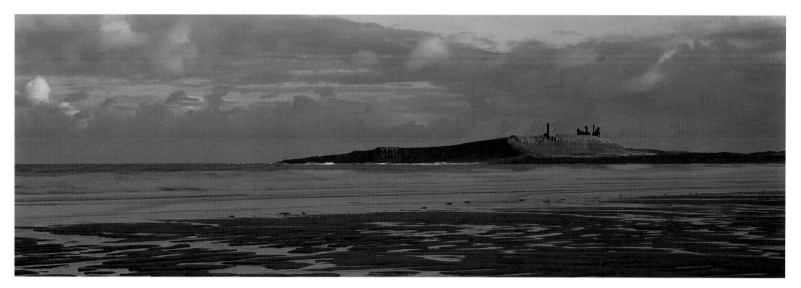

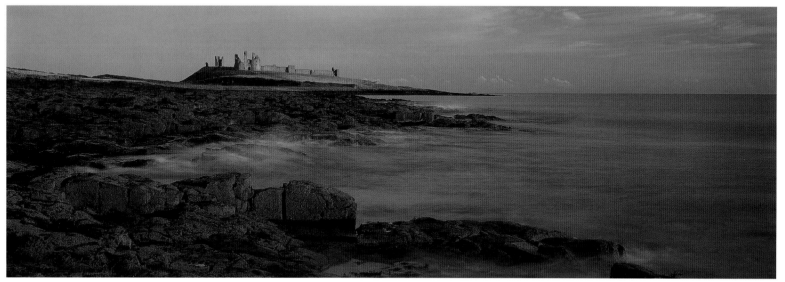

HORSEMAN SW612 PRO

If you consider the aspect ratio of a 6x17cm camera to be too elongated, then a 2:1 ratio will probably appeal to you – photographers who love one tend to dislike the other, and vice versa.

I actually prefer the 6x17cm format for panoramics, but at times feel frustrated by the lack of a really wide-angle lens for my Fuji GX617. With that in mind, I recently tried out a Horseman SW612 Pro – a wideangle camera that accepts lenses from a super-wide 35mm to a modest 90mm, plus rollfilm backs in 6x7cm, 6x9cm and 6x12cm. I was interested only in 6x12cm, and the model I used came fitted with a 65mm lens, though the lenses are interchangeable.

ADVANTAGES OF THE HORSEMAN SW612 PRO

It's the wideangle capability that appeals to me most about this camera, but it offers numerous other benefits.

- It's quite neat and compact considering that it's capable of producing 6x12cm images.
- Lens quality is superb thanks to the Rodenstock optics.
- It's easy to use handheld.
- As well as an optical viewfinder and masks for each lens, a ground glass back can be fitted for more precise composition, focusing and filter alignment.
- With the 6x12cm format, you get six shots on a roll of 120 film and 12 on a 220 roll.
- Up to 17mm of rise and fall can be applied to the lens, as well as 15mm of lateral shift, to correct converging verticals and distortion.
- The removable film back has a darkslide so lenses can be changed mid-roll without causing fogging.
- Though lens guards are available, they're optional and can be removed, so fitting a filter holder to the lens is no problem.

An additional benefit is that you can fit a 6x7cm or 6x9cm rollfilm back, as well as a 6x12cm, so the Horseman can be used as a 'normal' medium-format camera as well as a panoramic, satisfying two needs in one compact system – just like the dual-format Hasselblad XPan (see page 26).

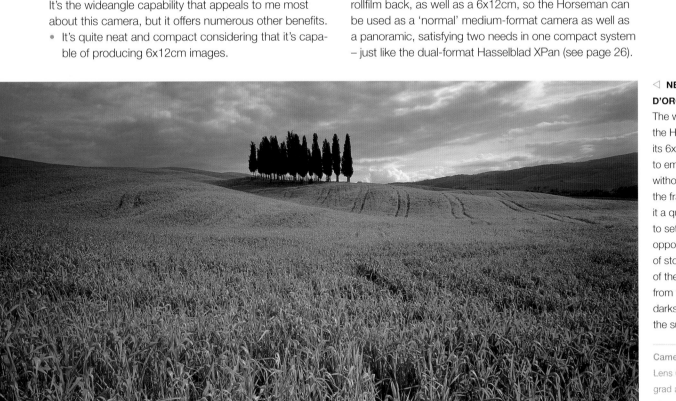

◁ **NEAR SAN QUIRICO D'ORCIA, TUSCANY, ITALY**
The wideangle capability of the Horseman coupled with its 6x12cm format allow you to emphasize the foreground without getting too much in the frame either end. I also find it a quick and easy camera to set up, so I didn't miss the opportunity to catch this burst of storm light – though some of the shots I took suffered from fogging because I left the darkslide out while waiting for the sun.

Camera Horseman SW612 Pro Lens 65mm Filters 0.6 ND hard grad and polarizer Film Fujichrome Velvia 50

△ The Horseman 612 Pro is a versatile wideangle camera with superb optics.

Lenses for the Horseman SW612 Pro

These are the focal lengths currently available for the Horseman – as you can see, it truly is a wideangle camera.

Focal length	Equivalent in 35mm format
35mm	11.5mm
45mm	14mm
55mm	17mm
65mm	20mm
90mm	28mm
135mm	35mm

The alternatives

There are two alternatives to the Horseman: the Linhof Technorama 612 PCII and the Fotoman 612. On paper the Fotoman is the most versatile when it comes to lens options – you can use it with a wide range of large-format lenses from 47mm to 210mm. It can also be fitted with a ground glass focusing screen but lacks movements. The Linhof does offer 8mm of built-in rising front, which is handy for architectural photography, and can be fitted with a 120mm or 150mm lens, whereas the longest lens for the Horseman is a 135mm, but the widest for the Linhof is 58mm, compared to 35mm for the Horseman. Having not tested it, I can't vouch for its quality, but the Fotoman seems the most promising 612 camera and costs around half that of the Horseman or Linhof.

△ Linhof Technorama 612 PCII Fotoman 612 △

If you like the compact nature of the Horseman, but prefer a more elongated aspect ratio, you could crop your images down to 4x12cm or 4.5x12cm. The image quality is high enough for you to do this, and the difference between a cropped 6x12cm image and a full-frame 6x17cm image wouldn't be that obvious unless you make huge enlargements.

QUIRKS OF THE HORSEMAN SW612 PRO

The main thing I don't really like about this camera is the optical viewfinder; the view you get through it changes quite dramatically if you move your eye even slightly, so I find that I never really know what the true view is. A second objection is that, if you change lenses you must also change a mask in the viewfinder to match the lens, which is fiddly and time-consuming. The alternative is to buy an optical viewfinder for each lens so the correct mask is always fitted, but doing so will add quite a lot to the cost of the outfit. A 5x4in camera fitted with a 6x12cm rollfilm back would be more versatile and less costly. However, it's the compactness that makes the Horseman SW612 Pro such a great camera. I carry it quite comfortably in a LowePro Photo Trekker AWII backpack alongside a Fuji GX617 and three lenses, plus a Hasselblad XPan and three lenses – the Horseman takes up barely more space than my Pentax 67II.

Would I buy one? At this stage, probably not. Although I think it's a superb camera, and I love the idea of having one to use alongside my Fuji GX617, it would always play second fiddle as I don't very often need a lens wider than the 90mm for my Fuji. However, if you have yet to invest in a rollfilm panoramic camera and you like the idea of 6x12cm instead of 6x17cm, and if you are more likely to use wideangle lenses than telephoto, then this camera has no equal.

▷ **SIENA, TUSCANY, ITALY**

The Horseman SW612 Pro comes into its own in cities, where you can work in confined spaces with wideangle lenses and create dramatic perspective. In this scene, I was attracted by the view through the archway towards Siena's stunning cathedral, with the sunlit wall on the right. The 65mm lens on the Horseman allowed me to include both elements with ease.

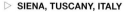

Camera Horseman SW612 Pro **Lens** 65mm **Filter** Polarizer
Film Fujichrome Velvia 50

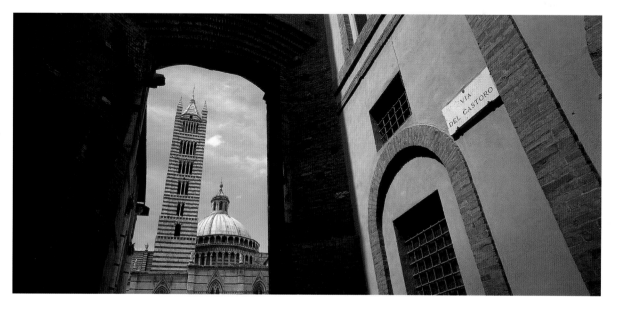

VAL D'ORCIA, TUSCANY, ITALY

This photograph was taken on my very first outing with the Horseman 612 Pro camera; I had hired it for a week with a 65mm lens and used it alongside my Fuji GX617 system. I had visited and photographed this location several times before, so other than how the light would be at 5am that morning, I knew what to expect and decided to experiment. The main benefit I found in using the Horseman was that I could make a feature of an interesting sky, as I did here, while still including plenty of foreground. The Fuji GX617, even when fitted with its widest lens – a 90mm – can't achieve this effect in such a dramatic way.

Camera Horseman SW612 Pro **Lens** 65mm **Filter** 0.9 ND hard grad **Film** Fujichrome Velvia 50

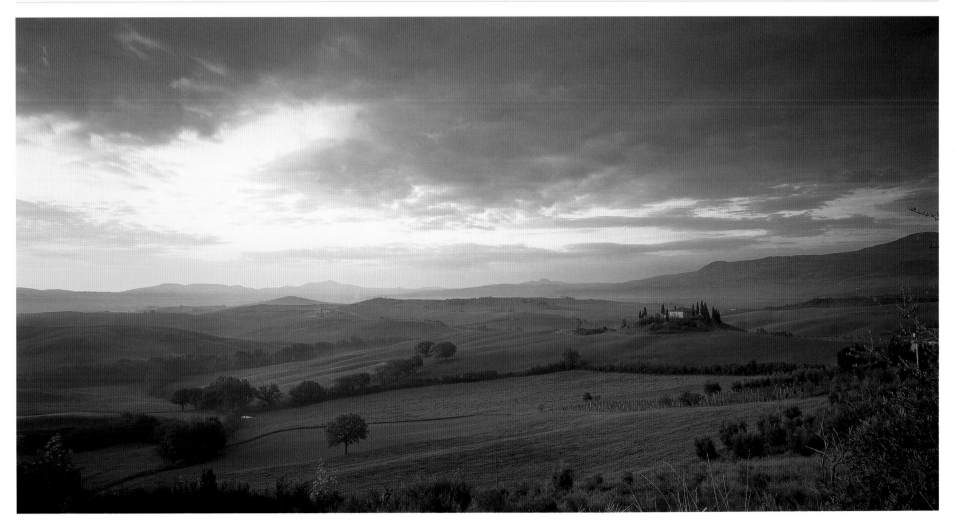

VAL D'ORCIA, TUSCANY, ITALY

This shot was taken around 20 minutes after the photograph opposite. The sun has risen and transformed the scene; cold tones have been replaced by beautiful warm hues and the famous farmhouse, Belvedere, in the distance has been picked out by golden light. You can see that there is only a slight change in viewpoint as the same isolated tree appears in both images. I also photographed this scene with my Fuji GX617 (see page 48). For this shot, I had to use my body to cast a shadow over the lens and avoid flare.

Camera Horseman SW612 Pro Lens 65mm Filters 0.9 ND hard grad and 81C warm-up Film Fujichrome Velvia 50

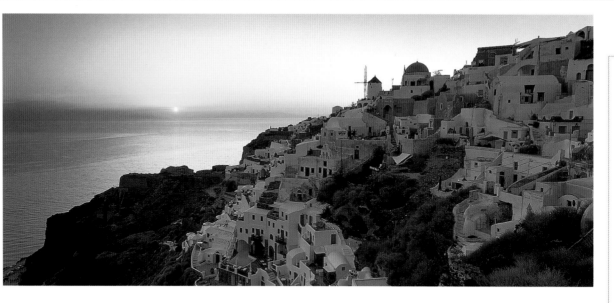

▷ Here's the XPan, in all its glory, with 45mm lens and hood attached.

HASSELBLAD XPAN

If one camera is responsible for revolutionizing panoramic photography, and making it accessible and affordable to the masses, this is the one. Launched in 1998, the XPan is small, relatively lightweight, superbly constructed, beautifully designed and highly versatile. Hasselblad (well, Fuji actually, as they make the camera) clearly thought long and hard about how they could make the XPan as user-friendly as possible, and the outcome is truly amazing. The XPan is the biggest-selling panoramic camera in the world, and the first choice for many landscape and travel photographers who want to produce high-quality

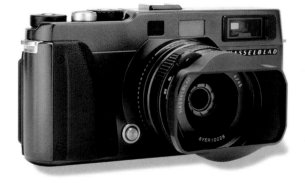

panoramics without the weight, slowness and expense of rollfilm panoramic cameras such as the Fuji GX617.

I'm a big fan of the XPan. I purchased one of the original bodies (the XPan II is now available, offering various modifications and improvements) with 45mm and 90mm lenses a few years ago and have since added a second body and 30mm super-wide lens. For static subjects such as landscapes, my first choice is always the Fuji GX617. However, for travel photography, where I'm covering a wide variety of subjects – scenery, architecture, people, details – and often working handheld, I choose the XPan every time, as it's much quicker and easier to use than the GX617. It also gives 21 shots on a roll of 35mm film compared to four on a roll of 120 with the GX, which makes a huge difference.

THE ADVANTAGES OF THE XPAN
The Hasselblad XPan is unique for a number of reasons:
- It's the only flatback panoramic camera in production that accepts 35mm film; all other 35mm models are swing lens cameras (see pages 30–33).
- It offers a choice of three interchangeable lenses (see panel opposite); all other 35mm models have a fixed lens.
- It offers dual formats – panoramic (24x65mm) and full-

frame 35mm (24x36mm) – and you can switch from one to the other, mid-roll, whenever you like.

- It uses a coupled rangefinder system, which means that, although you're not looking through the lens as you do with an SLR, you can focus accurately using the rangefinder. No other panoramic camera offers this.
- It benefits from through-the-lens (TTL) metering, which speeds up operation. It also offers the choice of aperture priority and metered manual exposure modes, exposure compensation, autobracketing and DX coding.

The coupled rangefinder is particularly useful, because it allows you to focus on a specific point quickly and easily. This is invaluable if you're working in low light and need to shoot at a wide aperture to maintain a decent shutter speed, because you can focus on your main subject. It also means that you can choose to shoot at a wide aperture to isolate your main subject from the foreground and background. This is something you can't do with any other panoramic camera unless you attach a ground glass focusing screen and set up the shot from beneath a darkcloth – and this works only on static subjects because you need to remove the focusing screen and load a roll of film before you take a picture.

THE XPAN AND ITS QUIRKS

Of course, no matter how great a camera is, you can always find fault, and the XPan is no exception. For instance, I have mixed feelings about the integral metering system. Sometimes it's very accurate and other times it's way out. The fact that you need to use a centre ND filter with the 45mm and 30mm lenses to ensure even exposure across the frame doesn't help.

To avoid error, I tend to use a handheld meter and compare the reading it gives me to the reading the XPan gives. If there's a difference – often half a stop or one stop – I 'correct' it by dialling in the appropriate amount on the exposure compensation dial of the XPan. I can then shoot in aperture priority mode, so that when I bracket exposures the shutter speed is adjusted by the camera and the aperture remains the same. This means that depth of field is unaffected, which is an important factor when shooting landscapes.

▽ **TINERHIR OASIS, DADES VALLEY, MOROCCO**
These three photographs were taken from the same spot and show how each of the three XPan lenses records the same scene.

Camera Hasselblad XPan
Lens 30mm, 45mm and 90mm
Film Fujichrome Velvia

Lenses for the Hasselblad XPan

There are three lenses available for the XPan: 30mm, 45mm and 90mm. In all three cases, optical quality is superb. In panoramic mode, the 30mm lens has a horizontal angle of view of 94 degrees – the same as a 17mm ultra-wide in 35mm format. If you switch to full-frame 35mm, the angle of view is 62 degrees – similar to a 28mm lens in 35mm format.

The 45mm 'standard' lens has an angle of view of 71 degrees, similar to a 24mm lens in 35mm format when the camera is set to panoramic mode, and 47 degrees in full-frame 35mm mode, which is similar to a 50mm lens.

The 90mm gives you a horizontal angle of view of 40 degrees in panoramic mode, similar to a 50mm standard lens in 35mm format, and 23 degrees in full-frame mode, similar to a 100mm in 35mm format.

It is recommended that a centre ND filter be used with the 45mm and 30mm lenses to ensure even exposure across the whole picture area (see page 44). For the 45mm lens this is an optional extra that I have never found necessary, but the 30mm lens kit comes supplied with a 0.45 centre ND filter and it is essential if you want to avoid dark corners in your pictures.

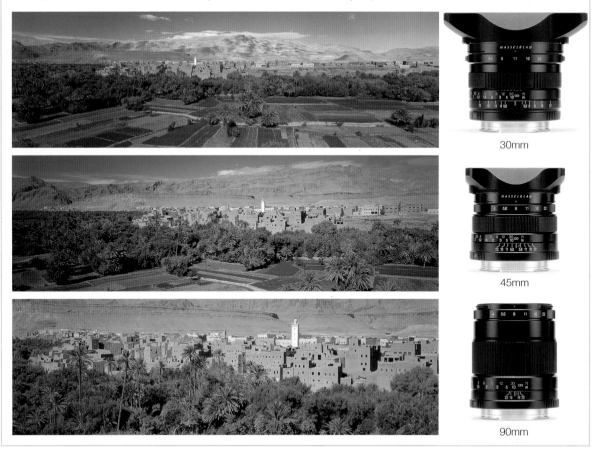

30mm

45mm

90mm

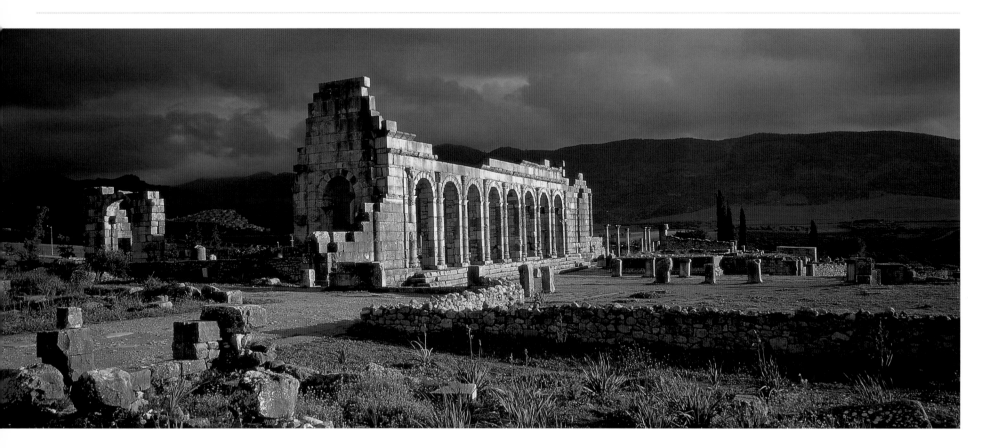

Using filters is fiddly with the XPan, as it is with any rangefinder camera. However, matters are made worse if you attach a filter holder to either the 45mm or the 90mm lens, because it obscures the viewing and focusing aids, making it impossible to take handheld shots with a filter holder in place. This isn't so great a problem with the 30mm lens because the rangefinder is attached to the top plate of the camera.

A third niggle is that when set to bulb (B), the longest exposure you can use is 41/2 minutes with the original XPan and 9 minutes with the XPan II. These times are long enough for most situations, but subjects such as star trails are out of reach because to capture these you need to expose for several hours. I thought a bulb setting enabled you to lock the shutter open indefinitely, but this is not the case with the XPan. Fortunately, the XPan II has a multiple exposure facility, so you can re-expose the same frame several times when an exposure longer than 9 minutes is required.

Should these quirks put you off buying an XPan? Absolutely not. I would recommend it to anyone over any other panoramic camera available at the present time. It's by far the most versatile and user-friendly model, and is fast making the panoramic format as normal and acceptable as 35mm – which can only be a good thing.

△ **VOLUBILIS, MOROCCO**

Here's a classic example of the XPan coming into its own. I had been wandering around the Roman ruins at Volubilis for an hour or two, taking very few pictures as the weather was grey and overcast. However, just as I was about to leave, the sun suddenly broke through storm clouds and illuminated the Forum, the most impressive building at the site. With no time to lose, I leapt onto a low wall, composed the scene and started shooting handheld, bracketing exposures until the film in my camera ran out. I'm not sure how long the light lasted – perhaps 30 seconds – but I do know that the XPan was the only panoramic camera that I could have used for the shot. If I had tried to set up my 617 camera on a tripod, load a film and take a meter reading, the opportunity probably would have been missed.

Camera Hasselblad XPan Lens 90mm Film Fujichrome Velvia 50

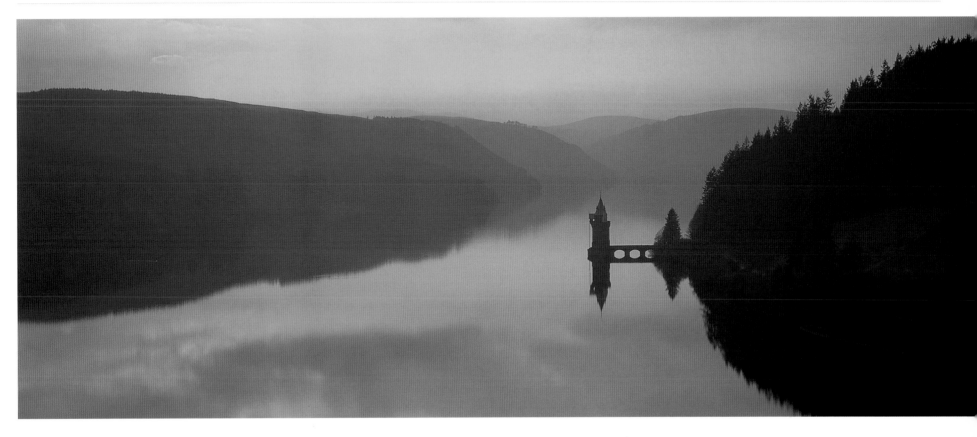

△ **LAKE VERNWY, MID-WALES**

Because the XPan is so compact, you can take it anywhere
and never miss an opportunity. I photographed this scene while
attending my brother's wedding. I knew that the hotel where he
was being married overlooked a lake, so I packed one XPan
body and two lenses, just in case! I'm glad I did – the sunset
from the balcony outside my room was beautiful, and by loading
slightly faster film (ISO 100 instead of my usual ISO 50), I was
able to capture it handheld.

Camera Hasselblad XPan **Lens** 90mm **Filter** 81C warm-up
Film Fujichrome Sensia 100

NOBLEX 135S

Many photographers who are familiar with the Hasselblad XPan assume that it's the first and only panoramic camera made that accepts 35mm film. In fact, swing lens panoramic cameras have been around for decades. Before the XPan was even a glint in its designer's eye, photographers produced stunning panoramics on 35mm film – mainly with the legendary Widelux panoramic camera, which, sadly, is no longer in production.

These days, the Noblex 135S is one of the most popular swing lens panoramic cameras. This model produces 19 shots per roll of 35mm film, each with an image size of 24x58mm (compared to 24x65mm from the XPan). It also features a fixed 29mm f/4.5 lens and offers an angle of view of 136 degrees, which is superwide in 35mm terms – roughly equivalent to a focal length of 10mm. When considered in isolation, it's a great camera – not too bulky or heavy, and easy to use either on a tripod or handheld. There are five shutter speeds to choose from: 1/30sec,

1/60sec, 1/125sec, 1/250sec, and 1/500sec. These are selected using a traditional dial on the top plate, while the aperture is set by adjusting a notched ring on the front of the camera to the required f/number, from f/4.5 to f/16.

With no integral metering system, exposure readings have to be taken with a handheld meter and then set manually. The film is advanced manually by turning a wheel on the top plate. As the shutter is cocked when the film is advanced, you can't accidentally double-expose the same frame, simply because the shutter won't fire until you advance to the next frame.

USING THE NOBLEX 135S

The main attraction of a swing lens panoramic camera like the Noblex 135S is the extreme angle of coverage it can achieve; it is wider than any lens for a flatback camera with the exception of the 35mm lens on the

◁ The Noblex 135S is one of three Noblex swing lens panoramic cameras that produces 24x58mm images on 35mm film.

▷ **SAN GIMIGNANO, TUSCANY, ITALY**

This photograph was taken handheld from an ancient tower overlooking the medieval town of San Gimignano. Because everything in the scene was some distance away, I was able to shoot at a wide aperture and maintain a decent shutter speed (1/125sec). The curvature of the horizon is typical of the distortion you get with swing lens cameras.

Camera Noblex 135S
Film Fujichrome Velvia 50

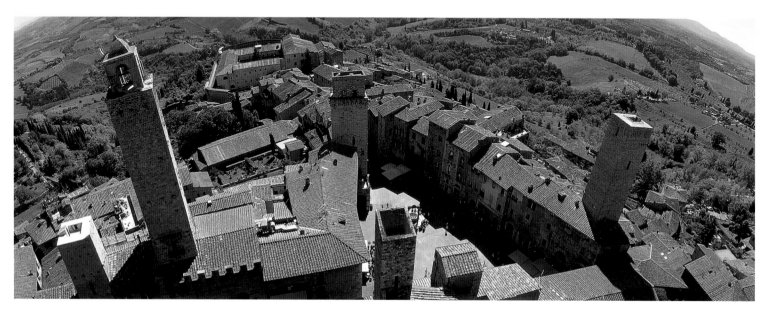

Horseman SW612 Pro. Depth of field is also extensive, even at wide apertures, so you can keep everything in sharp focus from near foreground to infinity. These two factors make the camera ideal for sweeping cityscapes, interiors, architectural shots and landscapes. The Noblex 135S is also ideal for handheld photography; I have had great fun just wandering around carrying this camera and a light meter, photographing anything that caught my eye. In fact, all the photographs you see on pages 30–33 were taken handheld, and all are very sharp due to the high optical quality of the lens.

On the downside, distortion is very obvious if you don't keep the camera perfectly level and upright. If you exaggerate this, the effects can look stunning – look down from a high viewpoint, for example, and the horizon will bend like a banana – but it's something you need to be aware of. Also, because the lens rotates and exposes the film gradually, anything moving through the frame, such as people or traffic, can be stretched if you time the exposure wrongly because the lens will follow them.

Using filters with swing lens panoramics

One of the factors that limits swing lens panoramics is the use of filters on its rotating lens.

Noblex produce a range of small filters for their cameras, including neutral density, warm-up, black and white and a single ND grad, which attach to the front of the lens via small magnets. Fitting them is fiddly: you have to press the shutter release button as if taking a picture, then flick the camera's on/off switch to 'off' so the rotating lens stops moving with the rear slit facing you so you can pass a filter through the slot using tweezers and attach it to the lens.

The Widepan Pro II 140 also comes supplied with a set of filters that clip onto the swinging barrel of the lens – again, this is not ideal. An alternative is to attach filter gels to the front of the camera so that the lens can rotate and make an exposure without touching the surface of the gel. However, this is not ideal either and may increase the risk of flare.

If you tend to use filters on a regular basis then a swing lens panoramic camera isn't really going to suit you.

▽ **TUSCANY, ITALY**

Extensive depth of field means that using a swing lens camera you can achieve front-to-back sharpness with ease and make a feature of interesting foregrounds. Here I shot at f/11 with the flowers less than 1m (3ft) away.

Camera Noblex 135S **Film** Fujichrome Velvia 50

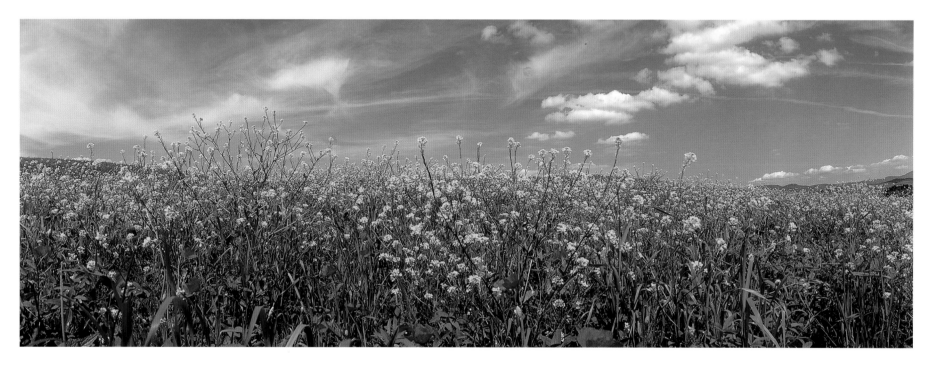

△ **ROAD SIGN, TUSCANY, ITALY**

I took this purely to show the distortion you get with a swing lens camera. The two signs were almost parallel to the side of the road, but by moving close to the centre of the signs, perspective has been stretched significantly.

Camera Noblex 135S
Film Fujichrome Velvia 50

▽ **LUCIGNANO D'ASSO, TUSCANY, ITALY**

Here's an example of how one frame can be exposed several times to achieve the metered exposure. I needed an aperture of f/11 to achieve sufficient depth of field for this street scene in the village of Lucignano d'Asso, but the required shutter speed to achieve correct exposure at f/11 was 1/4sec and the slowest speed available on the Noblex 135S is 1/30sec. To overcome this, I set the multiple exposure facility and exposed the same frame of film eight times at 1/30sec to achieve the same result as a single 1/4sec exposure.

Camera Noblex 135S Film Fujichrome Velvia 50

△ **YORK MINSTER, YORK, ENGLAND**

One of the great things about a swing lens camera is that it's ideal for handholding. I took this photograph while wandering around the old city of York with my family and taking in the sights.

Camera Noblex 135S
Film Fujichrome Velvia 50

Swing lens panoramic cameras tend to have a limited shutter speed range. For normal picture taking this isn't a problem, but in low light the only solution is to set the camera to multiple exposure mode and build up the exposure gradually by re-exposing the same frame of film a number of times. For example, the slowest speed on the Noblex 135S is 1/30sec, so if your meter reading indicates an exposure of 1/15sec, you need to expose the same frame twice; if the required exposure is 1/8sec, you need to re-expose the same frame four times; if it's 1/4sec, you need to make eight separate exposures, and so on. I tried this myself with the camera and it works fine providing the camera is mounted on a sturdy tripod. Once exposure times go beyond 1/4sec, however, taking a single photograph becomes time-consuming and prone to error because you need to re-expose the same frame so many times that you're likely to lose count.

Noblex have a solution: you can buy an optional slow speed module, which allows you to use shutter speeds down to 1sec. But this goes only part-way towards solving the problem; if you are taking a night shot, for

example, and the required exposure is 10sec at f/4.5 (the widest aperture the camera has), you would need to re-expose the same frame of film around 15 times to cover the 10-second exposure, and add extra for the reciprocity failure. Having to do this isn't the end of the world, but compared with setting your camera to bulb (B) and counting down a single exposure, it's a lot of hassle.

BUYING A SWING LENS CAMERA

Ultimately, your decision to buy a swing lens panoramic camera will be based on your needs and how much you can spend. If you don't mind the limitations outlined above and you can live with both a fixed angle of view and the distortion that all swing lens cameras produce, then you will have lots of fun and take some great pictures. Swing lens cameras like the Noblex 135S also cost significantly less than flatback cameras that share the same film format (a Hasselblad XPan II with a 45mm lens is almost double the price of the Noblex 135S), so you can get into high-quality panoramic photography without breaking the bank.

▷ **KITTY, NORTHUMBERLAND, ENGLAND**

It is possible to get creative with a swing lens camera. I was experimenting with colour infrared film in both the Noblex and my Hasselblad XPan, and took this handheld shot of my daughter during an afternoon by the sea. A yellow filter is required with this film, so I taped a yellow gel across the front of the camera. I wasn't sure how well this would work, but, as you can see, it did.

Camera Noblex 135S
Film Kodak Ektachrome EIR
colour infrared

Alternative swing lens cameras

Noblex is the main name in swing lens panoramic cameras, with models available in three formats: 24x58mm on 35mm film, and 6x12cm and 6x17cm on rollfilm.

In addition to the 135S, there's the 135 Pro Sport. This is the most basic model, with no spirit level and no shift facility, but the same shutter speed and aperture range as the 135S. The 135U offers all the features of the 135S but with an extended shutter speed range down to 1sec. This is invaluable for low-light photography, as it reduces the number of times you need to re-expose the same frame of film to achieve the required exposure time – although in low light this technique would be necessary.

In rollfilm, the 150F2 is the basic 6x12cm model with shutter speeds from 1/250sec to 1/15sec. The 150FS offers 5mm of upward shift, and the 150UX also has a slow speed module that offers shutter speeds from 1/250sec down to 2sec.

Moving up to 6x17cm, the 175UX has shutter speeds from 1/250sec to 1/15sec, while the 175UX Set comes with a slow speed module with additional shutter speeds of 1/8sec down to 2sec. If you initially buy a Noblex camera without the slow shutter speed capability, an optional Panolux slow speed module can be added to provide the slower shutter speed range. A 360-degree adaptor is also available so you can produce 360-degree panoramics.

If you're on a tight budget, the Horizon 202 is the least expensive panoramic camera available. It produces 24x58mm images on 35mm film; has shutter speeds from 1/2sec to 1/250sec (a more useful range than the Noblex 135); and has a 28mm rotating lens that gives an angle of view of 120 degrees (equivalent to less than 14mm in 35mm format).

An alternative to the Noblex 6x12cm models is the Chinese Widepan Pro I 140. This not only produces 55x110mm images on 120 and 220 rollfilm, but also has a 35mm adaptor so you can produce 24x110mm panoramics on 35mm film. The shutter speed range is limited to just three speeds: 1/2sec, 1/20sec and 1/60sec. This is limiting, but focus will go down to 0.8m (2½ft); with the extensive depth of field achieved by swing lens cameras, this means you can keep everything sharp from near foreground to infinity. The Widepan has a 50mm lens and comes supplied with a set of filters that clip to the lens.

Finally, if 6x17cm just isn't enough, there's the Eyescan 624 from KST, who also manufacture 360-degree digital scanning cameras. The 624 produces 6x24cm images on rollfilm, has a 105mm lens with a 120-degree angle of view, and shutter speeds from 1/2sec to 1/250sec.

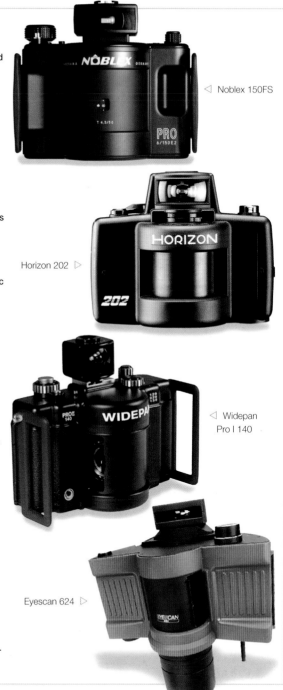

◁ Noblex 150FS

Horizon 202 ▷

◁ Widepan Pro I 140

Eyescan 624 ▷

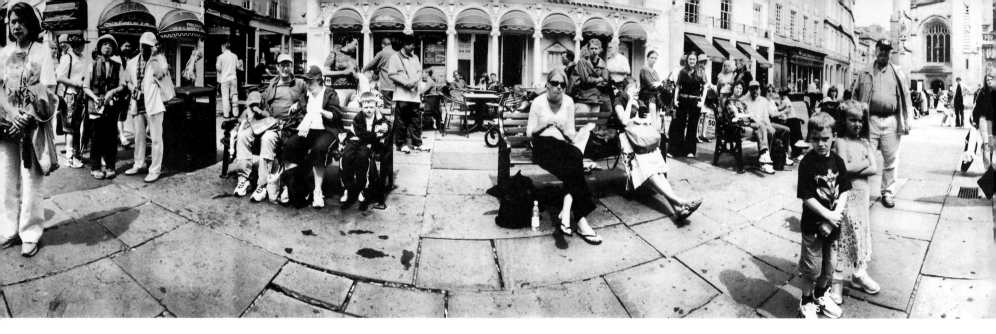

LOOKAROUND

I was in two minds whether to include 360° panoramic cameras in this book, as they are highly specialized and not really suited to general photography. However, my mind changed when I discovered the Lookaround 360. Not only does it look like something from another age (think of a cigar box with wings) but it is also great fun to use and, best of all, doesn't cost that much in photographic terms.

Alan Zinn of California designed the Lookaround and makes each camera himself by hand from wood and brass. His website (see page 140) is full of great pictures showing just what can be achieved, and despite the simplicity of the camera, the results can be truly stunning.

USING THE LOOKAROUND

The most surprising thing about the Lookaround is that it's completely mechanical. Instead of a motor, it has wings with counterweights on the end. All you do is set it up level on a tripod (though it can also be handheld), give it a gentle spin, and the weights both regulate the speed of rotation and keep the camera rotating long enough to make several exposures.

You fit your own lens to the Lookaround. Alan recommends a 28mm or 24mm, though you could go wider or longer. I had an old screw-thread Vivitar 24mm widean-

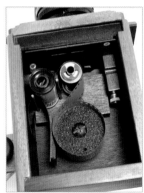

△ The slit disc on the front of the lens helps to avoid flare.

◁ The film is fed around a wheel onto a take-up disc.

gle on the camera which I used, but really any make of lens is suitable.

To create a shutter, a black disc with a narrow slit is fitted to the front of the lens. There's also an even narrower slit just behind the lens. The Lookaround has no viewing system, so when you set it up you just have to guess what you'll get in the picture – but that's all part of the fun.

MAKING AN EXPOSURE

To take a photograph with the Lookaround you simply set the camera spinning in a clockwise direction, wait until a suitable rotation speed is achieved, then grip a

◁ This is the Lookaround in all its glory!

wooden disc on the handle. Doing this feeds the film past the slit shutter behind the lens and in this way an exposure is made.

How do you calculate correct exposure? Well, it's all down to the speed the camera is rotating at. With a 24mm lens stopped down to f/11 and ISO 400 film loaded, a rotation speed around ¾ revolution per second is roughly equivalent to shooting at 1/500sec. For convenience, I round this up to 1 revolution per second.

Based on this information, all you need to do is take an exposure reading – I use a handheld incident meter – then calculate the rotation speed accordingly. For example, if the meter reading suggests an exposure of

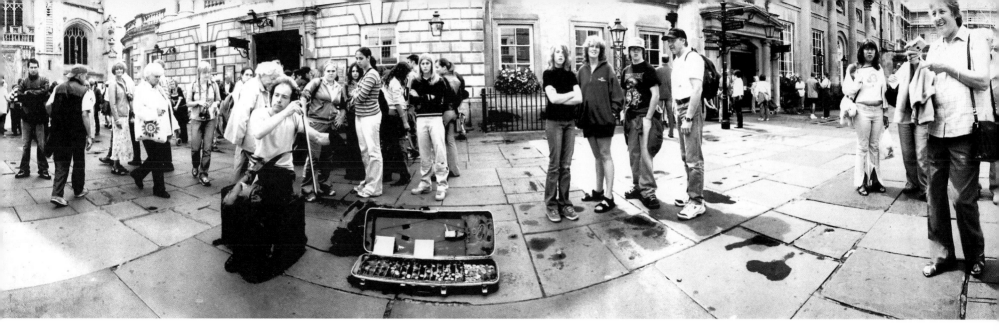

The alternatives

If the idea of 360° panoramic photography appeals to you, there are various cameras available, all of which are far more sophisticated than the Lookaround but with a hefty price tag to suit.

For film there are models from Seitz (the Roundshot), Globuscope, Mottweiler (the Fosterpan) and Hulcherama. Seitz also produce digital 360° scanning cameras, as do Spheron.

For more information on these cameras, check the makers' websites (see pages 140 and 142).

◁ Seitz Roundshot Super Digital 2

△ Spheron PC 12X

▽ Mottweiler Fosterpan

▽ Hulcherama

△ **BATH, ENGLAND**

I took this photograph during my first outing with the Lookaround, to see what it was capable of. Initially, I was sceptical that it was capable of producing decent results, but I was wrong! To get the shot, I set up the camera next to a street entertainer then waited for a crowd to gather. To avoid getting myself in the picture, I ducked down beneath my tripod once the camera was set in motion then made the exposure. It was only when I scanned the negative and looked at the image on my computer monitor that I realized just about every person in the scene was looking at me. But when you see the Lookaround in action, you begin to realize why!

Camera Lookaround 360 Lens 24mm Film Ilford HP5 Plus rated at ISO 400

1/125sec at f/11, you can either use a rotation speed of 1 revolution in 4 seconds, or 1 revolution in 2 seconds and set the lens to f/8, which is one stop wider.

This all sounds a bit hit and miss, but if you use negative film instead of transparency (slide) film, you don't have to get the exposure spot on because the latitude of the film will compensate for any exposure error. Also, it's actually difficult to get the exposure way off – if you take a picture with the Lookaround spinning at 2 revolutions per second when it should be rotating at 1 revolution per second, the exposure difference is only one stop, which won't make any difference.

To make the most of the Lookaround, you need scenes where there's 360° interest. This means that it's more suited to use in urban areas than for landscapes. It also works wells at outdoor shows and events where there are lots of people. Alan Zinn himself has some great pictures of balloon festivals and classic car shows.

I can't imagine that I will use the Lookaround on a regular basis, but if you want to take your panoramic photography to a new level, I can heartily recommend it.

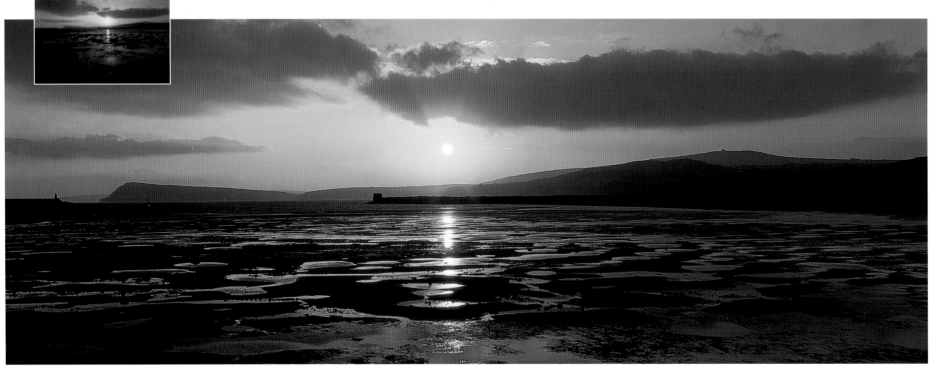

▽ **FISHGUARD BAY,
PEMBROKESHIRE, WALES**
Here's a good example of how
cropping a medium-format
original down to panoramic
format can improve the shot.
In the full-frame version,
a large area of immediate
foreground came out too dark.
By cropping, this is lost and
all attention is focused on the
brighter area of the image.

Camera Pentax 67 Lens 45mm
Filter 81B warm-up
Film Fujichrome Velvia 50

ALTERNATIVE OPTIONS

Although the most straightforward way to shoot pano-
ramics is to use a purpose-made panoramic camera,
there are ways in which you can explore the medium and
produce top-quality images without investing large sums
of money in a specialized camera. If you're not completely
sure that panoramic photography is for you, or if you
can't find a panoramic camera that suits your needs and
you don't want to make an expensive mistake, some of
the ideas covered in this section may solve your dilemma.

CROP YOUR PICTURES

A quick and convenient way to produce panoramic
images is to take photographs using a conventional
film format and then crop them down to panoramics.

The smallest film format you're ever likely to crop
down to panoramic is 35mm. GePe make slide mounts
with panoramic masks already inserted, though a similar
effect can be achieved using pieces of card or tin foil – a

popular camera club technique. The other option is to
scan the original, crop it as required and output an inkjet
print, or send your negatives or slides off to a commercial
printer and ask for panoramic prints to be made. If you
have a home darkroom, you can do the same yourself.

The main thing to remember is that if you start out
with a 35mm original and crop it down to an aspect ratio
of 2:1 or 3:1, the piece of film you end up with will be
small, and will tolerate only a limited degree of enlarge-
ment before image quality begins to tail off. For that
reason, you're better off starting with a medium-format
original, so the final panoramic image is bigger. If you crop
down a 6x7cm colour transparency so it's 24mm deep,
for example, the image you end up with will be the same
size as one shot on a Hasselblad XPan using 35mm
film – about 24x65mm.

I use a Pentax 67 system and sometimes feel that
pictures I have taken work better as panoramics. Instead
of mounting them in black card masks with a 6x7cm

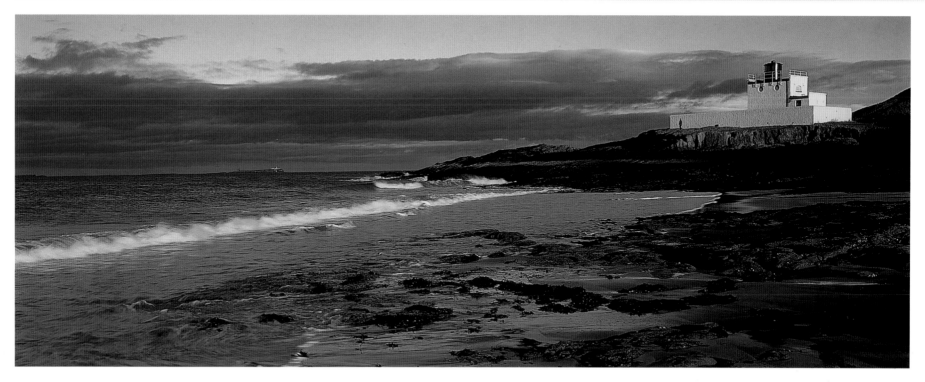

aperture, I simply mount them in masks with a 24x65mm aperture cut for XPan images and no one knows the difference! For suppliers of panoramic masks and mounts, see page 142.

If you use a different medium-format, such as 6x4.5cm or 6x6cm, XPan-size mounts will be too big. However, this is easily remedied by masking off either end of the mount with small pieces of black card.

PANORAMIC INSERT

If you don't have a medium-format camera system and feel that it would make more sense to invest in one than in a panoramic camera, why not consider the Mamiya 7? As well as being a highly capable camera, with a range of excellent lenses covering focal lengths from 43mm to 210mm, it also has a handy trick up its sleeve in the form of an optional panoramic adaptor. This inexpensive accessory allows you to expose 35mm film and produce 24x65mm panoramic images just like those of the Hasselblad XPan.

If you're currently shooting in 35mm format and like the idea of adding a panoramic camera to your outfit, the Mamiya 7 is a viable alternative to the XPan; as well as allowing you to shoot panoramics that are comparable to those from the XPan, you can also produce high-quality 6x7cm images on rollfilm. Okay, so the camera is a little bigger than the XPan, but it won't cost any more to purchase a body, panoramic insert and 43mm

△ **BAMBURGH BEACH, BAMBURGH, NORTHUMBERLAND, ENGLAND**

This photograph was taken using a Mamiya 7 with a panoramic insert (shown below) enabling 35mm film to be exposed to produce images with a format of 24x65mm.

Camera Mamiya 7 Lens 43mm Filter 81B warm-up Film Fujichrome Velvia 50

◁ Mamiya 7

and 80mm lenses than it would to buy an XPan with 45mm and 90mm lenses, yet you get the medium-format option as well, which is better than the XPan's full-frame 35mm format option. The only downside to choosing the Mamiya 7 over an XPan is that the widest lens for the Mamiya is 43mm, whereas there's a superb 30mm super-wide for the XPan. Other than that, it depends on whether you would rather have a pukka panoramic camera than a medium-format model with a panoramic insert.

BUILD YOUR OWN PANORAMIC CAMERA

If you like adventure, risk and fun, you could always try constructing your own panoramic camera – or find someone with the knowledge and ability to build one for you.

Not only does this option allow you to produce a high-quality camera for a fraction of the cost of a purpose-made model, but you can also come up with all kinds of weird and wonderful designs.

Trelawny Burt of the UK photographic retailer Robert White (see page 142) owns a 6x12cm camera (pictured below) that was made by a customer of his, who also happens to be a clever engineer and retired lecturer in photography. The camera was made from the rollfilm holder of an old Mamiya 6x9cm press camera machined out to 6x12cm and fitted with a Schneider 75 f/8 Super

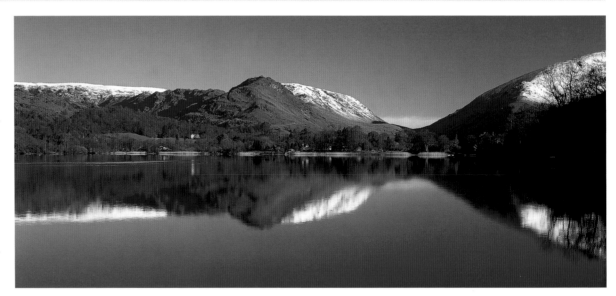

△ **GRASMERE, LAKE DISTRICT, ENGLAND**
Some scenes are just made for the panoramic format. This view across Grasmere on a flat calm winter's morning didn't work so well in full frame 5x4in because there was too much empty sky and foreground, but by using a 6x12cm back I was able to exclude unwanted areas and concentrate on the distant hills and reflection.

Camera Horseman Woodman
Lens 150mm Filter Polarizer
Film Fujichrome Velvia 50

◁ Making your own panoramic camera is not only fun but can save you a small fortune as well. This 6x12cm model belongs to photographer Trelawny Burt.

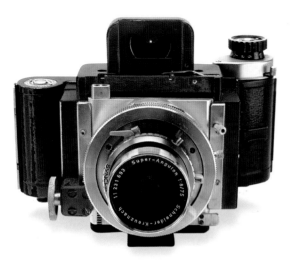

Angulon lens. This may seem crude, but the viewfinder has a coupled mask to show the composition when rising front is in use – a feature even more sophisticated than you will find on a Linhof Technorama 612!

Trelawny's colleague at Robert White, Matt Sampson, also makes his own cameras, one of which is a 4x10in panoramic masterpiece fashioned from wood. It features a homemade 4x10in darkslide re-engineered from a pair of 5x4in darkslides and uses a Schneider 90mm XL lens. Slicing sheets of 10x8in film in half, in the dark, produces the film for this beast.

Obviously, camera design and construction isn't for everyone, but even if you don't have the technical know-how there are plenty of people who do, and some of the more specialized camera manufacturers, such as Gandolfi, Rayment Kirby and Walker Cameras, will discuss one-off projects. See page 142 for contact details.

LARGE-FORMAT CAMERA AND ROLLFILM BACK

The most versatile cameras available, from a technical point of view at least, are large-format field and view cameras, because they offer movements that allow you to control depth of field, perspective and distortion. It goes without saying, therefore, that if you were able to

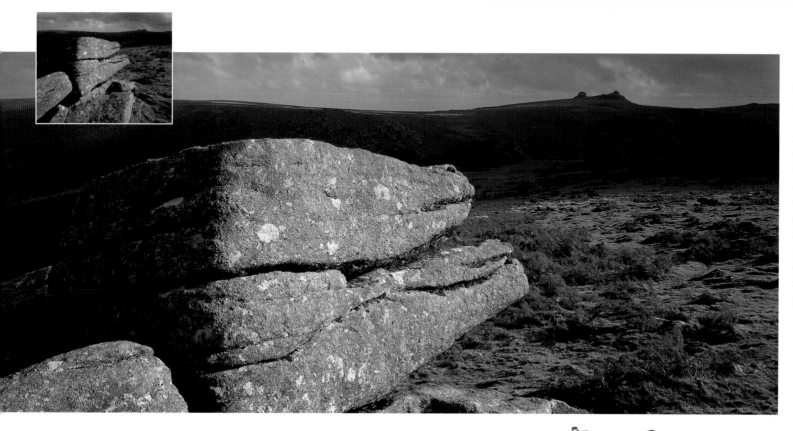

◁ **HOUND TOR, DARTMOOR, DEVON, ENGLAND**
When I'm shooting with a 5x4in large-format camera I may photograph the same scene on 5x4in film then again with a 6x12cm rollfilm back fitted if the composition shoots as a panoramic. In this case, doing so allowed me to make a feature of the sunlit granite outcrops in the foreground.

Camera Horseman Woodman **Lens** 90mm **Filter** 0.6 ND hard grad **Film** Fujichrome Velvia 50

convert a large-format camera so that it produced panoramic images, you would end up with a highly versatile panoramic camera.

The good news is that such an option is available: you just need to fit a 6x12cm Horseman rollfilm back to a 5x4in camera, or a Canham 6x17cm rollfilm back to a 5x7in camera. By doing this, you get to benefit from all the movements of the large-format camera, build up a more extensive lens system than is offered by any pukka panoramic camera, and use the camera full-frame to produce stunning large-format images as well.

On the downside, large-format cameras are bigger and heavier than panoramic cameras, they take longer to set up, and it requires a lot of skill and experience to really make the most of the movements on offer.

My opinion is that for 6x17cm I would choose a panoramic camera such as the Fuji GX617 every time, as a 5x7in camera is bulky and heavy in comparison. However, for 6x12cm, I feel that a 5x4in camera fitted with a 6x12cm back is well worth consider- ing instead of a 6x12cm panoramic camera – I use a non-folding Ebony RSW45 with a Horseman 6x12cm back – as you can get a lot more for your money compared to cameras such as the Horseman SW612 Pro.

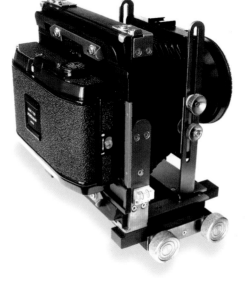

◁ If you already own a 5x4in large-format camera, adding a Horseman 6x12cm rollfilm back will allow you to produce high-quality panoramics.

FILTERS & ACCESSORIES

Any specialized area of photography brings with it a few teething troubles that need to be overcome in order to produce successful results, but that's all part of the challenge – if everything in life were easy, mastering it wouldn't be nearly as much fun. Panoramic photography is no exception, especially when it comes to using filters.

Most photographers who move into shooting panoramics do so having first cut their teeth on 35mm or medium-format SLR cameras with direct viewing, so having to work with a rangefinder often comes as a shock to the system.

'How do I align a polarizing or graduated filter with my Hasselblad XPan?' is a question that I am frequently asked when leading photo workshops. It's an issue that the questioner didn't even consider when they were buying their camera, but it soon becomes a problem when they start taking pictures and want to use a filter that requires precise alignment.

Many photographers simply don't use these filters on their panoramic cameras, but this means that you are

▷ **NAMIB RAND, NAMIBIA**
I use a polarizer more than any other filter when shooting panoramics, and this photograph is a good example of why it's so useful. As well as enhancing the sky, it has also reduced haze so the mountains are more sharply defined, and deepened the rich colour of the orange dune in the foreground. From the angle of the shadows here, you can see that the sun was at almost 90 degrees to the camera – the best position to get the most from your polarizer.

Camera Fuji GX617
Lens 300mm Filter Polarizer
Film Fujichrome Velvia 50

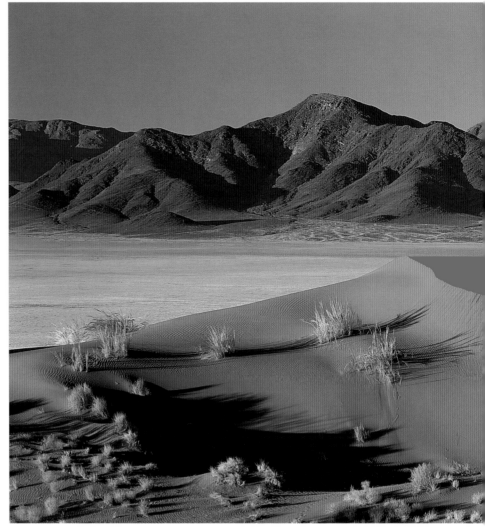

▷ This photograph shows how I attach filters to my Fuji GX617 and get around the problem of the lens protection bars. I place small balls of Blu-tac on a filter holder adaptor ring and press the filter I want to use against them to hold it in place in front of the lens.

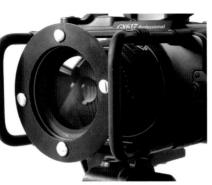

compromising your pictures and not getting the most out of your equipment, so it is best just to address the issue.

WHICH FILTER SYSTEM SHOULD YOU BUY?

The main consideration is how you are going to attach the filters to the lenses of your panoramic camera.

First off, I would say you should avoid screw-in filters as they cause vignetting on wideangle lenses if you use more than two at the same time. I prefer holder-based filter systems. For a number of years, I have used the 100mm-wide system from Lee Filters plus a 105mm screw-in polarizer that can be attached to the front of the Lee holder via a 105mm threaded ring. Having said that, my first-choice panoramic camera, the Fuji GX617, has protection bars that protrude in front of the front element of each lens, and these are too close together for me to fit a 100mm Lee filter holder between them. So, while I still use the same Lee filters, I attach them using Blu-tac.

Here's what I do: a filter holder adaptor ring is screwed to the lens. I use Cromatek rings for this as they have a handy flat face. On that flat face, I place four small blobs of Blu-tac, of around 5mm (¼in) in diameter. The first filter – a polarizer, say – is secured by pressing it against the Blu-tac. If I want to use a second filter, I then

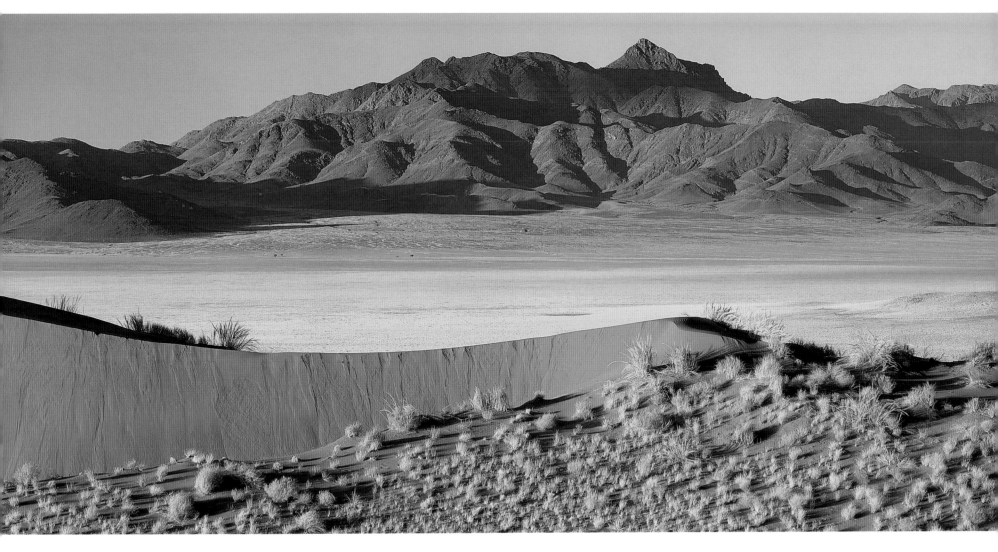

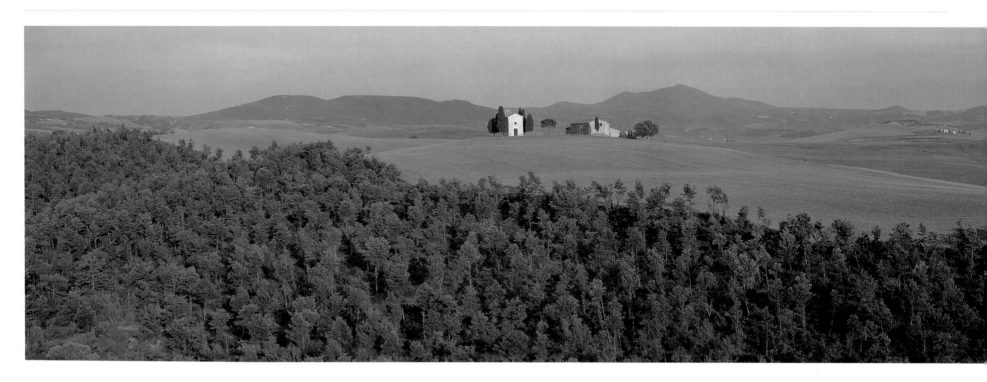

▽ You can use a filter holder with the Hasselblad XPan, but once it is on the lens it obscures the viewfinder, so you need to compose the picture before fitting it.

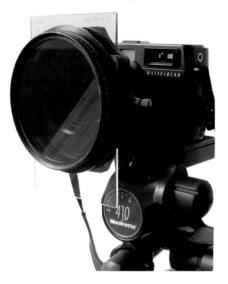

place four more small balls of Blu-tac on the edge of the polarizer and press the next filter against it, and so on – although I rarely use more than two filters at a time.

One benefit of doing this, other than getting around the issue of the protection bars on the lens, is that the filters are positioned close to the lens, so there's less risk of vignetting with wideangle lenses. The downside is that in cold or wet weather, Blu-tac loses its tackiness – on one occasion my expensive glass polarizer fell off and then smashed.

If you use a 35mm panoramic camera, such as the Hasselblad XPan, then you don't need 100mm-wide filters. In fact, big filters are a nuisance on the XPan because once on the lens they block the optical viewfinder, especially the 45mm and 90mm lenses, so you can't see half of the composition. To minimize this, I would recommend the Cokin P system, which uses 85mm-wide filters. An advantage of the Cokin system is that the polarizer fits into a narrow slot at the back of the holder, so you can rotate it before your eyes to achieve correct alignment,

△ **CAPELLA DI VITALETA, TUSCANY, ITALY**
Once you devise a way of attaching and aligning filters, you can use more than one in combination. For this early evening shot, I used a polarizer to increase colour saturation and enhance the sky, together with an 81C warm-up to emphasize the warm glow on the distant church and barn.

Camera Fuji GX617 Lens 300mm Filters Polarizer and 81C warm-up Film Fujichrome Velvia 50

then lower it into the holder, which is already attached to the lens (see next page).

POLARIZING FILTERS

Using a polarizer on an SLR is easy; you just point the camera at your subject, rotate the filter while looking through the viewfinder, and stop rotating when the desired effect has been achieved. You can't do that with a panoramic rangefinder though, so what's the solution?

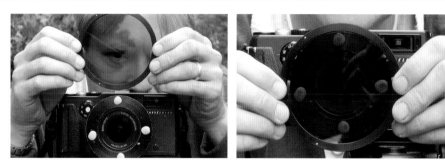

▷ To align a polarizer when using one of my panoramic cameras, I rotate it in front of my eye to gauge the effect, then secure it on the lens with Blu-tac.

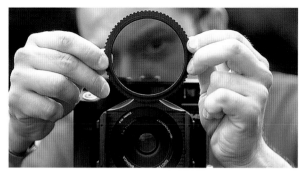

△ The Cokin P system is ideal for use with rangefinder cameras because you can align the polarizer by eye, as shown, then slot it into the rear of the holder.

▷ Another way to secure your polarizer once it's aligned is to place balls of Blu-tac on either side of the outer barrel of the lens and pinch the filter against them.

▷ A glass polarizer in its mount can be quite heavy, and is more likely to fall off the lens when secured with Blu-tac. However, you can lighten the load by removing the filter from its mount, as I did here.

Much depends upon the filter system you use. Systems that use a slot-in polarizer, such as Cokin P and Xpro, are easy to work with. All you need to do is hold the polarizer just above the front of the lens, rotate it while looking through the filter itself, then, when the desired position has been achieved, carefully lower the filter and slot it into the holder, taking care not to change its position. If this isn't possible, another option is to rotate the polarizer as described above, then lower it in front of the lens and secure it with blobs of Blu-tac pressed onto the outer edges of the lens barrel or on a filter holder ring.

If you use a polarizer that screws to the lens, you need to put reference marks on the rim of the mount so you can align it correctly once it's on the lens.

1. Etch a single mark on the rear section of the filter mount – the part that doesn't rotate – then screw the filter onto your lens and count the number of full turns you need to make before the filter tightens.
2. Repeat this several times until you know roughly where the reference point on the filter needs to be in relation to the circumference of the lens's front element when you start screwing it in place, so that when it is tight it will be at the top of the lens.
3. Now mark a series of numbers or lines around the rotating front ring of the polarizer at 5mm (¼in) intervals.
4. Holding the polarizer in front of your eye with the rear reference marker at the top, rotate the front section of the filter to achieve the desired level of polarization, then check to see which number or line marked on the front section of the filter lies opposite the reference mark on the rear section.

△ If you have a screw-in polarizer, use reference marks around the mount to help you align it correctly. I scratched a line on the rear of the mount of this filter, as shown, and use the numbers around the rotating front end of the mount for reference.

5. Screw the polarizer onto your lens as described in step 2, so that when it's fully screwed on the rear reference point is at the top.
6. Now rotate the front section of the polarizer, if necessary, to ensure that the number or mark established by following step 4 is opposite the reference point on the rear section of the filter.

This procedure may seem a little confusing initially, but once you have marked reference points on the polarizer you should be able to get perfect alignment.

The majority of panoramic cameras don't have any integral metering, so you can use either a circular or linear polarizer – both cause the same two-stop light loss so you can take an exposure reading with a hand-held meter then compensate accordingly (see page 46). If you use a Hasselblad XPan that has integral metering, use a linear polarizer if you intend metering through the filter.

Once the polarizer has been aligned, you can attach other filters such as grads or warm-ups. I do this using Blu-tac, as already explained, but the other option, if you use a screw-on polarizer, is to screw a filter holder to the polarizer itself and then slot other filters into the holder. Screw-in polarizers usually have a front thread for this purpose, although slim-line models tend not to.

GRADUATED FILTERS

Graduated filters are essential for landscape photography; they allow you to reduce the brightness of the sky so that it doesn't overexpose when you meter for the landscape itself. I carry a range of Lee graduated filters in the densities listed below. All are hard-edged grads as I find they give a more pronounced effect than soft-edged grads.

Density	Reduction in sky brightness
0.3	1 stop
0.45	1½ stops
0.6	2 stops
0.75	2½ stops
0.9	3 stops

As well as the standard 100x150mm ND grads that Lee produce for their 100mm-wide filter holder, I also have a set of 80x120mm grads specially made by Lee Filters in the same densities. The reason for this is that the protection bars of my Fuji GX617 are only a little over 100mm apart and they protrude in front of the lens. This means that, while I can fit 100mm-wide filters between them, there's no room for adjustment, so I can't angle the graduated filters, which is necessary if the horizon in a scene is sloping. Having smaller grads made means there's more room either side, so I can attach them to the lens at an angle. Another problem solved!

To align the grad with a panoramic camera, I compose the shot with the camera on a tripod then approximate how much of the image area is occupied by sky – the top quarter, top half or whatever. Looking head-on at the front of the lens, I then position the grad accordingly. If the picture consists of half sky, half landscape, I make sure the neutral density (grey) part of the filter covers the top half of the lens, for example. It may sound crude, but it works, and I have yet to spoil a panoramic photograph by aligning a grad filter badly.

If you feel you may not be quite as fortunate, one option is to buy soft-edged grads as these are more forgiving. However, I have found that to get the desired effect with a soft grad I need to use a density one step darker than I would if it were a hard grad.

▽ I align my ND grads by eye and then secure them on the lens with Blu-tac (see pages 42–43). If the horizon is sloping, the filter is angled accordingly to give an even and discreet effect.

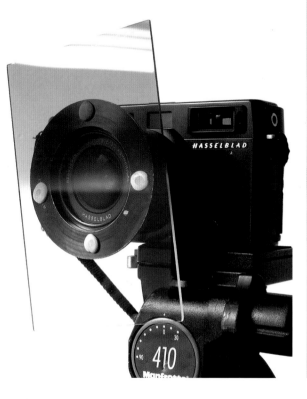

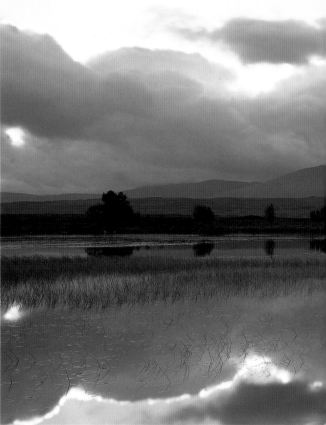

Some panoramic cameras also give you the option of direct viewing so you can align filters with more precision. For example, the Fuji GX617, Art Panorama 617 and Horseman SW612 Pro can be fitted with a ground glass focusing screen, though using one is time-consuming and fiddly.

CENTRE ND FILTERS

Certain wideangle lenses for panoramic cameras require you to use a centre-spot ND filter so that even illumination is achieved across the entire picture area. This is because the field of view of the lens is almost as wide as its image circle, so you get a fall-off in illumination towards the frame edges, and the corners of the picture come out

▷ This is what centre ND filters look like. The grey circle in the centre is what does the trick, holding back the central area of the image so that more exposure can be given to the edges to ensure even exposure across the whole frame. Above is the 0.3 centre ND for the 90mm lens of the Fuji GX617. This requires a one-stop exposure increase. Below is the 0.45 centre ND filter for the 30mm Hasselblad XPan lens; this requires a 1½ stop exposure increase.

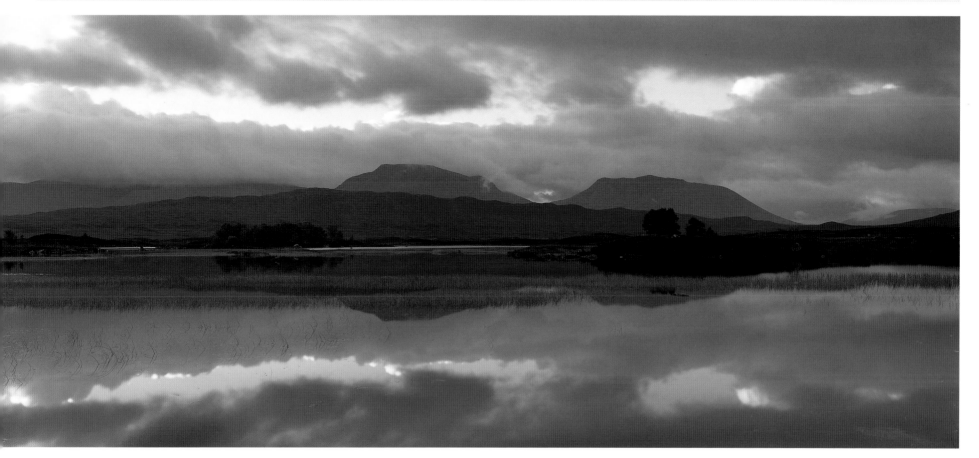

darker than the centre. Once that difference exceeds one stop, it's noticeable enough to need resolving, so a centre-spot ND filter is used to reduce the amount of light reaching the central area. This balances out the difference so illumination is even across the whole image. Most of these filters cause a light loss of between one and two stops.

The type of centre-spot ND filter you need will be governed by the camera and lens in use. Usually the manufacturer produces a specific filter for each lens; with the Fuji GX617 panoramic camera, for example, a specific centre ND filter is required for the 90mm lens, and a slightly different one for the 105mm lens. The same applies with other specialist cameras such as the Horseman SW612 Pro, the Linhof 612 and 617 models, and the Hasselblad XPan.

Centre NDs are required only with wide and ultra-wide lenses; longer focal lengths use only the central part of the lens's image circle so there's no fall-off. The 180mm and 300mm lenses for the Fuji GX617 don't require an ND filter, for example. Neither does the 90mm lens for the Hasselblad XPan, although the 45mm and 30mm lenses do.

△ **LOCH BA, RANNOCH MOOR, HIGHLANDS, SCOTLAND**
I often use neutral density grad filters to tone down the sky in landscape photographs, although the key is to ensure that the effect of the filter isn't noticeable. In this case, a grad filter was necessary to balance the sky and its reflection in the foreground. A reflected image is always slightly darker than the real thing, so I used a 0.45 grad to keep the sky slightly lighter than its reflection, while at the same time preventing it from over-exposing. The photograph was taken at dawn – the most magical time of day to be photographing a place as beautiful as Rannoch Moor.

Camera Fuji GX617 Lens 90mm Filters 0.3 centre ND and 0.45 ND hard grad Film Fujichrome Velvia 50

FILTER FACTORS

Because panoramic cameras generally don't have any integral metering, exposure readings tend to be taken using a handheld meter and then set on the camera manually. There is nothing wrong with that, but if you are using filters you must remember to compensate the exposure accordingly or you will underexpose the photograph. If you use a polarizer and an 81C warm-up filter, for example, you need to increase the exposure by 2½ stops – 2 for the polarizer and ½ for the warm-up. If you come into panoramic photography having got used to TTL metering, which automatically takes into account any light loss from filters, it's easy to forget to compensate. I should know, I've done it myself often enough.

What complicates things more is that if you use a camera system that requires centre-spot ND filters for some lenses but not others, such as the Hasselblad XPan or Fuji GX617, mistakes are even more likely. If you're taking pictures with a 30mm lens on an XPan, for example, it will have a centre ND filter fitted and you must increase the exposure by 1½ stops to compensate. This must be added to any other filter factors to establish the correct exposure. So, if you're using a polarizer and an 81C warm-up, as well as the 0.45 centre ND filter, you need to increase the exposure by four stops. Get the idea? If you then switch to a lens that doesn't need a centre ND filter, however, you must remember to adjust the exposure, otherwise the pictures will be overexposed.

▽ **BURANO, VENICE, ITALY**

This scene presented me with an exposure headache. If I exposed for the sunlit area, the rest of the scene, in shade, would come out too dark. If I exposed for the shade, the sunlit area and the sky would have been overexposed. To overcome this, I used a neutral density hard grad, positioned at an angle so it affected only the sunlit area. This enabled me to give more exposure to the shady areas so the whole scene was evenly exposed. To determine the correct exposure, I took a spot meter reading from the pathway on the right side of the canal. I also used a polarizer, fitted to the lens before the grad, to emphasize the sky and increase colour saturation in the painted houses.

Camera Hasselblad XPan Lens 30mm Filters 0.45 centre ND, polarizer and 0.75 ND hard grad Film Fujichrome Velvia 50

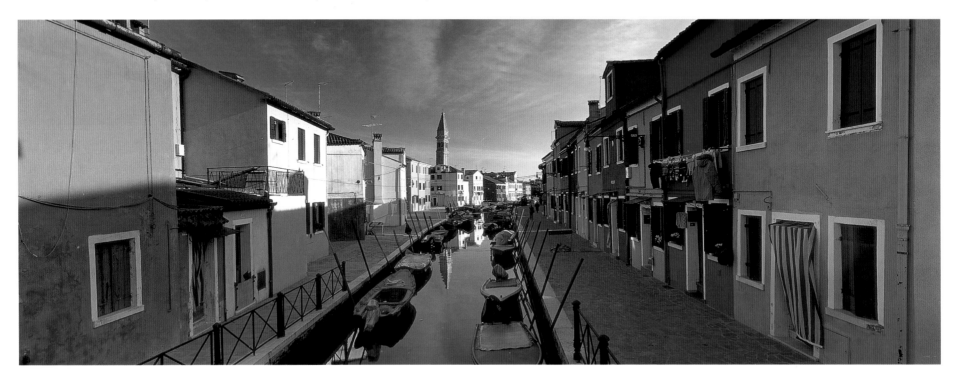

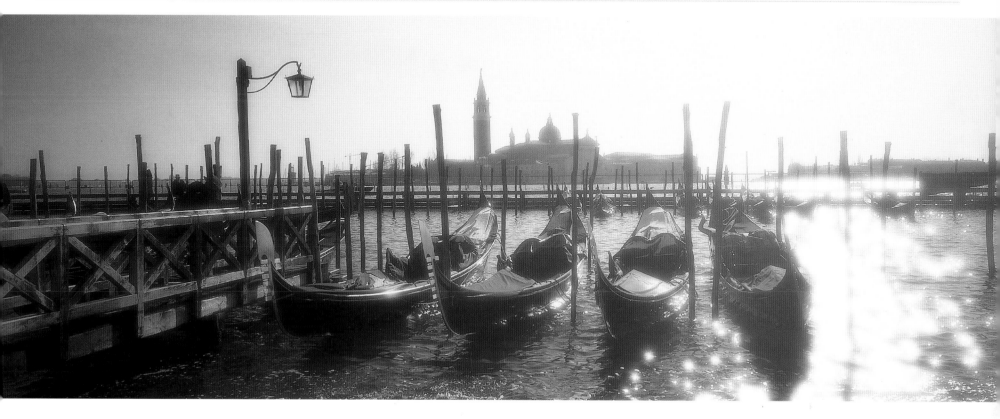

When it comes to applying the filter factors, if the total amount of compensation required is in full stops, I increase the exposure time and leave the lens aperture constant so depth of field isn't affected. If the total includes a fraction of a stop, then I apply the full stops by adjusting the shutter speed and the remaining fraction (usually half a stop) by adjusting the aperture as it has half-stop settings.

VIGNETTING

Something you have to be aware of when using filters on your panoramic camera is that, if those filters are too small, the filter holder is too small, or you use too many screw-in filters at the same time, vignetting may occur because the lens's field of view has been obscured, causing the corners of the picture to come out black. This is known as vignetting. With direct-viewing SLR cameras,

you can often see vignetting when you look through the viewfinder. As this isn't an option with rangefinders, you need to take great care to avoid the problem.

Many photographers leave a UV or skylight filter permanently attached to each lens to protect the front element. This makes sense, but if you then screw in a filter holder, or one or two more screw-in filters, the combined depth of holder and mounts may cause vignetting. The same applies if you're using a lens that must be fitted with a centre ND filter and you put a filter holder or other filters in front of it.

If in doubt, conduct some tests. It may be that all you need to do to avoid vignetting is remove the protective filter from the lens before attaching a filter holder or other filters. If the lens requires a centre ND filter that you can't remove, you may need to invest in a bigger filter system, such as 100mm.

△ **VENICE, ITALY**

I always carry at least one soft-focus filter with me. I don't use these filters very often, but on the right kind of scene the effect they produce can add loads of atmosphere. Backlit scenes work particularly well, and in this case I increased the exposure to burn out the highlights on the water and add mood.

Camera Hasselblad XPan **Lens** 90mm **Filters** 85C and Cokin Diffuser 1 **Film** Fujichrome Velvia 50

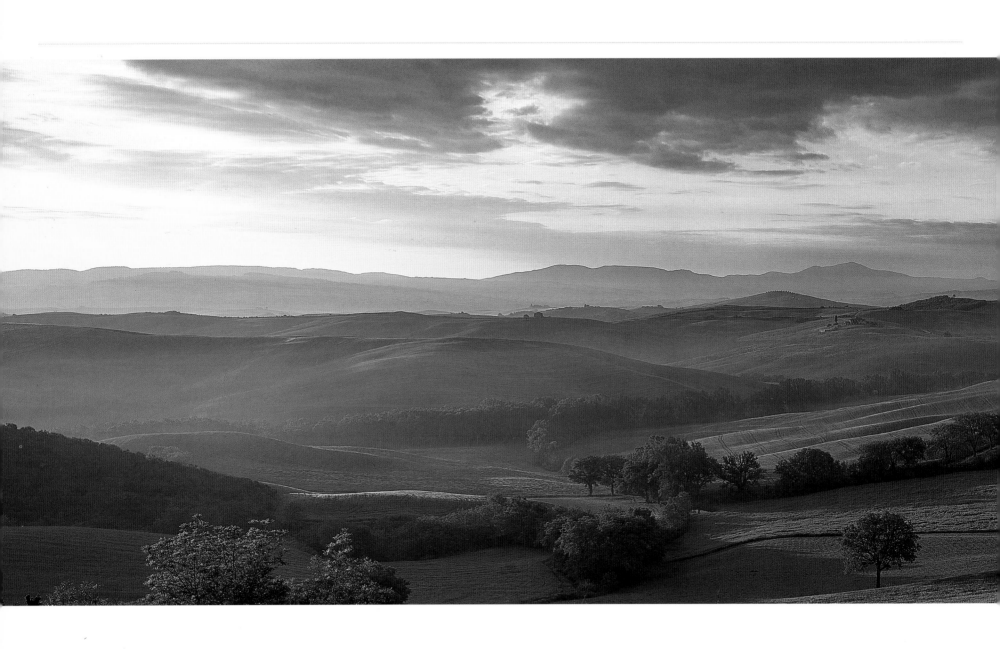

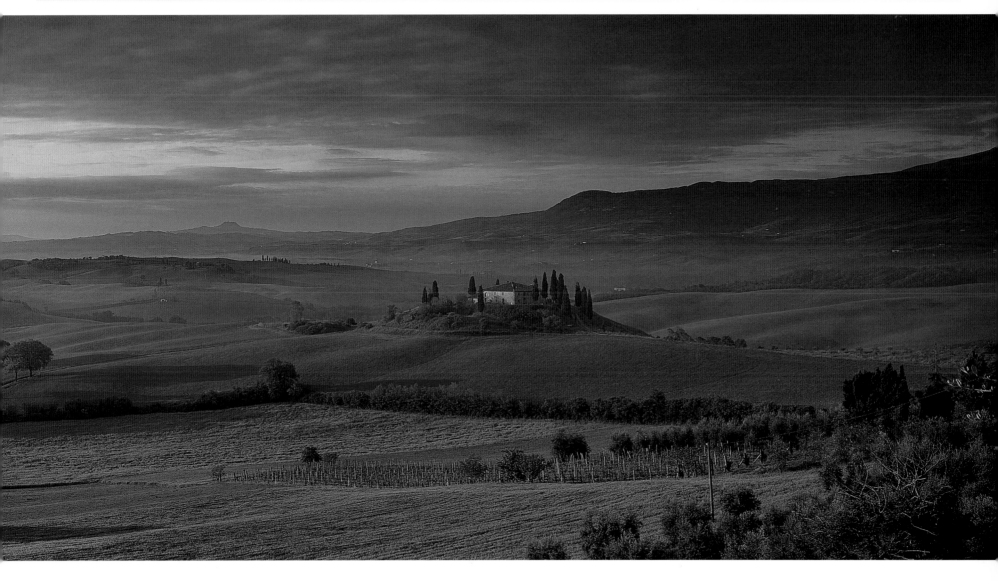

BELVEDERE, NEAR SAN QUIRICO D'ORCIA, TUSCANY, ITALY

I arrived at this location at around 5am, expecting the valley to be filled with mist. Instead I found it to be almost clear. Initially I was disappointed. However, in the minutes preceding sunrise, at around 5.40am, clouds began to build up over the valley and I predicted that there would still be some great pans to be taken, even if they weren't quite what I had expected. Before long, my prediction came true – the sun rose into a clear patch of sky and lit the farmhouse in the distance. I had already composed the scene, using a 0.75 ND hard grad on the sky and an 81C warm-up filter to enhance the dawn light.

Camera Fuji GX617 Lens 90mm Filters 0.3 centre ND, 0.75 ND hard grad and 81C warm-up Film Fujichrome Velvia 50

TRIPODS AND HEADS

Although I have used both my Hasselblad XPan and Fuji GX617 panoramic cameras handheld on more than one occasion, whenever possible I prefer to mount them on a solid tripod. There are three main reasons for this:

1. It frees me to set small apertures to increase depth of field without worrying about how long the exposure is. Often I am shooting at f/22 or f/32 with polarizer and centre ND filters attached, so even in bright sunlight exposures can be as long as 1sec with Fujichrome Velvia 50 film.

2. The tripod keeps the camera in position, so once a picture has been composed you can wait as long as you need to for the light to improve or attend to what ever else you need to do, and the composition will remain the same. Also, it doesn't matter if filters or filter holders obscure the viewfinder of the camera; if it's mounted on a tripod, you can compose the picture first, then put the filters on the lens.

3. It's easier to get a camera level and square when it's on a tripod because you can stand back and check levelling aids (see panel opposite).

◁ **FLORENCE, TUSCANY, ITALY**

This is the classic view over Florence, taken at sunset from the Piazza Michelangelo high above the ancient city. I had just arrived in Florence, and after finding a hotel for the night I raced up to the piazza in my hire car, hoping to catch the sunset. I just managed it, though the sky became more intense in the first few minutes after the sun had gone down, which is when I took this shot. Shooting in the panoramic format allowed me to capture all the city's main monuments, from the Ponte Vecchio to the Duomo, without including lots of unwanted foreground.

Camera Fuji GX617 Lens 180mm Filters 0.45 ND hard grad and 81D warm-up Film Fujichrome Velvia 50

These days I use one of two tripods and one of two heads. If I don't have to worry about weight, my first choice is a Gitzo 1348 carbon-fibre tripod fitted with a Manfrotto 410 Junior Geared Head. The tripod is very solid but relatively light because of its carbon-fibre construction. It also extends to over 2m (6ft) in height without a centre column fitted, which is more than I am ever likely to need – though if I do need to go higher, I can attach a centre column.

I chose the head because, as well as being strong enough to carry all my different camera systems, from 35mm to 6x17cm and 5x4in, it also has geared controls, which makes precise adjustment of the camera in one direction at a time quick and easy.

When I need to travel light, I choose a Manfrotto 190 and a Manfrotto Heavy Duty Ball Head. This combination is fine for use with my XPan system and at a push the GX617. The tripod extends to only around 1.5m (4½ft), but that's high enough for most situations, while the head is lighter and more compact than the geared head and is quick to use – although precise alignment can be fiddly because the camera moves in all directions when the locking mechanism on the ball is released.

▷ The Gitzo 1348 carbon-fibre tripod and Manfrotto 410 Junior Geared Head provide a solid, sturdy platform for my panoramic cameras.

Lens hoods and shades

Although I have lens hoods for all my panoramic lenses I never use them, simply because they get in the way when I want to use filters. The principle aim of a lens hood is to shade the front of the lens and reduce the risk of flare. However, there are other ways in which you can do that, as outlined on pages 80–81. Your body is the most effective lens hood available, and, of course, it goes everywhere with you!

Levelling the camera

If you want to shoot a series of images and stitch them together later, the camera should be set up so that it's perfectly level and doesn't deviate as you move it between frames.

Using the levels in your tripod head or placing a spirit level on the camera's hotshoe may work, but unless the tripod itself is set up perfectly level, the camera will be level in only one position: as soon as you swing it left or right, it will go out of level.

The easiest way around this is to buy a special levelling head that works independently of the tripod legs so that, even if they are leaning, the camera itself can be levelled through 360 degrees. Manfrotto produce several items that allow this: the Pan Rotation Unit (code 300N), the Levelling Base (code 338), and the Compact Levelling Head (code 438).

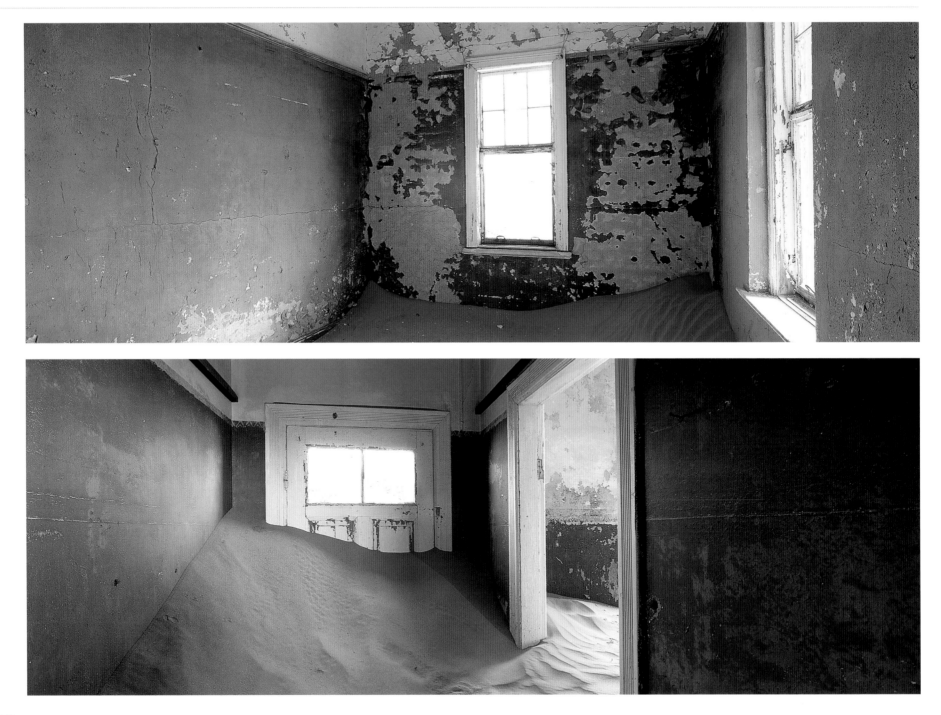

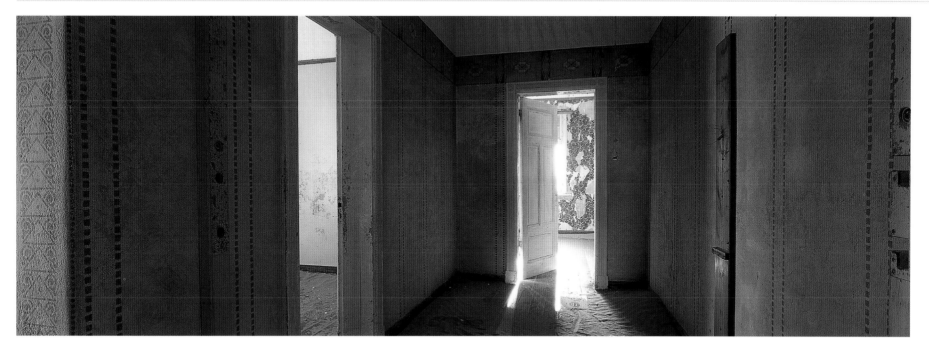

◁△ **KOLMANSKOP, NAMIBIA**

Kolmanskop is a deserted diamond-mining town close to the Atlantic coast of southern Namibia. Once said to have been the wealthiest place on earth, in its heyday it boasted grand houses, a casino, a hospital, and even a hall where an orchestra played at tea dances. Sadly, the town was abandoned in 1938, since when it has been left to the ravages of nature. Fierce winds have broken windows and blown in doors, and airborne sand is slowly filling up the rooms, covering the buildings forever. I visited the town in March 2004 and spent a morning wandering from house to house, entranced by the sand-filled interiors, peeling wallpaper, creaking floorboards and echoing voices. Natural, reflected daylight provided the only source of illumination, and the quality of light was ideal for taking atmospheric shots of the interiors. I found the panoramic format to be perfect and used only one camera and one lens for the entire morning: my Hasselblad XPan and 30mm lens. In the space of three hours I had exposed ten rolls of Velvia 50 and taken almost 200 pictures. There were times when I felt compelled to put the camera away and just enjoy being there. But then I'd walk into the next room, see another great picture waiting to be taken, and the temptation to reach for my XPan was just too great to resist!

Camera Hasselblad XPan Lens 30mm Filter 0.45 centre ND Film Fujichrome Velvia 50

COMPOSING PANORAMICS

Perhaps the most difficult aspect of panoramic photography for beginners is getting used to composing images within the letterbox-shaped format. Having spent years working with a rectangular or square image shape and learning how to create balanced, stimulating compositions, it usually comes as something of a shock to realize that the same principles of composition don't necessarily apply to, or work with, panoramics, and a whole new way of seeing is necessary in order to make full use of the format.

Rather than seeing this as a chore, however, you should think of it as a challenge. Using a panoramic camera will help you to see the world in a new way. You will become more visually attuned to your surroundings and notice things that you haven't noticed before. You will also learn to work within the limitations imposed by the camera and understand how to juxtapose the elements in a scene so they work in harmony to fill the image space. I find that if I start out shooting panoramics, I might as well have left all my other equipment behind because it's

highly unlikely that I will take a picture in any other format that day. This is because my brain somehow automatically switches to panoramic mode and I start seeing the world through letterbox-shaped spectacles, mentally seeking out compositions that work as panoramics. Sometimes I may shoot a panoramic and then photograph the same scene in a more conventional format – usually 6x7cm or 35mm – but more often than not, if a scene suits panoramic format it won't be successful in any other.

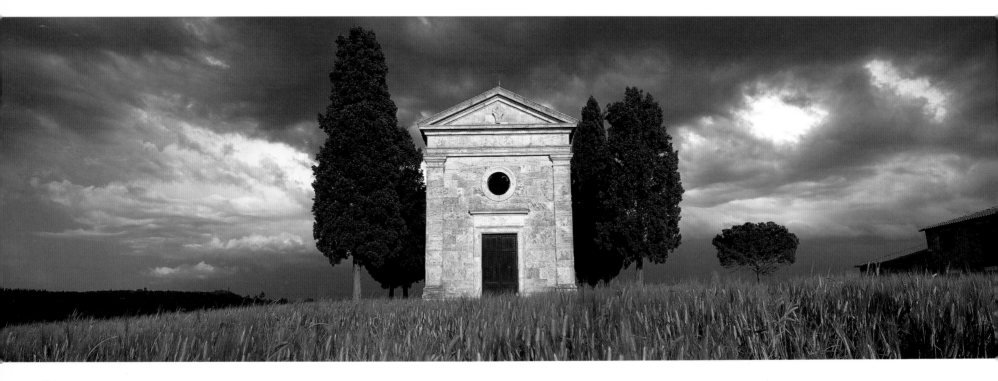

Confidence counts for a lot. I could happily go on location now armed with only a panoramic camera and two or three lenses because I know that I will be able to produce interesting panoramic photographs. In the early days, however, I didn't have that confidence in either the format or my ability to make use of it, so my panoramic camera always took second place to a 35mm SLR or Pentax 67. The change in emphasis took place slowly, over a number of years. You are probably in a similar situation, but if you stick with it and keep practising and experimenting, that will soon change.

There are no magic formulas to guarantee success; no quick fixes or tricks. Composition is all about looking at a scene and deciding which parts of it you would like to put into your picture, then deciding how to arrange those bits so they work well together and produce a visually interesting photograph. There are no rights or wrongs in this respect, and you should let your own way of seeing influence the way you compose, rather than relying on a set of rules or guidelines.

I like my pictures to tell a story. They should have a beginning that grabs the viewer's eye, a middle that holds the attention and an end that brings the story to a conclusion. However, this can be achieved only if each part of the story is linked to the next, so that the eye drifts effortlessly through it.

In complete contrast, I also like to create simple, abstract compositions that make use of bold shapes and strong colours. Rather than take the viewer on a long, meandering journey, these photographs offer a quick fix – they hit you between the eyes.

FILL THE FRAME

Whatever approach you take, the one thing you must always strive to do is fill the frame. The most common compositional mistake made by newcomers to panoramic photography is concentrating all the interesting stuff in the centre of the frame, so that the further you travel out towards the edges of the picture, the less interesting the composition becomes – to the point that the composition would be tighter and more effective if you cropped out the central area and ignored the rest.

I'm not saying that a panoramic is a failure if you can do this – actually, you should be able to extract several good pictures from a single panoramic – but it's vital that you see the edges of the picture as being as important as the centre because, if you have interesting stuff going on at the edges, the viewer will be encouraged to look for longer and take in the whole composition.

Another factor to consider is that panoramic photographs tend to be read from side to side rather than bottom to top when composed in the horizontal format, so you need to make sure that there are things at the edges of the composition that will carry the eye through the scene – usually from left to right. The wider the lens and the more elongated the picture format, the more difficult this becomes – which is why the 2:1 aspect ratio is usually favoured over 3:1. However, for me, 3:1 is the most natural panoramic format there is, and a well-composed picture taken in that format is hard to beat.

FOREGROUND INTEREST

One of the most important elements you can use to create a dynamic composition is foreground – the part of a scene closest to the camera. Foreground interest is useful because it contains more information than the rest of the scene, and being the area closest to the camera, it allows you to record fine detail and isn't affected by atmospheric haze, mist and fog. Emphasizing the foreground also helps to give your photographs a strong sense of distance and scale due to the effects of perspective, as well as providing a convenient 'lead-in' to the picture.

Having always been a big fan of strong foreground interest in my landscape photographs, I was initially rather shocked to find that even with a wideangle lens attached to a panoramic camera, the amount of foreground that can be included is minimal compared to using moderate wideangle lenses on 'normal' film formats.

It makes sense, of course: a 45mm lens on a Hasselblad XPan gives an angle of view from side to side similar to a 24mm lens on full-frame 35mm but is only half as deep. It's a similar story with the 90mm lens for the Fuji GX617, and this was one reason why I experimented with the Horseman 612 and its super-wide lenses.

◁ **CAPELLA DI VITALETA, TUSCANY, ITALY**

Often I know pretty much how a photograph will be composed even before my camera is mounted on its tripod. In this case, the dominant feature in the scene was the church, bathed in storm light against the dark, dramatic sky. For me there was only one place for it to go – in the centre of the frame. Had I placed it anywhere else, the composition would have lost its balance and simplicity, and the effect of the clouds radiating from behind the church would have been diminished. I wasn't sure about including the barn over on the right, but there was no way to avoid it without cropping the 6x17cm image down to 6x12cm. Fortunately, it was in shade, and the dark hillside on the far left of the frame helps to counter it so that the church remains prominent. I can't really see how the composition could be improved; the scene suited the 6x17cm format perfectly, and full use has been made of the picture area.

Camera Fuji GX617 Lens 90mm Filter 0.3 centre ND
Film Fujichrome Velvia 50

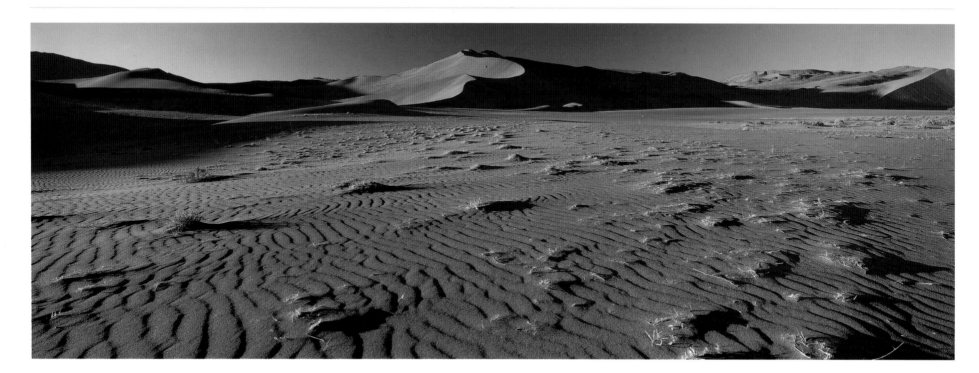

△ **SOSSUSVLEI, NAMIB DESERT, NAMIBIA**

When I arrived at this location I was immediately attracted to the ripples in the sand that were being emphasized by the setting sun – they made perfect foreground interest. To make the most of them, I set my tripod low so the camera was only about 45cm (18in) above the ground, stopped the lens right down to f/45 and set focus to maximize depth of field. This gave me a zone of sharp focus from 2m (6ft) to infinity, and I adjusted the camera's position until the nearest point in the picture was no less than 2m (6ft) to ensure front-to-back sharpness. The dominant dune in the distance seemed to work best when placed centrally in the top of the frame, while a polarizing filter deepened the blue sky and strengthened the rich colour of the orange sand. With no time to spare – the sun was going down fast – I was set up and ready to shoot in less than a minute. I often take my best pictures when I'm working under pressure and have to rely on my gut instinct. In this case, it certainly paid off.

Camera Fuji GX617 Lens 90mm Filters 0.3 centre ND and polarizer Film Fujichrome Velvia 50

That said, it is still possible to compose panoramics with dynamic foregrounds if you locate the right type of scene and maximize depth of field so you can get as close to the foreground as possible. Setting your camera low to the ground will also emphasize the foreground – a technique I used for the desert scene above.

With every loss there is also a gain, and one great benefit of the panoramic format is that you can still produce stunning wideangle photographs without needing an interesting foreground.

USING LINES

Natural or manmade lines are one of the most potent compositional tools available to you. As well as providing a natural route into and through an image – humans are inquisitive, so they can't resist following lines to see where they go – lines can also be used to divide an image into different areas, or to add a strong graphic element.

The most obvious lines are those created by manmade features in the landscape, such as roads, paths,

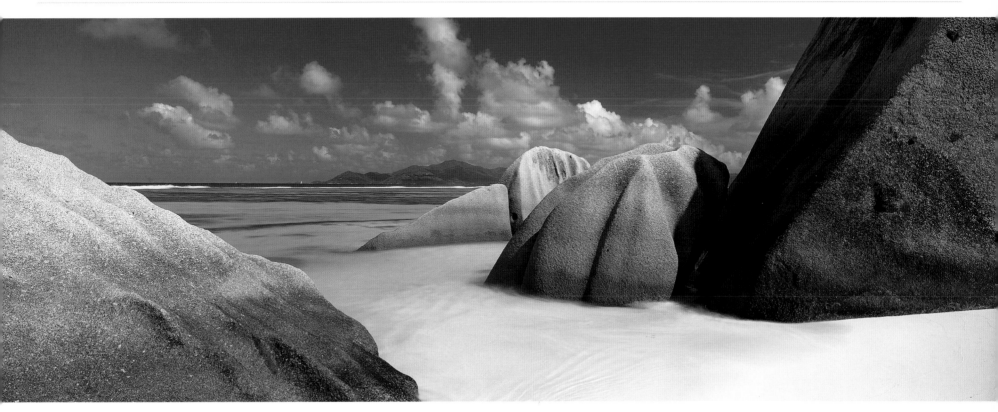

tracks, bridges, telegraph wires, walls, hedges, fences and avenues of trees. Shadows can also create strong lines, especially early or late in the day when they are at their longest and rake across the landscape, while natural features such as rivers and streams, although not necessarily straight, can have the same effect as they wind through a scene into the distance.

Assumed lines can also be formed by the layout of features or objects in a scene, such as stepping stones across a stream. Although there is space between them, our brain automatically joins up the individual elements to create a recognizable form.

Lines running horizontally across the frame echo the horizon and the force of gravity. This makes them easy on the eye, as they suggest repose and are naturally passive. Manmade boundaries in the landscape, such as walls, fences and hedges, are examples of horizontal lines that help to divide the image up into definite areas. Shadows can also be used in this way.

Vertical lines are more active, producing dynamic, tense compositions. Think of the regimented trunks of trees and the soaring walls of skyscrapers. To maximize the effect, turn your camera on its side so the eye has further to travel from the bottom of the frame to the top.

△ **ANSE SOURCE D'ARGENT, LA DIGUE, SEYCHELLES**
It took me a while to get my head around this location. I went there to photograph the weathered granite formations that rise from the beach, but when I first arrived I struggled to see any interesting compositions. This soon changed once I started to play around with the bold shapes, changing camera position to vary the relationship between the rock formations until the composition in the camera's viewfinder seemed to work. Once I had managed to create one interesting shot, others quickly followed, and I left the beach several hours later feeling that I had done the place justice.

Camera Fuji GX617 Lens 90mm Filters 0.3 centre ND and polarizer
Film Fujichrome Velvia 50

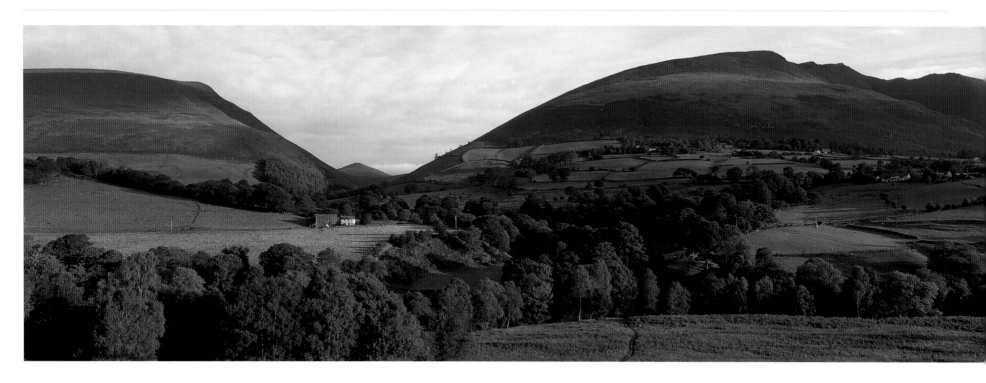

Diagonal lines have great directional value and add depth to a composition, as they suggest distance and perspective. They also contrast strongly with the horizontal and vertical lines that form the borders of the image, and in doing so can create dynamic compositions that catch the eye and hold the attention.

The eye tends to drift naturally from bottom left to top right, so diagonal lines travelling in this direction have the greatest effect as they carry the eye through an image from the foreground to the background. In the landscape, roads, rivers, drainage ditches, rows of trees, hedgerows and other features can be used to form diagonal lines.

Most powerful of all are converging lines. If you stand in the middle of a long, straight road and look down it, you'll notice that, as distance increases, the parallel sides of the road appear to move closer and closer together until they eventually seem to meet at the 'vanishing point' in the distance. This effect also occurs with railway lines, paths, avenues of trees, bridges, the furrows in a ploughed field, rows of crops, and so on. When they are

included in a composition, converging lines add a strong sense of depth. In fact, so powerful are converging lines that you often don't need anything else to produce a successful image.

CONTROLLING DEPTH OF FIELD

When shooting panoramics, especially landscapes, you will usually want everything to be recorded in sharp focus, from the immediate foreground to infinity. However, because panoramic cameras generally don't offer TTL viewing (other than a couple of models, such as the Fuji GX617, that can be fitted with a ground glass focusing screen), there is no way of making a visual assessment of the depth of field. This means you must use the scales on your lenses to ensure you get what you want.

The technique I use to assess and control depth of field is basically the same as hyperfocal focusing, but instead of establishing the hyperfocal distance then focusing on that (to achieve sharp focus from half the hyperfocal distance to infinity) I do the following.

△ **NEAR KESWICK, LAKE DISTRICT, CUMBRIA, ENGLAND**
This was one of the first panoramic photographs I ever took. I had travelled to the Lake District for a few days to try out a recently acquired 6x17cm camera. As I headed home one morning, I noticed this scene just off the busy A66 road. It was the white farmhouse that first caught my eye, then the way the hills swept down towards it. By carefully choosing my shooting position, I was able to place the house in front of the 'V' created by the hills so the eye was naturally drawn towards it. I also positioned the house roughly a third of the way in from the left of the frame, rather than in the centre, as I felt this made the composition more interesting.

Camera Fuji GX617 Lens Fixed 105mm Filters 0.3 centre ND and polarizer Film Fujichrome Velvia 50

STEP 1

Compose the shot, then establish how far away from the camera the nearest point is. If you are using a Hasselblad XPan with a coupled rangefinder, you can focus on the nearest point then check the depth-of-field scale to see how far away it is – in this case, just under 3m (10ft). With any other panoramic camera, you will have to estimate the distance.

If the near point is close to the camera, as will be the case if you're using a wideangle lens, estimating the distance is simple. If you're using a telephoto lens and the near point is further away, it's not so easy. To avoid mistakes, I often use a camera with direct viewing, such as one of my Nikon SLRs, to focus on the near point and establish how far away it is.

STEP 2

Once you know how far away the near point is, you also know how much depth of field is required and the focus on the lens can be set to make sure you achieve this. To do this, I look at the depth-of-field scale on the lens and adjust the focusing ring to establish what is the widest aperture that I can set and still record everything in sharp focus from the near point to infinity.

On the 45mm lens for my Hasselblad XPan, for example (pictured here), if I needed depth of field from just under 3m (10ft) to infinity, I would set focus so the central part of the infinity marker fell over f/11, as shown, and the 3m (10ft) distance mark also fell over f/11 on the opposite side of the depth-of-field scale.

Rather than shooting at f/11, however, I would stop the lens down to f/16. This is because depth-of-field scales are rarely completely accurate; I like to use an aperture one stop smaller than what the scale says I need, just to be on the safe side. If pushed, I would set the infinity symbol between 11 and 16 on the depth-of-field scale, and shoot at f/16. I would expect this to give me depth of field from 2.5m (7½ft), perhaps a little less, to infinity.

This is a quick and easy way of assessing and controlling depth of field with a panoramic camera, and it works very well.

The rule of thirds

The most common compositional 'rule' involves dividing the picture area into a grid using two horizontal and two vertical lines, equally spaced. This framework can then be used to help you achieve compositional harmony and balance.

- If you have a focal point in a scene – such as a barn – it can be positioned on any one of the four intersection points created by the grid.
- The horizon can be placed along the top line to give emphasis to the foreground, or along the bottom line to emphasize the sky.
- Any key vertical features can be placed a third of the way in from either the left- or right-hand edge of the picture.

▷ **VAL D'ORCIA, TUSCANY, ITALY**

Several versions of this scene appear throughout the book – it's such a wonderful view, full of character and atmosphere, that I can't help photographing it whenever I visit the area. For this photograph, I wanted to make a feature of the receding planes, so I turned my camera on its side. Each step that your eye takes reveals another area of interest, from the single tree in the field, to the rolling hills, distant farmhouse and finally the hazy mountains. By using a telephoto lens I was also able to home in on the most interesting slice of scenery and focus attention on it – though I had to crop the 6x17cm original down to 6x12cm to get rid of a messy foreground and to make the tree the point of entry into the composition.

Camera Fuji GX617 Lens 300mm Filter Polarizer Film Fujichrome Velvia 50

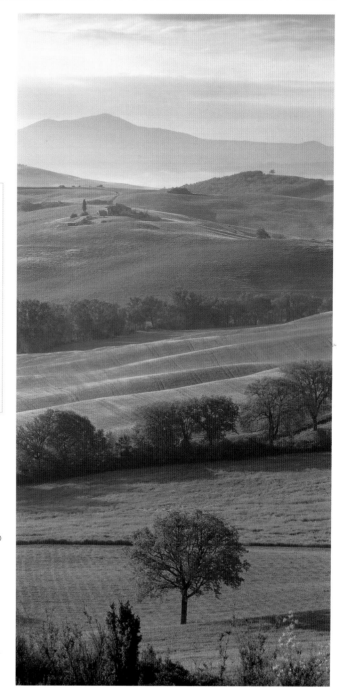

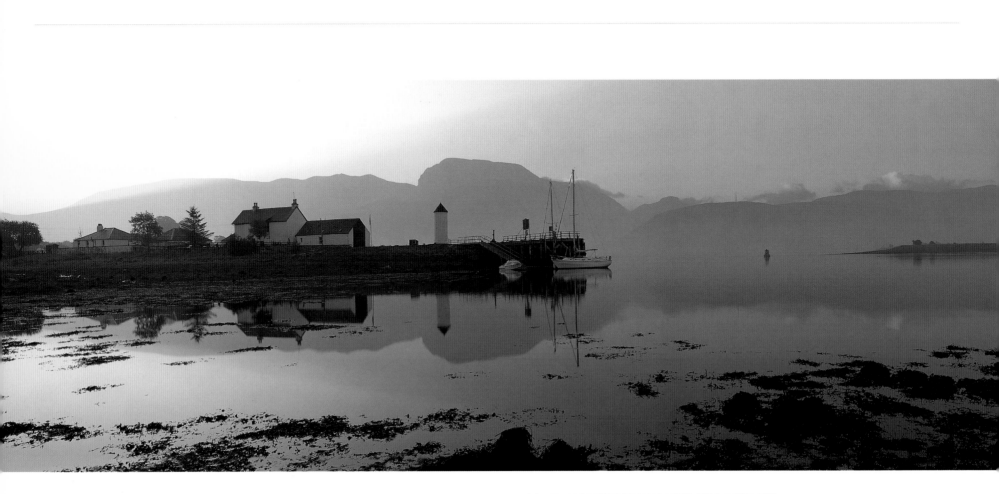

LOCH EIL, NEAR FORT WILLIAM, HIGHLANDS, SCOTLAND

I love photographing scenes containing reflections; they're very atmospheric and tranquil, and the symmetry created by the reflection makes for simple, balanced compositions. Two factors dictated how I composed this picture. The most important was the sun rising just out of frame to the left. Had I swung the camera more to the left, there would have been a high risk of flare, with no way for me to shield the lens without obscuring its field of view. The second factor was that, with hardly a cloud in the sky, there would have been too much empty space at the top of the frame if I had placed the horizon centrally, so I tilted the camera down slightly and used the edge of the seaweed-covered beach as foreground interest.

Camera Fuji GX617 Lens 90mm Filter 0.3 centre ND Film Fujichrome Velvia 50

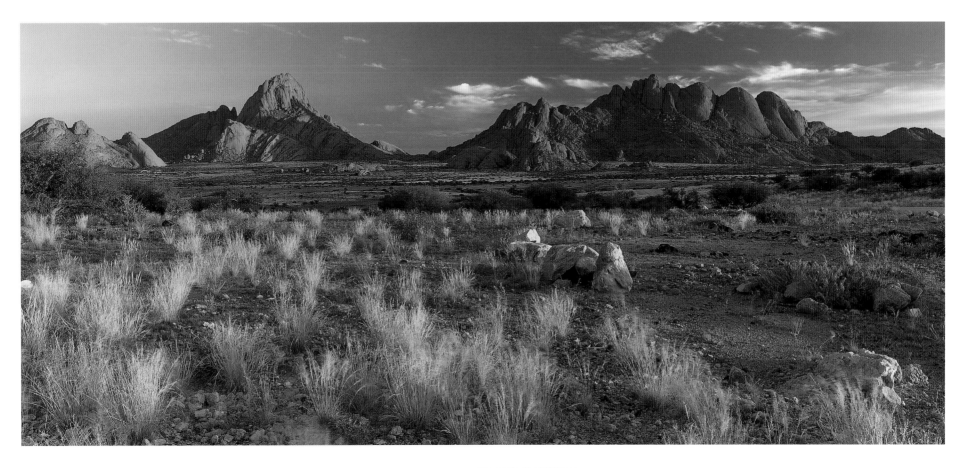

SPITZKOPPE, NAMIBIA

Although I generally prefer to shoot full frame and not crop my photographs later, I have no problem doing that occasionally if a better composition results. In this case, I needed to use the 90mm lens on my Fuji GX617 to make the most of the foreground grasses. However, doing so meant that I included too much of the scene on either side of the mountain range, which diluted the impact of the picture. To remedy that, I mounted the 6x17cm original in a 6x12cm mask, and also masked off about 5mm (¼in) from the bottom of the frame in order to tighten the composition and exclude any unwanted detail.

Camera Fuji GX617 Lens 90mm Filters 0.3 centre ND and polarizer Film Fujichrome Velvia 50

UPRIGHT PANORAMICS

Although panoramic cameras are mainly used in land-scape (horizontal) format, you should not be afraid of turning yours on its side from time to time. It may seem awkward to use a panoramic camera in upright format – especially if you have a bulky 6x17cm model like my Fuji GX617 – but the results can be amazing if you choose the right scene.

Upright panoramic photographs have a completely different visual effect to those composed in the landscape format. They are full of energy and tension, they are exciting to look at, and the viewer 'reads' the photograph from bottom to top rather than side to side. For bold, graphic subjects such as the Greek scenes shown here, the technique works a treat, turning familiar scenes into dynamic images.

Turning a panoramic camera on its side also allows you to emphasize the layers in a scene, as shown in the Tuscan landscape on page 59, and, because you're abstracting just a thin strip from the foreground up to the sky, you can tell the viewer just as much about the scene as a 'normal' picture would, but in a much more visually stimulating way.

If you are using a wideangle lens to shoot upright panoramics, you should make sure that you can get enough depth of field to record everything in sharp focus from the immediate foreground – which may only be 1m (3ft) or so away – to infinity.

The 30mm lens for my Hasselblad XPan is ideal in this respect because it offers extensive depth of field when stopped right down to f/22. The 90mm lens on my Fuji GX617 isn't quite as effective. This is because depth of field can never be more than 2m (6ft) to infinity, so it doesn't always work; either the composition has to be changed or I simply crop the image to 6x12cm format (see page 9, far right picture) so that any foreground that didn't record in sharp focus is removed.

As well as using flatback panoramic cameras to shoot upright pans, try swing lens models too. You can even shoot upright pans with a 360-degree camera like the Lookaround (see pages 34–35), though they do look rather bizarre!

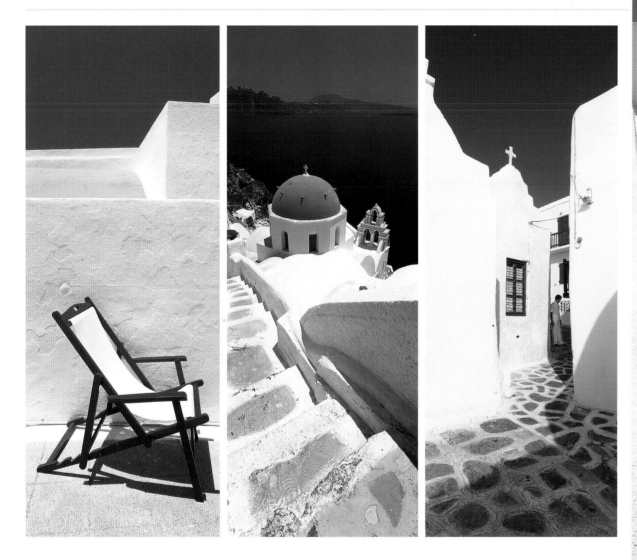

◁△ MYKONOS AND SANTORINI, GREEK ISLANDS

Blue and white is a colour theme that you see time and time again throughout the Greek Islands, but nowhere more so than on Santorini, which is famed for its blue-domed churches. Having visited both Mykonos and Santorini on two previous occasions, I decided to try something different on my third trip, in the summer of 2003. One technique that captured my imagination was to shoot graphic panoramics in the upright format, using a 30mm super-wide lens on my Hasselblad XPan. Having found one scene that worked, others seemed to present themselves everywhere I went, and as the days passed my eye for this type of picture improved considerably. I'm sure my blinkered vision caused me to miss some other great shots, but I had lots of fun just playing around with shapes and colours, knowing that my pictures would be unusual.

Camera Hasselblad XPan **Lens** 30mm **Filters** 0.45 centre ND and polarizer **Film** Fujichrome Velvia 50

▽ DEAD VLEI, NAMIB DESERT, NAMIBIA

I love the simplicity of this composition. The three bands of colour created by the gleaming white mud pan, vivid orange dunes, and deep blue sky provide the foundations for the photograph, while the row of dead trees adds the interest. Although it looks like a straightforward picture to take, I spent a good ten minutes establishing where to place my camera so that the trees didn't break the lower ridge across the dunes, none of the trees overlapped each other, and they were fairly evenly spaced across the entire width of the frame. These factors aren't important to the viewer, but they make a big difference to the impact of the composition.

Camera Fuji GX617 **Lens** 180mm **Filter** Polarizer **Film** Fujichrome Velvia 50

USING COLOUR

The overall mood of a photograph can be influenced dramatically by the colours that appear in it and their relationship to each other. Bright, vivid, primary colours such as red, blue, yellow and green create a fresh, exciting feel, and if those colours contrast strongly with each other, such as yellow and blue, or red and green, tension is created that can add to the impact of an image.

Softer, muted colours are generally more soothing to look at and give pictures a gentle, tranquil feel. This effect

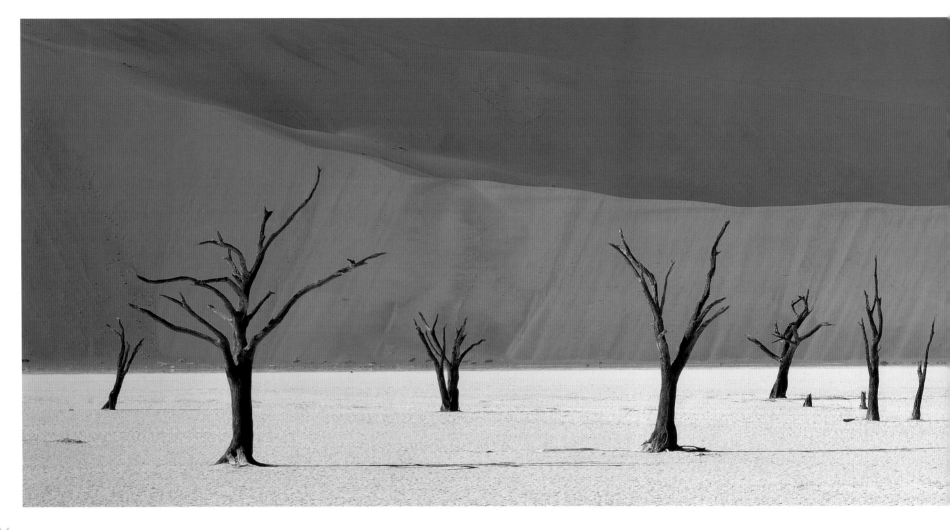

can be achieved with any colours providing that their strength is sufficiently subdued, although the effect tends to be most successful when you combine harmonious colours such as warm shades of yellow, red and orange, or blues and greens – colours that are close to each other in the spectrum.

Another option is to concentrate on a single colour and make use of its symbolic value. Green suggests freshness, new birth and beauty. Blue is an ambiguous colour: it can be cold, lonely and sad in some situations, such as bad weather, yet joyous and free when the sun shines. Yellow and orange are warm, soothing colours that remind us of sunshine, so they tend to work positively. Red is the most potent colour of all and can dominate a composition even if it only occupies a tiny part of it.

Colour strength is mainly influenced by the time of day and weather. In bright, sunny conditions, all colours appear very strong and distinct. You can emphasize this by using a polarizing filter to reduce glare and maximize colour saturation, or by choosing a film that is renowned for its vibrant colour rendition, such as Fujichrome Velvia. Slight underexposure of colour transparency film will also increase colour saturation, though this should be no more than ⅓ stop, otherwise the colours are likely to appear dark and muddy and any benefit will be lost.

On dull, cloudy days, colour strength is reduced quite considerably, so the landscape appears to be more muted and tranquil. Photographs taken in such conditions have a more soothing feel – although a splash of colour in the foreground will still appear strong due to its closeness to the camera, and can be used to brighten up an otherwise dull scene.

In misty or hazy conditions, especially at high altitudes, all colours tend to merge. This monochromatic effect can look stunning at dawn or dusk, when the landscape is reduced to a series of delicate warm shades that grow lighter with distance. The effect, known as aerial perspective, is best seen in hilly or mountainous areas.

BE BOLD

As your experience grows, you will become much bolder in the way you compose photographs, and you will also have a clearer idea of how the panoramic format can work in your favour.

The type of camera that you use will also influence your compositional style. I find that the type of pictures I take with the Hasselblad XPan tend to be bolder, more graphic, and much more spontaneous than those I take with the Fuji GX617, simply because the camera lends itself to that kind of approach. I'm also happy to handhold the XPan, so I can take pictures in awkward positions, and the increased field of view of the 30mm lens allows me to juxtapose the elements of a scene in a more unusual way – you can literally create pictures from nothing with the 30mm lens.

My compositional style has evolved dramatically in the last couple of years as I have pushed the boundaries and taken risks. Initially I purchased a panoramic camera purely for landscape photography, but now I love to use the letterbox format for all subjects, and in some cases it's the shape of the image more than anything else that makes the photograph work.

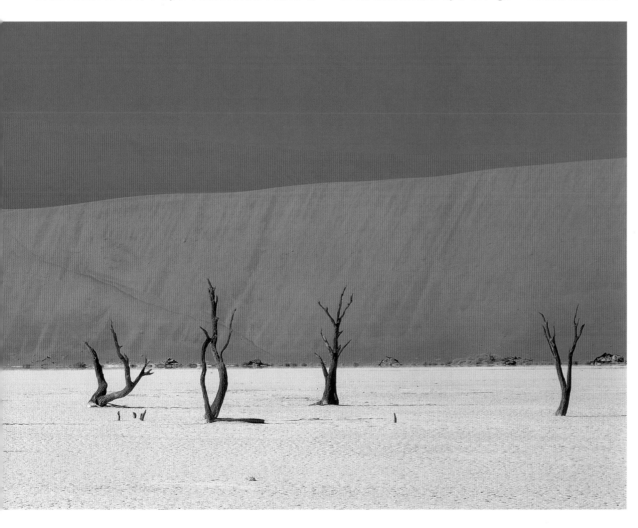

MICHELANGELO'S *DAVID*, FLORENCE, ITALY

When I arrived at the Piazza della Signoria in May 2004, I was horrified to find scaffolding everywhere. Not only that, but the sky had clouded over and rain threatened at any moment. Rain and scaffolding are a photographer's worst enemy, so to suffer both at the same time is about as bad as it can get. The only thing I could see that raised my spirits slightly was this bizarre sight of Michelangelo's famous work *David* surrounded by the intricate network of scaffold tubes, so I decided to take a shot, if only to avoid leaving the square empty-handed. Once home and with my processed films spread on the lightbox, however, I realized that I had produced a better photograph than I expected. The contrast between the old marble sculpture and the rigid lines of the brand-new scaffolding works brilliantly, and the diffuse light encountered on the day was perfect for highlighting that contrast – it worked far better than strong sunlight ever could. Even in the most unpromising circumstances, you can still salvage a decent picture if you're willing to work at it.

Camera Fuji GX617 **Lens** 300mm **Film** Fujichrome Velvia 50

NAMIB DESERT, NAMIBIA

How simple can a composition become before it loses impact? It's hard to say, but you'd be hard-pressed to find a simpler scene than this. I started out shooting from further away so I could include some distant mountains and dune grasses in the scene. However, I found that the closer I moved and the more information I removed from the composition, the more I liked it. Ultimately, I ended up with just a mound of sand against the deep blue sky. The bold colours of the sand and sky undoubtedly form the basis of the composition, but it's the ripples that round it off, adding pattern, texture and depth, as well as leading the viewer's eye up the dune to the sky.

Camera Hasselblad XPan **Lens** 30mm **Filters** 0.45 centre ND and polarizer **Film** Fujichrome Velvia 50

METERING & EXPOSURE

It goes without saying that if a photograph is to be successful, it must be correctly exposed. You can compose the most breathtaking vista, wait for the light to be perfect, and take all the other steps necessary to create a masterpiece, but unless you get the exposure right, all your hard work will be in vain.

Negative film is easier to work with in this respect, because if you don't get the exposure spot-on in-camera, a reasonable degree of error can be corrected at the printing stage. Colour transparency films, on the other hand, are highly unforgiving, so you need to make sure your metering technique is up to scratch and get the exposure exactly right when the picture is taken. This isn't as difficult as it might sound, and even with basic knowledge of exposure and metering there's no reason why you shouldn't always achieve success, as I will discuss in this chapter.

METERING FOR PANORAMIC PHOTOGRAPHS

Metering for panoramic photographs is no different from metering for any other format. There are no fussy calculations involved, other than remembering to compensate the exposure if you are using a centre ND filter, and unless you are using an extreme wideangle lens or a 360-degree camera, you are unlikely to encounter problems with excessive contrast.

One factor you do need to consider, however, is that the majority of panoramic cameras lack any form of integral metering (the Hasselblad XPan being one notable exception). This means that you really need to master the use of a handheld meter so exposure readings can be taken remotely and then set on the camera. If I have a 35mm SLR with me, I often use that as a light meter.

The matrix metering system of my Nikon F90x or Nikon F5 is able to cope with the most demanding lighting conditions, and I have come to know its strengths and weaknesses very well over the years. More often than not, I don't have these cameras with me when shooting panoramics, however, and instead I have to rely on a handheld meter. There are three ways in which you can take an exposure reading: reflected, incident, or spot meter. These methods are explored below.

REFLECTED READINGS

A reflected reading, as the name implies, measures the light bouncing back off the subject or scene you are photographing – all integral metering systems work in this way. This is the most basic way to measure light, and is also the most prone to error – as you may have discovered if you have used a 35mm SLR in tricky light – because the amount of light bouncing back off a surface is governed by its reflectivity, colour and density, and this influences the exposure reading you get.

A good way to explore this is by laying two sheets of card, one black and one white, next to each other so the same light is falling on both. An overcast day outdoors would be ideal for this experiment because the light is even and contrast low. If you take a reflected reading off the white card, then another off the black card, you will find that the two readings differ by as much as three stops. The exposure for the white card would be briefer than the exposure for the black card because a white surface reflects a lot more light than a black surface. In fact, though, as both cards are being lit in exactly the same way, they both require the same exposure – it's just that their relative reflectancy has 'fooled' the light meter.

▽ **BLUE MOSQUE, ISTANBUL, TURKEY**

Getting the exposure right when shooting panoramics at night can be tricky, simply because conditions are so different from during the day, with different light sources and high contrast. I tend to use a spot meter to isolate a small area of the scene that I want to be correctly exposed. In this case, I chose one of the floodlit minarets of the mosque. I knew that the light tone of the marble was at least one stop brighter than a midtone.

I therefore increased the metered exposure by one stop and bracketed a sequence of frames using exposures of 10, 15, 20, 30 and 40 seconds at an aperture of f/16. I found that the middle three exposures were all acceptable, while 10 seconds was too brief and 40 seconds too long. Bracketing is essential at night as reciprocity failure reduces the effective speed of the film.

Camera Fuji GX617 Lens 300mm Film Fujichrome Velvia 50

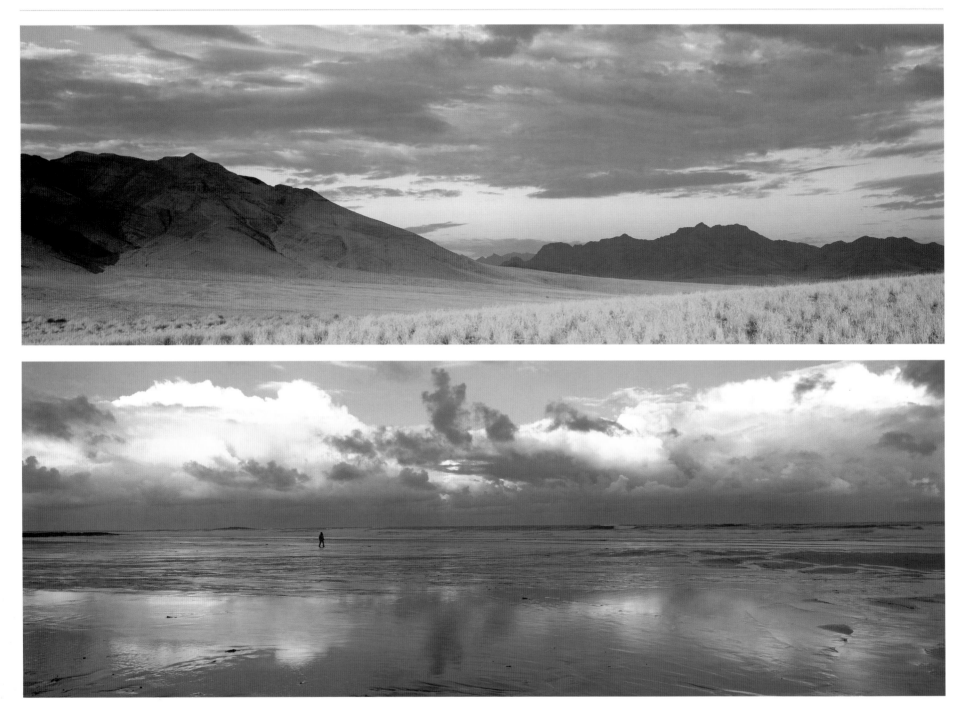

So which exposure is correct? Neither. Reflected light meters are calibrated to expose a midtone correctly, which in colour terms is mid-grey (18 per cent grey). In this example, if you placed an 18 per cent grey card between the black and the white cards and took a reading from it, you would find that the exposure fell mid-way between the exposures of the white and black cards. This is the exposure you should use.

In the real world, of course, it's very rare that you would be photographing a single colour or tone – there would be many in a typical scene. However, the same theory applies: if you jumbled up all those colours and tones and they reflected roughly the same amount of light as a midtone, a reflected light meter would give an accurate

◁ **NAMIB RAND, NAMIBIA**
The most dramatic photographs are often taken on the spur of the moment, when a chance opportunity presents itself. This is one such example. I was set up and ready to record the scene shown on page 72, when the rising sun burst through the clouds. It was far too bright to include in my picture without flare, so while I waited for it to drift behind cloud I turned to admire the scenery behind me – only to be confronted by this scene, with golden sunlight illuminating the hills against a beautiful sky. Without hesitation, I turned the camera 180 degrees on its tripod, composed, took an incident meter reading, and fired off two frames before the sun disappeared.

Camera Fuji GX617 Lens 180mm Film Fujichrome Velvia 50

◁ **EMBLETON BAY, NORTHUMBERLAND, ENGLAND**
I was on this beach in late October, leading a workshop for a group of photographers. The weather was cold, wet and windy, but as the location is only a short distance from my home, I knew that it could change quickly – with dramatic consequences. Having already taken some shots of Dunstanburgh Castle bathed in storm light (see page 21), we were heading back to our cars when I noticed this amazing cloud formation and its reflection in the wet sand. Not wanting to keep the group waiting – we were all ready for hot drinks by this stage – I loaded a roll of film into my camera, and asked a member of the group to walk into the scene to add scale. I then exposed four frames, using the integral TTL metering system of my Pentax 67 medium-format camera to quickly establish correct exposure.

Camera Fuji GX617 Lens 90mm Filter 0.3 centre ND Film Fuji-chrome Velvia 50

exposure. If they reflected more light than a midtone – a snow scene being the most extreme example you are likely to encounter – underexposure would occur. If they reflected less light than a midtone, there would be a danger of overexposure. Very few panoramic cameras have integral metering systems, so you might be wondering why it is necessary to discuss them. However, there's a very good reason…

SPOT METER READINGS

One of the most reliable means of taking exposure readings, and probably my favourite of all, is using a spot meter. The main advantage of a spot meter is that it has a very small metering angle – often as little as 1 per cent – so you can meter from a specific area in a scene and achieve exposure accuracy in the trickiest lighting situations.

There is one vitally important factor you need to consider, though: all spot meters measure reflected light. This means that the exposure reading you obtain will be influenced by the reflectancy of the area you meter from. As outlined above, if that area is too light, underexposure will result; if it's too dark, overexposure will result. The error also tends to be exaggerated when using a spot meter because the area it measures from is so specific, and the reflectancy of other colours and tones in the scene are ignored. To avoid problems you must therefore think very carefully about what you use to meter from.

I use a spot meter in various different ways to establish the correct exposure for a scene. The simplest method is to identify a midtone and take a reading from that. Green grass, foliage, stonework, weathered concrete, blue sky, brickwork, tarmac – all these things and many more have approximately the same reflectancy as the 18 per cent grey that the meter is calibrated for.

When you first buy a spot meter, a useful exercise is to go out with it and an 18 per cent grey card and take meter readings from lots of different surfaces, then compare them to spot readings taken from the grey card held in the same light. This will help you to establish what is likely to give an accurate exposure reading when you are using the meter in real situations.

As your experience grows, this midtone knowledge will enable you to look at other colours and tones and decide how much you would need to compensate the exposure by if you took a meter reading from something you felt was lighter or darker than a midtone. On a recent trip to Namibia, for example, I often found myself taking spot readings from bright orange sand dunes then increasing the exposure by one stop because I felt that they were roughly one stop brighter than a midtone.

Some photographers use a spot meter in a more complicated way. They take readings from different areas to establish the brightness range of the scene, averaging them out to establish a working exposure – perhaps even employing the principles of the Zone System, which is mainly used for black and white photography but can also be applied to colour photography. However, I like to keep my working methods as simple as I possibly can, and metering from a midtone when shooting colour transparency film works perfectly well for me.

Having taken a meter reading from a midtone, I turn my attention to the sky and decide if a neutral density graduate filter is needed to bring its brightness closer to that of the midtone so that it doesn't overexpose. More often than not, I select the density of graduated filter by simply looking at the sky and comparing its brightness to that of the landscape. Based on my findings I then tend to use either a 0.6 ND hard grad, which I find is ideal for general use, or a 0.9 ND hard grad when the sky is very bright – at dawn or dusk, for instance.

This may seem like a simplistic approach, but when you stop to consider that the three main ND grads used are 0.3 (1 stop), 0.6 (two stops) and 0.9 (three stops), making a wrong decision once you have experience of using such filters is actually quite difficult. You become accustomed to working in similar lighting situations and quickly get a feel for which density of grad will give you the desired effect. On the odd occasion when I'm not sure, I use my spot meter. I usually take a reading from the brightest and darkest areas of the sky, work out the average of the two, and then find the difference between that average reading and a spot reading from a midtone in the landscape. The difference tells me which density of ND grad filter to use.

For example, if a spot reading from the brightest area of the sky gives me an exposure of 1/60sec at f/16 and a reading from the darkest gives me 1/15sec at f/16, the average is 1/30sec at f/16. If I then take a spot reading from a midtone in the scene and

△ **NAMIB RAND, NAMIBIA**

A neutral density graduate filter was required for this shot, so that I could hold detail and colour in the sky while correctly exposing the foreground. To establish the correct exposure for the foreground, I took a spot reading from the pale yellow grass and increased the exposure reading by half a stop to compensate for the light tone of the grass. I then took a second spot reading from the darker clouds to determine which density of grad would be required.

Camera Fuji GX617 Lens 180mm Filters 0.9 ND hard grad and 81C warm-up Film Fujichrome Velvia 50

◁ **BLUE MOSQUE, ISTANBUL, TURKEY**
The light tone of the marble interior in this mosque would have caused exposure error had I taken a reflected light reading. Instead, I used an incident meter to measure the light falling onto the walls and columns, which gave me a perfect result.

Camera Hasselblad XPan
Lens 30mm Filter 0.45 centre ND
Film Fujichrome Velvia 50

this gives me an exposure of 1/4sec at f/16, the difference between the sky and that midtone is three stops, so I would use a 0.9 ND hard grad. Get the idea?

Initially, you may feel nervous about using a spot meter because it is so selective and therefore easy for you to make mistakes. But once your experience and confidence grows, you will think of it as the most useful accessory in your panoramic system.

INCIDENT READINGS

An alternative way to establish correct exposure for a photograph is to measure the light falling onto the subject or scene, rather than the light reflecting back. This is known as an incident reading.

An immediate benefit of taking incident readings is that the exposure you get isn't influenced by light or dark areas in the scene, so providing you use it correctly, exposure accuracy can be taken for granted even if you know little about exposure theory. The vast majority of handheld meters allow you to take incident readings. They do this with the aid of a white dome or invercone that fits over the metering cell and draws light in from a wide area to give you an exposure.

To take an incident reading when shooting landscapes, all you do is hold the meter in the same light as that falling on the scene and point the invercone behind you – simply by raising the meter over your head.

The only exception is if the sun is at a right angle to the camera position. In that case, I take an incident reading with the invercone pointing towards the sun and use the exposure reading obtained as my starting point – though I would also bracket at least one stop over it (see below).

If you're shooting an accessible subject, such as a person or a building, the alternative is to walk up to that subject, hold the meter in front of it, and point the invercone back towards the camera. By pressing a button on the side of the meter, a light reading is taken and the correct exposure shown, either as an EV (Exposure Value) number plus a range of aperture and shutter speed combinations, or as a single aperture and shutter speed. With the latter, you can look at the other possible combinations by pressing a button to change the shutter speed and aperture combination.

The only time an incident light meter doesn't work is when you can't hold it in the same light as you want to expose for. A typical example would be in stormy weather when the sun breaks through cloud and illuminates a small area in the distance. You need to expose for that specific area, but you can't hold the meter in the same light to take an incident reading, and a spot meter would therefore be necessary.

Similarly, there's no point taking an incident reading if you're shooting into the light – at sunrise or sunset, say – because all you would do is correctly expose the shadows and overexpose the highlights, which are what you need to expose for.

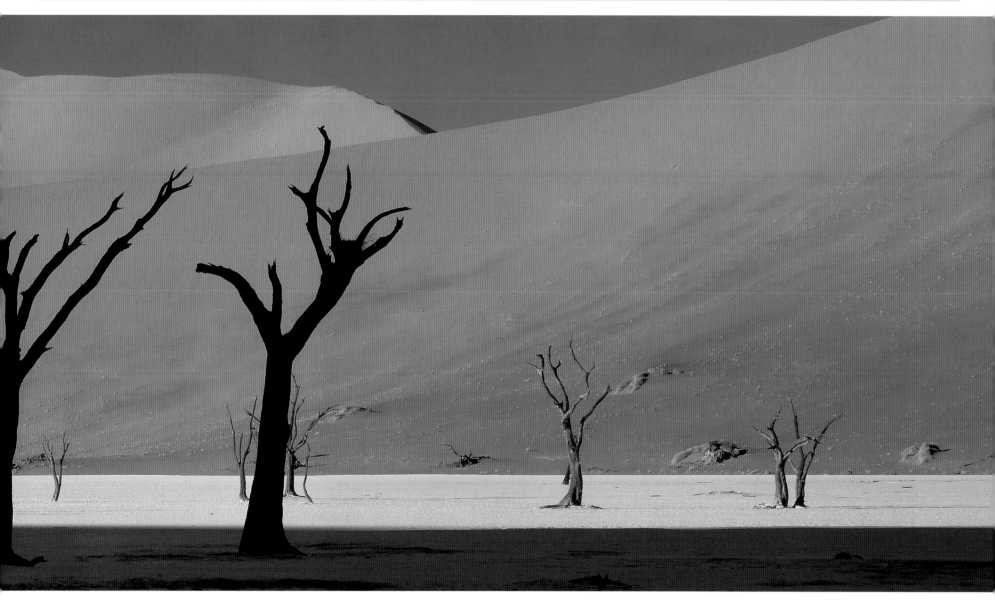

DEAD VLEI, NAMIBIA

I arrived at this location soon after dawn, while part of the mud pan was still in shadow. I was immediately attracted to these two trees, which I knew I could silhouette against the orange dunes that were already bathed in bright sunlight. As I was standing in shadow, an incident light meter would have been useless unless I walked into the scene. Instead of doing this, I took a spot meter reading from the sunlit dune in the distance, decided that it was probably a stop lighter in tone than a midtone, compensated the exposure accordingly and started shooting. Just to be sure, I bracketed exposures ½ stop over and, rarely for me, ½ stop under this first exposure.

Camera Fuji GX617 Lens 300mm Filter Polarizer Film Fujichrome Velvia 50

BRACKETING EXPOSURES

If there's one good reason why you should never get stressed about metering, it's that no matter how tricky an exposure situation becomes, there's always a safety net available to keep error at bay: bracketing.

Bracketing involves taking pictures at the exposure you or your light meter thinks is correct, then others at exposures over and under it to ensure that at least some of the frames are spot-on. There are few photographers who don't bracket exposures, despite what they say, and it's far cheaper to 'waste' a few frames of film than risk losing an important shot completely.

At the same time, you should never see bracketing as a panacea of all ills, because your most successful photographs are likely to be taken in situations where you don't have time to bracket lots of exposures. You should always strive to get it right with the first frame, just in case that frame is the only one you get the chance to shoot.

I bracket EVERY photograph I take if time permits. My first-choice film, Fujichrome Velvia 50, is highly exposure-sensitive and can tolerate barely more than 1/3–1/2 stop of error either way. Since its launch more than a decade ago, photographers have debated the true speed of Velvia 50. Although ISO 50 is the manufacturer's recommended speed, some rate it at ISO 32 – which represents a 1/2-stop difference.

I rate Velvia 50 at ISO 50, but in doing so I know that I am always on the edge of underexposure. So, having taken a frame – or several – at my metered exposure, I always take more at exposures of 1/3 or 1/2 stop over, and sometimes bracket up to one stop over the initial metered exposure. This system works for me. I have some wastage, but I can't remember the last time I lost a shot completely due to exposure error.

What I very rarely do is bracket exposures under the metered exposure. Because of the speed I rate Velvia 50 at, and the way I meter – usually from a midtone with a spot meter – the risk of overexposure is minimal. I can't see the point in bracketing under as well as over the metered exposure when I know that the underexposed part of the bracket will invariably end up in the bin.

BRACKETING AND PANORAMIC CAMERAS

The increments you are able to bracket exposures in will depend on the type of panoramic camera you have. Some lenses have 1/2-stop click settings on the aperture ring (Hasselblad XPan, for example), and others have 1/3-stop settings (Fuji GX617, for example).

◁ **BERWICK-UPON-TWEED, NORTHUMBERLAND, ENGLAND**

It was the end of the last day of a photographic workshop that I had been leading on the North-umberland coast. My group and I had spent a rewarding afternoon on Lindisfarne (Holy Island), but before the end of the workshop, I decided to chance a brief visit to Berwick-upon-Tweed, where I knew there was this view over the river towards the old town. Past experience had told me that the light was at its best just before sunset, and though the sun was by now hidden behind cloud, there was a chance that it might drop below the cloud before setting. As we were setting up, my prediction came true and the town was suddenly illuminated by the most amazing golden light. It all happened so quickly that I just grabbed my panoramic camera, took a spot meter reading from one of the sunlit stone houses and quickly exposed four frames – the entire roll of film. Before I had a chance to change lenses and load another film, the light was gone, but I felt confident that I had a good shot in the bag – and so did everyone else. It was the perfect end to a productive weekend!

Camera Fuji GX617 **Lens** 90mm **Filter** 0.3 centre ND **Film** Fujichrome Velvia 50

I always bracket in the smallest increments that are available to me. If I am using the Fuji GX617, I bracket by opening up the lens aperture in 1/3 stops to achieve +1/3 snd + 2/3 stop. If I want to bracket all the way to +1 stop, then I set the aperture back to its original f/stop and set the shutter speed to the next slowest speed – shutter speeds can usually only be adjusted in full stops on panoramic cameras.

When I'm out working with the Hasselblad XPan, I adjust the lens aperture to achieve the first bracket of +1/2 stop. Then, in order to increase the exposure by one stop, instead of opening up the lens by another 1/2 stop so that it's set to an aperture one stop wider than the metered exposure, I stop the lens back down to the original f/stop and set the shutter speed to the next slowest speed.

Choosing a handheld meter

There is a wide range of handheld meters on the market today, so you need to think carefully about your requirements before making a decision to buy one.

I carry two: a Pentax Digital Spotmeter, which is compact, simple and robust; and a Minolta Autometer IV F, which I use for incident readings. Both have given me years of trouble-free service and are relatively simple to use.

There are now several combined spot/incident meters available, such as the Sekonic L-608 (far right). These give you the best of both worlds. However, I have found them to be highly complicated, with far too many buttons and dials for my liking. Also, if you carry one combined meter and it breaks down, you're finished, whereas it's unlikely that two will break down on the same day.

Here are just three of the numerous hand-held meters available: the Minolta Autometer IV reflected/incident meter; the Pentax Digital Spotmeter; and the Sekonic L-608 combined reflected/incident/spot meter.

▽ **CAPPADOCIA, TURKEY**

This photograph was taken around one hour after sunrise in the town of Uchisar, from the terrace of a hotel I was staying in. The high position of the hotel afforded amazing views over the surrounding countryside, and I was rewarded with the added bonus of some hot air balloons drifting through the scene. Metering was straightforward. I just took a spot meter reading from a patch of sunlit grass in the foreground to establish the exposure, positioned an ND grad on the lens so it covered the sky and the top part of the scene as far down as the base of the distant escarpment, waited for one of the balloons to drift into view, and then fired the shutter.

Camera Fuji GX617 **Lens** 300mm **Filter** 0.6 ND hard grad
Film Fujichrome Velvia 50

DEPTH OF FIELD

The reason for adjusting the shutter speed rather than the aperture in these cases is that it allows me to maintain decent depth of field, which tends to be a more important factor than the shutter speeds for the kind of photographs I take. For example, if the metered exposure is 1/4sec at f/22, to increase the exposure by +1 stop I could either set 1/4sec at f/16 or 1/2sec at f/22. I would always go for the latter, to maintain depth of field.

I also make sure that the depth of field I require isn't compromised by opening up the aperture by any amount to increase the exposure. So, if the widest aperture I can use to achieve sufficient depth of field is f/22, I would make the following sequence of exposures:

Meter reading – 1/4sec at f/22
First exposure – 1/4sec at f/22
Second exposure – 1/2sec at f/22 2/3 (to achieve + 1/3 stop)
Third exposure – 1/2sec at f/22 1/3 (to achieve + 2/3 stop)
Fourth exposure – 1/2sec at f/22 (to achieve +1 stop)

By using this system, the f/stop never goes wider than f/22, so I know that I will always maintain sufficient depth of field.

In extreme situations, I may find that I need to stop the lens down to its minimum aperture to get enough depth of field. This then creates a dilemma because in order to increase the exposure by an amount less than a full stop, I can only do so by adjusting the aperture to a wider f/stop.

The solution I use is to rely on the lens's depth-of-field scale more than I would like to ensure that everything will be in sharp focus from the nearest point in the shot to infinity. If necessary, I adjust the composition of the photograph so that the nearest point is slightly further away.

As with all things, practice and experience count for a lot. As you get to know your camera and lenses, you will be able to push them to the limits of their capabilities.

You don't need to be so accurate with colour negative film, as it's tolerant to exposure error and can still give an acceptable print even when over- or under-exposed by two or three stops. For this reason, bracketing in full-stop increments is fine.

▽ **PRAGUE, CZECH REPUBLIC**

This dawn shoot on the Charles Bridge in Prague took place in probably the worst weather I have ever tried to shoot in. Heavy rain was the biggest problem and ended up ruining several of the photographs (see page 86). However, I persevered because I knew that the deep blue sky would contrast dramatically with the warmer lights on the bridge. To determine correct exposure, I took a spot meter reading from the sky then bracketed up to a full stop over the metered exposure in 1/2-stop increments. The sequence was 30sec at f/22; 45sec at f/22; and 60sec at f/22. This was the first exposure, and despite being quite dark and low-key, it's my favourite, as it captures the atmosphere of the scene perfectly.

Camera Fuji GX617 Lens 180mm Film Fujichrome Velvia 50

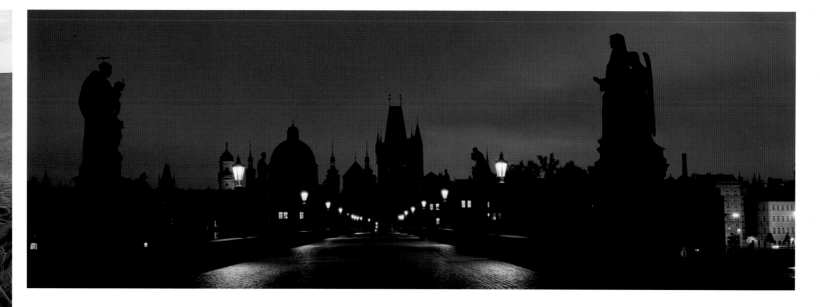

In fact, I only bracket negative film in the trickiest situations; often you can't tell the difference between a print made from a negative shot at the metered exposure and one that has been given more or less exposure.

Because of its exposure latitude, negative film is the best choice for panoramic cameras that don't allow you to bracket at all. The Lookaround 360 that I used while writing this book doesn't have any form of exposure control beyond the width of the slit shutter and the speed at which the camera is rotated, for example, so achieving correct exposure with colour transparency film would be almost impossible. With negative film, however, it's a formality, because being a stop or more out doesn't have an adverse effect on the quality of the final print.

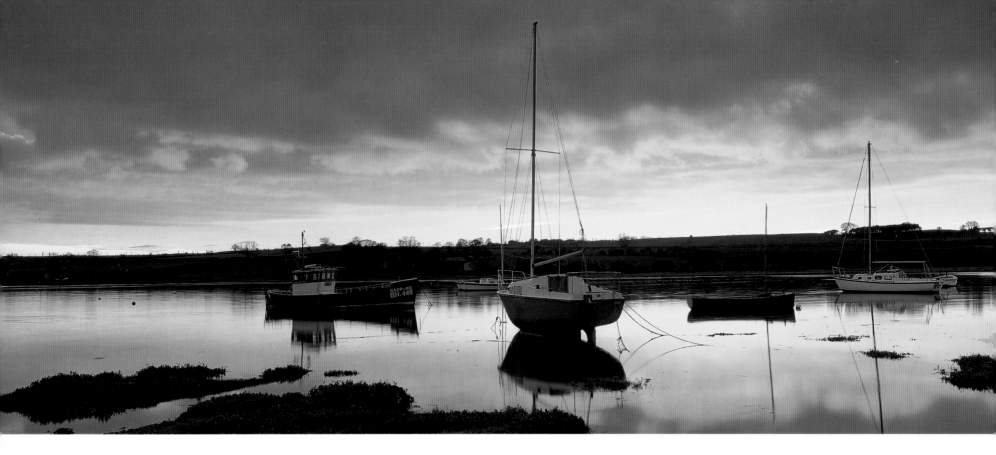

TROUBLESHOOTING

As with any specialized area of photography, shooting panoramics doesn't come without the occasional problem. Most can be attributed to the fact that, in the main, panoramic cameras utilize a rangefinder design that doesn't allow TTL viewing like an SLR does, so mistakes can be made without you realizing. Other aspects of panoramic camera design also encourage user error if you don't think carefully about what you're doing every step of the way. I know this because I've made all the

mistakes it's possible to make, more than once, and I have the pictures to prove it. In writing this chapter, my intention is to help you bypass the frustration and wasted film that I had to suffer.

FLARE

Flare is caused by stray light glancing off the front element of your lens, or any filters attached to it, and reflecting around inside the lens. This results in a reduction in contrast and colour saturation, and, more often than not,

ghosting on part of the image and annoying light patches that streak down from the sun.

If you're using an SLR camera, you can often see flare when you peer through the viewfinder because you are looking through the lens, and then take precautionary measures to eliminate it. Unfortunately, panoramic cameras don't offer this facility, unless you own a model such as the Horseman 612 or Fuji GX617, which can be fitted with a focusing screen, or you're using a large-format camera with a panoramic rollfilm back, so you can see

◁ **ALN ESTUARY, ALNMOUTH, NORTHUMBERLAND, ENGLAND**
Flare is most likely to occur when shooting directly into the sun at sunrise and sunset. If it does, there is nothing you can do to prevent it, other than wait for the sun to be obscured by cloud so its intensity is reduced, or wait for it to set. Keeping your lenses and filters clean will also reduce the risk of flare because dust, dirt and finger marks cause light rays to scatter.

Camera Fuji GX617 Lens 90mm Filters 0.3 centre ND and 81D warm-up Film Fujichrome Velvia 50

through the lens while you are setting up. The only way to get rid of flare, therefore, is to try to keep the sun – or any other bright light source – off the front of the lens.

My Fuji GX617 and Hasselblad XPan lenses each came with lens hoods, but I never use them because there's no way of gauging if they're actually doing the job as both are rangefinder cameras. They also prevent me from using filters on the lenses, which I need for pretty much every picture I take, so I don't even bother to carry them with me.

So what are the alternatives for getting rid of flare? Well, when the sun is low at dawn and dusk, the most successful method that I have found is to stand between the sun and the camera and use my body to cast a shadow over the lens. When the lens is in shadow – which you can see just by looking at it – the risk of flare is eliminated. The danger of doing this with wideangle lenses is that you end up getting yourself in the picture, but experience will teach you how far you need to be

away from the lens to avoid this. The distance you can stand away from the lens and still be able to release the shutter also depends on the length of your cable release – though remaining close to the lens makes your shadow much bigger.

When the sun is higher in the sky, a carefully placed hand or a sheet of card can be used from closer range to do the same thing. If you're able to shield the lens while still standing behind the camera, this is the safest option, because you can look through the rangefinder and check that you haven't obscured the lens. If you have to stand away from the camera to cast a shadow over the lens, then you need to be more careful.

Flare is the panoramic photographer's worst enemy because it often creeps up on you unawares, and by the time you realize, it's usually too late because your films have been processed and you are no longer at the location. However, if you see it as a threat and take evasive action, it need never ruin another great shot.

△ **RANNOCH MOOR, HIGHLANDS, SCOTLAND**
Flare is clearly visible in this picture, in the form of colourful streaks and rays radiating across the frame from the sun's position just out of the top of the frame. Shielding the lens with my hand or a sheet of card would probably have solved the problem.

Camera Fuji GX617 Lens 90mm Filters 0.3 centre ND and 0.6 ND grad Film Fujichrome Velvia 50

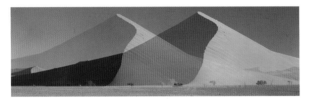

△ **NAMIB DESERT, NAMIBIA**

I was busy chatting to a fellow photographer while recording this scene and my lack of concentration led me to expose the same frame twice! Fortunately, I managed to get the photograph I wanted on the next shot.

Camera Fuji GX617 Lens 180mm Filter Polarizer Film Fujichrome Velvia 50

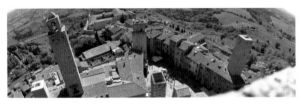

△ **SAN GIMIGNANO, TUSCANY, ITALY**

To get this photograph, I rested my panoramic camera on a wall. However, this turned out to be not such a good idea, as I didn't account for parallax error!

Camera Noblex 135S Film Fujichrome Velvia 50

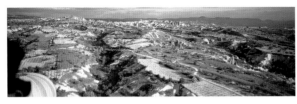

△ **OVER CAPPADOCIA, TURKEY**

Always check the corners of the viewfinder for unwanted details. Here, I was so busy photographing this view from a hot air balloon that I failed to notice another balloon creeping into the shot – plus the arm of someone standing next to me in the basket.

Camera Hasselblad XPan Lens 30mm Filter 0.45 centre ND Film Fujichrome Velvia 50

DOUBLE EXPOSURES

One thing you can't do with a 35mm SLR is expose the same frame of film twice – unless you accidentally put the same roll of film through the camera more than once, or you activate the multiple exposure facility without realizing, which is unlikely.

With some panoramic cameras, however, the film is advanced and the shutter cocked using two separate actions, so this mistake is easy to make. On numerous occasions, for example, I have been distracted while shooting with my Fuji GX617, only to re-cock the shutter and make another exposure without advancing the film. The same problem can occur with any flatback rollfilm panoramic camera, or a large-format camera fitted with a rollfilm back, because the shutter is in the lens rather than the camera body and has to be cocked independently.

If you find yourself in a situation where you're not sure if the film has been advanced, the solution is simple – advance it to the next frame anyway. The worst possible outcome of doing this is that you waste a frame of film, but if you gamble you could end up double-exposing a fantastic photograph.

Accidental double exposure isn't a problem with 35mm panoramic cameras because they either cock the shutter and advance the film automatically – as in the case of the Hasselblad XPan – or they won't allow you to make another exposure until you advance to the next film frame, as in the case of swing lens models such as the Noblex 135 series.

PARALLAX ERROR

It's always annoying when you get a roll of film back from the processing lab and find that some shots are ruined by unwanted elements straying into the frame.

This can occur with any type of camera, because even SLRs with direct viewing rarely show 100 per cent of the image area through the viewfinder. However, this is more likely to occur with panoramics, and when it does happen, the effect tends to be more extreme.

A vital factor you have to consider when using a panoramic camera is that because the viewing eyepiece and the lens are separate, they don't see exactly the

same thing. The rangefinder is usually above the lens (in the case of the Hasselblad XPan, it's to the left of the lens) and the distance between it and the lens can be 5cm (2in) or more. This causes a problem known as parallax error.

The further your subject is away from the camera, the less parallax error shows, so for general use, shooting landscapes for example, it can be pretty much ignored. It's when working at close range that you need to take care, because your pictures may end up looking noticeably different to how you expected, and contain elements that you thought had been excluded.

Some cameras are worse than others in this respect. For example, the Hasselblad XPan has frame marking in the viewfinder to help overcome parallax error with the 45mm and 90mm lenses. When using the XPan at close range with a 30mm lens attached, I have also found that by removing the detachable eyepiece that fits on the top plate and holding it directly above the lens – it's normally off to the left when placed in the correct position on the camera – I get a more accurate idea of what the lens is seeing and parallax error is minimized.

Rollfilm flatback panoramic cameras are less prone to parallax error. This is mainly because the close-focusing distance of the lenses tends not to be so great, so you can't get too close to your subject anyway. The Fuji GX617 and Horseman 612 also give you the option to fit a ground glass screen so you can compose images through the lens and avoid parallax error, as you can with

▷ **KOUTOUBIA MINARET, MARRAKECH, MOROCCO**
▷▷ **WEAVERBIRD NEST, NAMIBIA**
▷▷▷ **STATUE, VENICE, ITALY**

Once you become accustomed to your camera, mistakes will be few and far between and you can concentrate on what's important – the creative side of picture-taking. Of all the panoramic cameras available, the Hasselblad XPan is by far the most versatile and user-friendly, and I love working with it in both landscape and, as here, portrait format.

Camera Hasselblad XPan Lens 90mm and 30mm Filters 0.45 centre ND on 30mm, polarizer (Namibia), 0.6 ND grad (Marrakech) Film Fujichrome Velvia 50

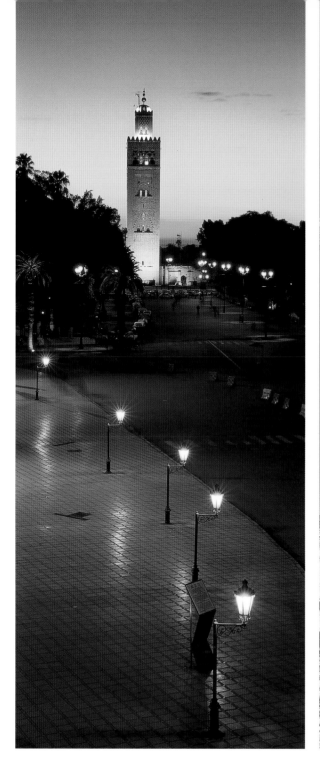
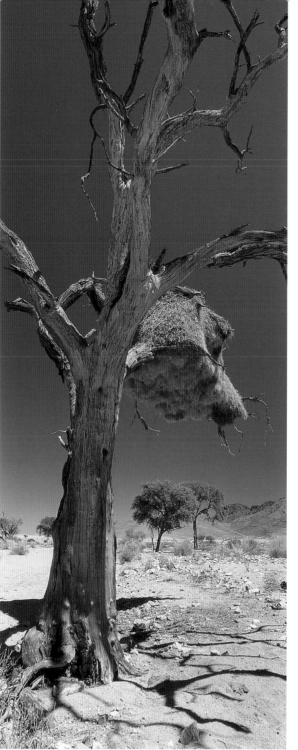

a large-format camera. The Linhof 617 and 612 models lack this facility – a factor you might want to consider if you are thinking of buying either camera.

The worst example of parallax error I have seen was when using a Noblex 35mm swing lens panoramic camera. Shooting from the top of a tower in the medieval town on San Gimignano in Tuscany, Italy, I rested the camera on a wall to gain support as no tripods were allowed. The view through the rangefinder eyepiece was fine, but it was only when I got the shots back from the lab that I could see that the edge of the wall appeared on every frame – the lens could see it, but because the rangefinder was positioned 5cm (2in) or so above it, I couldn't. I'll never make that mistake again!

FILM FOGGING

Fogging is caused when unprocessed film is exposed to light. This tends to happen when the camera back is accidentally opened part-way through a roll of film. Cameras can also develop light leaks due to wear and tear or damage, or because something is trapped in the back so it can't be closed properly.

I have never experienced fogging when using my Hasselblad XPan and Fuji GX617 camera systems, but it occurred several times while I was using a hired Horseman 612 camera on location in Tuscany, Italy. I didn't lose any shots as there was always at least one unfogged frame spared, but the moral of the story is clear: if you hire a camera, which many photographers do before deciding to buy a particular model, make sure you put at least one test film through to make sure it's working properly.

In my case, I'm fairly certain that fogging was caused because I left the removable darkslide out for long spells and sunlight managed to find a way in through the slot in the rollfilm back. On the films where I took out the slide, made my exposures, then put it back, there was no trace of fogging, but occasionally when I left the slide out while waiting for a break in the weather, fogging occurred.

The solution, if you use a panoramic camera with a darkslide or a rollfilm back on a large-format camera, is to remove the darkslide only when you're about to take a picture, and put it back immediately after you've finished.

UNSHARP CORNERS

Panoramic cameras expose a large piece of film in one hit; especially flatback 617 rollfilm models such as the Fuji GX617 and the Linhof 617S III. However, unless that piece of film is held flat and tight inside the camera, there's a risk of the corners of the image not being as a sharp as the centre.

This is problem that frequently occurs with the Fuji GX617 when it is fitted with a 90mm or 105mm lens. The 180mm and 300mm lenses are fine, but the wider lenses suffer more, probably because there's less depth of focus available, and even a slight buckling of the film can cause unsharpness.

When I first witnessed this problem with my own GX617, I assumed there must be something wrong with it. However, I spoke to other users of the GX617 and their story was the same. The solution lies in the way the film is loaded – it must be kept as tight as possible until the camera back is closed, which involves a fair amount of manual dexterity, as follows:

1. Pull the film backing paper across to the take-up spool on the right-hand side of the film back and insert as normal.
2. Place the index finger of your left hand on the take-up spool and then advance the film towards the start position by using the thumb of your right hand.
3. When the start position is reached, hold the film advance lever in position with your right thumb, close and secure the camera back, then continue advancing the film to frame number one.

This is easier to achieve with the camera on a tripod so it's held firmly in place, although I can do it with the camera on my lap, if necessary.

INSUFFICIENT DEPTH OF FIELD

The only purpose-made panoramic camera with a coupled rangefinder that allows you to focus accurately on a specific point is the Hasselblad XPan. All others require you to estimate focusing distance, use the depth-of-field scale on the lens to aid focusing (see page 58) or, where

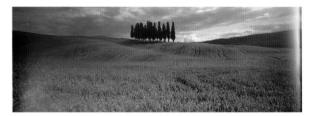

△ **NEAR SAN QUIRICO D'ORCIA, TUSCANY, ITALY**
Leaving the darkslide out of the 6x12cm back on my hired Horseman 612 camera for too long was clearly not a good idea – I ended up with numerous fogged frames. Fortunately, they weren't all ruined (see page 22).

Camera Horseman 612 Pro Lens 65mm Filters Polarizer and 0.45 ND hard grad Film Fujichrome Velvia 50

◁◁ **YORK MINSTER, YORK, ENGLAND**
Overestimating depth of field results in an unsharp foreground, as I discovered to my peril when I took this photograph.

Camera Noblex 135S
Film Fujichrome Velvia 50

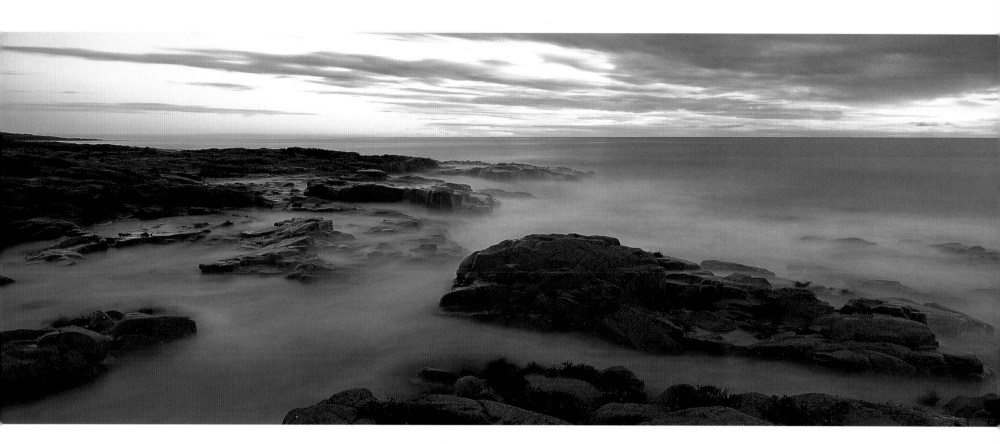

possible, attach a ground glass screen and compose/focus through the lens from underneath a darkcloth.

But what happens if your camera doesn't allow any of these methods? That's the problem I faced when I first used a swing lens panoramic camera (Noblex 135S). Because of the way the lens works, it has fixed focus and the only way to vary depth of field is by setting a wider/smaller aperture.

While testing the camera, I took some pictures of a statue outside York Minster in York, England. Unfortunately, I didn't realize that the statue itself was too close to the camera for the aperture set, so while the Minster in the background is pin-sharp, the statue in the foreground is noticeably soft.

The only way to avoid this when using swing lens cameras is to establish where the nearest point of sharp focus will be at different apertures and make sure you don't include something in your picture that's closer – although with no visual guides available, it's easy to forget and ruin an otherwise great picture.

△ **NEAR CRASTER, NORTHUMBERLAND, ENGLAND**
I arrived at this location before sunrise, hoping for a golden sky. Instead I was greeted with heavy cloud, but instead of giving up, I composed a scene to include large rocks in the foreground, then used a 45 second exposure to record sea washing over them. Care must be taken when shooting on the coastline as the sea air leaves a salty deposit on lenses and filters – plus there's always the danger of being swamped by a rogue wave! On this occasion, I lived to tell the tale.

Camera Fuji GX617 **Lens** 90mm **Filters** 0.6 ND hard grad and 0.45 centre ND **Film** Fujichrome Velvia 50

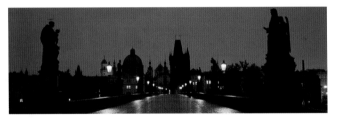

△ **CHARLES BRIDGE, PRAGUE, CZECH REPUBLIC**

Rain, rain go away! Sadly, on this morning it didn't, and many of my dawn pictures were ruined by rain on the pressure plate of the camera back. See page 79 for one that made it.

Camera Fuji GX617 Lens 180mm Film Fujichrome Velvia 50

△ **YORK MINSTER, YORK, ENGLAND**

Failing to advance the film fully to the next frame before making another exposure is really not a good idea – it means ruining two shots in one go.

Camera Noblex 135S Film Fujichrome Velvia 50

△ **VENICE, ITALY**

The chemical stain on this image could easily be removed digitally, but that's not the point.

Camera Hasselblad XPan Lens 90mm Filters Soft focus and moderate sunset grad Film Fujichrome Velvia 50

WATER MARKS

Rollfilm panoramic cameras are tricky to load at the best of times if fogging and buckling/curling are to be avoided, but throw some bad weather into the equation and life gets infinitely more difficult.

I've used my Fuji GX617 in all weathers, from tropical, clammy heat, to sub-zero temperatures when my fingers were so numb I could barely feel them, but the only time that I've actually lost shots due to adverse weather conditions was during a dawn shoot on Charles Bridge in Prague, in heavy rain.

The problem occurred because the back on the GX617 is hinged along the bottom rather than the side, so when you open the camera, the back drops down. This makes loading film in rain a nightmare because raindrops land directly on the pressure plate, and with only two hands available, it's difficult to load the film and keep rain off everything.

I thought I'd managed to pull it off – until I got the films back to the lab and two of them were ruined by large watermarks. Clearly, as I closed the camera back, raindrops on the pressure plate were squashed against the backing paper of the film and showed up as ghostly marks on the exposed and processed film. I did manage to get some decent shots that morning, but next time, I'll make sure I have an umbrella – and an assistant!

FILM OVERLAP

When it comes to advancing film to the next frame, some panoramic cameras are more sophisticated than others. That said, levels of automation are minimal compared to modern 35mm SLRs, so you still need to take care if mistakes are to be avoided.

If you use a camera with separate film advance and shutter cocking actions, it's quite easy to make an exposure with the film only partly advanced, so you end up with two images overlapping and both ruined.

This happened to me quite recently while I was using a Noblex 135S swing lens camera. The shutter is cocked when the film is advanced, and a firm click can be felt when the film has been advanced to the next frame. But somehow I still managed to overlap two frames, which

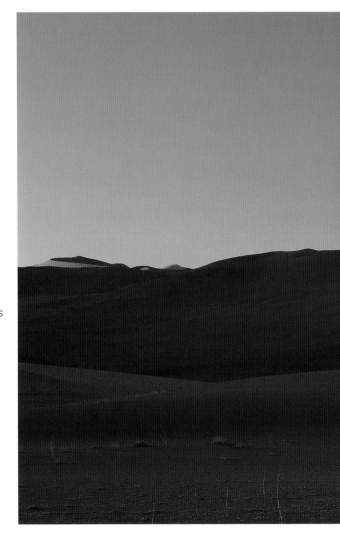

just goes to show that you can never be too careful. Thankfully, I took several more shots of the same scene, a policy I always adopt when using unfamiliar cameras, so all was not lost.

CHEMICAL STAINING

There's nothing more annoying than taking all the precautions in the world to ensure that your pictures are successful, only to have them ruined by someone else!

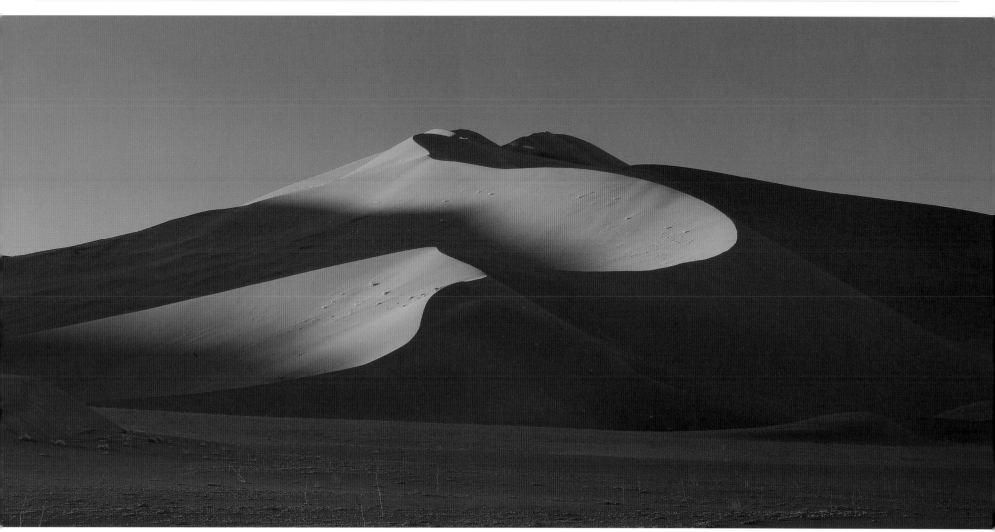

Considering the number of rolls of film that I have proc-
essed every year by the same lab – at least 1,000 – the
number of faults caused by them is almost neg-
ligible. However, not all labs achieve the same high
standards and I have heard many horror stories from
other photographers about films being ruined during
processing. If you experience such problems on a regular
basis, the answer is simple – find another lab. And when
you've found a good one, stick with it.

△ **SOSSUSVLEI, NAMIB DESERT, NAMIBIA**

Blowing sand can be a camera killer, so I'm always careful when using my panoramic equipment in
desert locations like this – a 617 camera is at its most vulnerable when film is being changed and
the back is wide open to the elements. Fortunately, I managed to avoid problems as I waited for the
last light of the day to pick out this beautiful dune.

Camera Fuji GX617 Lens 180mm Filter Polarizer Film Fujichrome Velvia 50

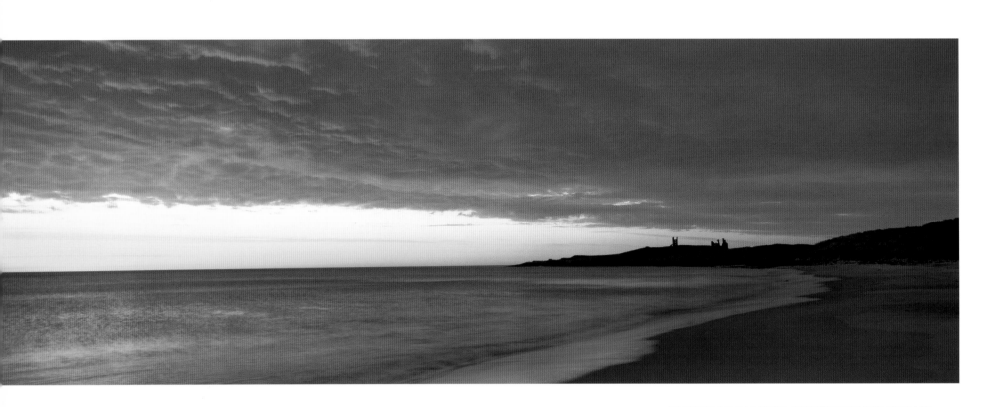

DUNSTANBURGH CASTLE, NORTHUMBERLAND, ENGLAND

The sun was rising just out of shot to the left – too far away from the castle for me to include in the shot. I was aware that if it was too bright, the sun's orb would cause flare. To avoid this, I stood on the left side of the camera and cast my own shadow over the lens, being careful not to get myself in the picture.

Camera Fuji GX617 Lens 90mm Filters 0.3 centre ND and 0.45 ND hard grad Film Fujichrome Velvia 50

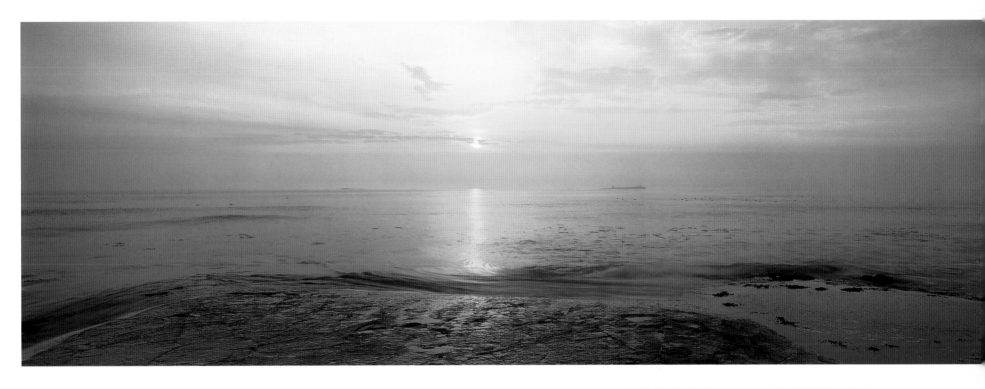

VIEW FROM BAMBURGH BEACH, NORTHUMBERLAND, ENGLAND

The sunrise was a subdued affair on this morning, so instead of photographing Bamburgh Castle, just out of shot on the right, I decided to point my camera towards the sun and capture the misty view out to sea. When shooting on the coast, I check my lens every few minutes for salty deposits that blow in off the sea – they can degrade image quality and increase the risk of flare.

Camera Fuji GX617 Lens 90mm Filters 0.3 centre ND and 81C warm-up Film Fujichrome Velvia 50

CREATIVE TECHNIQUES

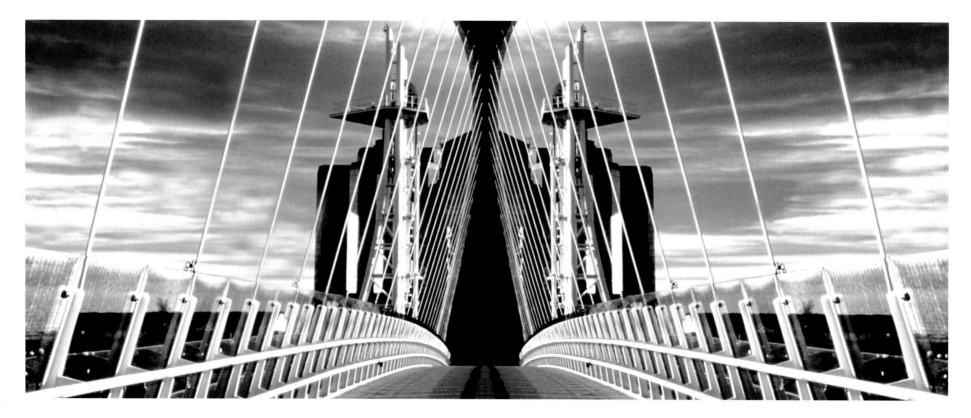

L ike the majority of photographers, I use panoramic cameras mainly to shoot landscapes and architecture. However, this is only one area where the panoramic format excels, and once you become accustomed to it, you will quickly realize that it suits a much wider range of subjects than you may originally have thought, and offers you endless creative potential.

The Hasselblad XPan is perhaps more suited to creative use than any other panoramic camera, mainly because the coupled rangefinder allows you to focus accurately on a specific part of the scene so you have more control over the final image. It's also small and lightweight, making it suitable for spontaneous handheld photography, and, as it uses 35mm film, you can use the wide range of different emulsions available in that format.

The key to success is to have an open mind, and be willing to experiment. A panoramic camera is a specialized piece of equipment, but that doesn't mean you have to wrap it in cotton wool and use it only on high days and holidays. Instead, think of it in the same way you think of your 35mm SLR – as a versatile, creative tool.

Use it at every opportunity so you become familiar with its features and controls and are able to operate it

◁ **SALFORD QUAYS, MANCHESTER, ENGLAND**

This photograph was taken on the same day as the one on page 3, though instead of shooting it with my XPan, I took a 35mm shot with a Nikon SLR on black and white film. I loved the symmetry of the bridge, and this gave me the idea of creating a mirror image by taking one half of the original shot, copying and reversing it, then adding the two halves together. Being a digital novice, I didn't really know how to achieve this, so I phoned a friend who did and he talked me through the stages. It was actually very simple, and took no more than five minutes. I really like the end result because it's something new and different for me and I never actually set out to create it – the idea just came in a moment of madness! After merging the two halves, levels and contrast were tweaked in Photoshop to create a sci-fi effect; I then cropped the image down to a panoramic.

Camera Nikon F90x **Lens** 28mm **Filter** Orange **Film** Ilford FP4 Plus

△ **BLUE REEF AQUARIUM, TYNEMOUTH, ENGLAND**

Because the Hasselblad XPan is so compact and easy to use, I often take it out with me on family outings and use it like a point-and-shoot camera to grab snaps. On this occasion, I was visiting a sealife centre with my wife and young children, and I decided to see how the camera would cope with moving subjects photographed indoors and through glass – a test for any non-autofocus camera! I shot a roll of colour print film, which I chose over slide film for its increased exposure latitude (there would be no time to bracket exposures) and just hoped for the best. Of the 21 pictures that I took that day, two or three worked okay, and this shot is the best of the bunch. To make it more interesting, I scanned the negative into my computer then played around with contrast and colour controls in Photoshop until I was happy with the result. It's no masterpiece, but I had fun taking it!

Camera Hasselblad XPan **Lens** 45mm **Film** Fujicolor Superia 800

quickly and confidently. Try to make it an extension of your eye. Get to know its strengths and weaknesses, then use them to your advantage. Be willing to experiment and take a few risks. The worst possible outcome is that you will waste a few rolls of film, but in the process of doing so you may create something that is unique and special, and that, ultimately, is the only way to move your photography forward.

When I first used a panoramic camera, I felt as if I was starting all over again. Everything seemed alien and I was never sure what I would end up with when I tripped the shutter release to take a picture. I made more mistakes than I care to remember and many of my early efforts ended up in the bin. But each time I made a mistake I learned from it, my confidence grew, and with it my ability to produce interesting images – some of which appear in this chapter.

INFRARED PANORAMICS

I have been experimenting with infrared film for almost as long as I have been taking photographs. Its unique characteristics are ideal for creating unique and innovative images, so it seemed perfectly natural that when I became involved in panoramic photography, the two were brought together.

I mainly use my Hasselblad XPan camera for infrared photography, simply because the film is more readily available in 35mm format (see below) and, in the case of mono infrared, I can print the negatives using a medium-format enlarger. The earlier XPan was said to cause fogging of infrared film, but in my experience this only affects the film rebate, not the image area, so it's not generally a problem. The XPan II apparently has improved infrared sensitivity.

Swing lens 35mm panoramic cameras are also suited to infrared photography, and I have made some basic experiments with a Noblex 135S. The main problem here is that a filter must be used with all types of infrared film, and fitting filters to a swing lens panoramic camera is tricky – not that you should be put off trying!

USING MONO INFRARED FILM

There are three mainstream films available: Kodak High Speed, Konica 750, and Ilford SFX. The Kodak emulsion, available in 35mm only, is the most sensitive to infrared radia-

△ **COSTA TEGUISE, LANZAROTE, CANARY ISLANDS**

I was attracted by the pattern of this row of palm trees while on a family holiday. Instead of shooting it on Velvia, I decided to add a surreal twist and use colour infrared film instead, knowing that the green foliage would come out a red or pink colour. The result is a simple, graphic image that makes use not only of repeated shapes, but also of repeated colour.

Camera Hasselblad XPan Lens 30mm Filters 0.45 centre ND, polarizer and deep yellow Film Kodak Ektachrome EIR colour infrared

tion and produces the most dramatic results. It's also the fastest and grainiest of the three and the one I generally prefer. Konica 750 comes in both 35mm and 120 formats. Though not quite as sensitive as the Kodak version, it's a wonderful film that offers superb resolution and fine grain. Ilford SFX is the least sensitive of all, though it can produce interesting results and is available in 35mm and rollfilm formats.

In order to get the best results from mono infrared films the following factors should be considered:

- You need to filter out as much of the visible spectrum as possible. This can be done using an opaque infrared filter, such as the Kodak Wrattan 87C or the Lee 87. However I always use a deep red filter instead, such as the Cokin 003 or the Lee 25, as it makes focusing, composition and exposure easier.
- If you're metering through a red filter, rate Kodak High Speed at ISO 400, Ilford SFX at ISO 200 and Konica 750 at ISO 50. If you're taking an exposure reading with a handheld meter, or using your camera without the filter in place, rate the Kodak film at ISO 50, Ilford at ISO 25 and Konica at ISO 6, so the three-stop filter factor is accounted for.
- Bracket exposures at least one stop over and one stop under the initial reading, in one-stop increments.
- Kodak High Speed must be handled in complete darkness to avoid fogging, so carry a changing bag on location. Konica and Ilford IR films are less sensitive, so you can load and unload them under a jacket.
- Infrared radiation focuses on a different point to visible light. If you're using a wideangle lens and a small aperture (f/11 or smaller) you can focus normally, as extensive depth of field will make up for the difference. If you're using a telephoto lens, refocus using the red IR focusing index on the lens barrel.
- Bright, sunny weather tends to give the best results outdoors as there's more infrared radiation around.

USING COLOUR INFRARED

Kodak Ektachrome EIR is the only colour infrared film available, and it's manufactured in just one format, 35mm. Here are some top tips on how to get the most from it.

- Like Kodak mono infrared, this film must be loaded and unloaded in complete darkness to avoid fogging.
- The vivid colour effects it produces can be varied by using different filters. Deep yellow is recommended, but orange, red and polarizing filters are also worth trying.
- Rate the film at ISO 400 or ISO 640 and meter through the filter you are using.
- For the best results, shoot colour infrared film in bright, sunny weather.
- Bracketing is essential. I usually bracket in 1/3 or 1/2 stops to two stops over and under the metered exposure.
- The film is E6-compatible, like colour slide film. However, when you take exposed rolls to the lab for processing, be sure to leave each cassette in its light-tight plastic tub, and stress that the film must be handled only in complete darkness.

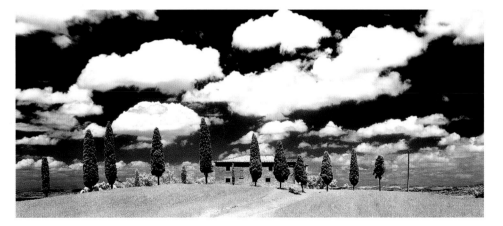

△ **NEAR PIENZA, TUSCANY, ITALY**
A toned version of this photograph appears on page 133. It was taken on Konica 750 Infrared film and exhibits all the main characteristics of mono infrared film: dramatic sky, pale foliage, and high contrast. I printed to grade IV to enhance this effect. The shot was originally taken on a medium-format camera, but I cropped it to a panoramic during printing.

Camera Pentax 67II Lens 45mm Filters deep red and polarizer Film Konica 750 Infrared

△ **KITTY, NORTHUMBERLAND, ENGLAND**
The vivid colours and high contrast of Kodak EIR makes it ideal for taking humorous pictures – my kids love it!

Camera Hasselblad XPan Lens 30mm Filters 0.45 centre ND and deep yellow Film Kodak Ektachrome EIR colour infrared

△ **TELOUET, MOROCCO**

I was wandering through some woodland, in search of an
alternative view of the ruined Glaoui kasbah at Telouet, when
I stumbled upon this garden in a clearing. To my surprise, there
was a woman tending her vegetables. She seemed rather nerv-
ous at my sudden appearance, but I spoke to her in (very) basic
French, and when I asked if it was okay to take her photograph,
she nodded approval. I didn't have time to change lenses or set
up the shot as she was on her way home, so I just focused and
fired off a single frame. Before I had the chance to shoot another,
she had her back to me and the moment was gone.

Camera Hasselblad XPan Lens 45mm Film Fujichrome Velvia 50

PANORAMIC PORTRAITS

Whenever I travel, I enjoy experiencing new cultures and meeting local people. A natural
extension of this is to photograph the people I meet. I now have a collection of travel
portraits that runs into the hundreds, most shot with a 35mm Nikon system.

In recent years, however, I have found myself reaching for a Hasselblad XPan more
than the Nikon, because I feel that the panoramic format is more effective than 35mm in
depicting a person in their natural environment.

The XPan is an ideal camera for portraiture thanks to its coupled rangefinder system,
and other features such as integral metering and automatic film advance, which allow
me to keep the camera to my eye and continue shooting.

Often I find myself shooting handheld in failing light with the lens set to its widest
aperture in order to maintain a decent shutter speed. This means that depth of field
is lacking, especially with the 90mm lens. However, because the XPan has a coupled

rangefinder, I can focus accurately and quickly on my main subject, which means that a lack of depth of field isn't important. This facility also means that depth of field can be intentionally reduced to throw a distracting background out of focus – a common technique in portrait photography.

Swing lens panoramics such as the Noblex 135S can be used successfully for portraiture, as they provide extensive depth of field and are easy to handhold. The distortion that they create must be considered, however, otherwise the results can end up looking rather unnatural.

For me there's no secret formula to successful portraiture, other than being polite and courteous to my subjects and showing them the respect they deserve. I always ask permission to take pictures, rather than shooting candidly, as this can offend many cultures. I also find that the results are more natural when the person is aware that they are being photographed and I am engaging them in conversation.

The appearance of the XPan is usually a source of much amusement, and that helps to keep the atmosphere nice and relaxed. Just wandering around with an XPan and a couple of lenses in search of interesting characters is a great way to spend a few hours. It certainly makes a pleasant change from standing behind a tripod for hours on end, waiting for the light to improve.

△ **AIT BENHADDOU, MOROCCO**

These two men were standing outside their shop near the ancient kasbah of Ait Benhaddou, waiting to entice passing tourists, so as I approached, I asked if it was okay to take their photograph. Initially they played up to the camera, posing side by side with cheesy smiles and folded arms, but I stood my ground and after a minute or two they lost interest in me and continued plying for custom. That's when I got the most natural poses and expressions. What makes the shot for me are the mud walls covered in old tools and implements; the earthy, natural colour of this backdrop helps to emphasize the vivid colours of my subjects' robes.

Camera Hasselblad XPan Lens 45mm Film Fujichrome Velvia 50

CROSS-PROCESSING

A great way to give your pictures a creative twist is by having the film cross-processed. This technique has been used by professionals for years, especially fashion and portrait photographers, and there's no reason why you can't use the technique for panoramics as well.

The two options are to process colour slide film as colour negative film in C-41 chemicals, so you obtain colour negatives from which prints can be made, or to process colour negative film as slide film in E-6 chemicals so you obtain colour slides.

Cross-processing slide film gives the most striking results, as you can see from the two shots reproduced here. Contrast and colour saturation are increased and some colours are totally transformed, depending on which film you use. Fujichrome Velvia, Provia and Sensia are popular, along with Agfachrome RSX II 100, but you can cross-process any slide film.

Because the resulting negatives will be printed, you get the same degree of exposure latitude that colour print film offers, even though you're shooting slide film.

△ **VENICE, ITALY**
I took this picture specifically with the intention of having the film cross-processed to maximize contrast and colour saturation and increase the impact of the dolls piled against the deep blue sky. I included the Campanile in St Mark's Square in the background to offer a clue as to where the photograph was taken.

Camera Hasselblad XPan **Lens** 45mm **Film** Agfachrome RSX II 100 cross-processed in C-41

This means that you can rate the film at the manufacturer's recommended ISO and you don't have to worry about bracketing exposures – even if you're a stop or two out, you will still end up with a decent print.

The most important thing to remember is that you must give the processing lab clear instructions so they know how to process the film. To avoid confusion, put a sticky label on the film cassette saying 'C-41 process' or 'E-6 process', and explain what you've done. Some high street labs refuse to cross-process film in this way, but most professional labs will accept your request. Cross-processing costs no more than conventional processing.

USING GRAIN

To the majority of photographers, grain is seen as a negative rather than a positive element, and they go to great lengths to minimize it. However, when used creatively, grain can enhance an image, and when intentionally exaggerated it can produce beautiful effects. In black and white photographs, it lends a stark, gritty feel to the image. In colour, the use of coarse grain adds atmosphere, producing images with a pleasing 'impressionistic' feel reminiscent of a painting rather than a photograph – especially if you shoot in warm light and use soft-focus filters to diffuse the image.

I have been producing grainy images for years, starting with a 35mm SLR and progressing up to 6x17cm panoramics – the film format doesn't matter; it's the effect that counts. The easiest way to emphasize grain is by using ultra-fast film with an ISO rating of 1000 and above. If you shoot colour slides, Fujichrome Provia 1600 is the only option these days, while for black and white photography you can choose from films such as Fuji Neopan 1600, Kodak T-Max 3200 and Ilford Delta 3200.

All these films offer fairly coarse grain at their normal speed rating, but if you want it to be even more obvious you could uprate the film to a higher ISO and then have it push-processed, a technique that boosts grain size and image contrast. Uprating slower ISO 400 film two stops to ISO 1600 is another option I often use, mainly because ISO 400 film is cheaper and more readily available than ultra-fast films.

▽ **VENICE, ITALY**

This sunrise over Venice was very subdued, so I decided to play on the subtle colours by using fast, grainy film and a strong soft-focus filter to add atmosphere to the scene. The original was shot on a 6x17cm camera, but I put too many filters on the lens and this caused vignetting – forcing me to crop the image down to 6x12cm.

Camera Art 617 Lens 90mm Filters Anti-Newton glass slide mount for soft focus and 81D warm-up Film Fujichrome Provia 400 rated at ISO 1600 and push-processed by two stops

◁ **EDINBURGH, SCOTLAND**

My first outing with a swing lens panoramic camera was in Edinburgh. As I had only colour slide film with me, I decided to have it cross-processed so there was less chance of exposure error – and also to make the pictures more unusual. The effect here is more subtle than on the shot above, but cross-processing has made the autumnal foliage colours really stand out.

Camera Noblex 135S
Film Fujichrome Sensia II 100
cross-processed in C-41

AERIAL PANORAMICS

You don't have to have your feet planted firmly on the ground to produce successful panoramic images. The renowned aerial photographer Yann Arthus Bertrand has proved that many times over with the stunning images contained in his book *The Earth From The Air*. In fact, it was that book that inspired me to take to the skies in a hot-air balloon over the Namib Desert in southern Africa one winter's dawn in 2001.

Unsure of what to expect, as it was my first balloon flight, I boarded with a veritable arsenal of equipment. What I didn't know was that the basket would become so congested with other passengers that I would be unable to reach the backpack at my feet and reach most of the equipment I had intended to use. All I could work with was the camera hanging from my shoulder; a Fuji GX617 with 180mm lens attached.

Initially I felt deflated by the prospect of missing some great shots. The other photographers around me were sporting 35mm SLRs with fast zoom lenses, and there I was with a bulky panoramic camera and a lens that wouldn't open up to an aperture wider than f/8. Things didn't look good for me.

Rather than give up, however, I decided to make the most of what I had. A friend standing nearby had an SLR, so I asked him to give me an exposure reading (my GX617 doesn't have any metering) and I got to work. An hour and several rolls of film later, we landed and enjoyed a champagne breakfast, and I was sure that I must have something decent to remind me of an unforgettable flight.

Almost two weeks later, my hopes were confirmed. I had used a 6x17cm camera handheld, from a hot air balloon, and produced what I considered to be some fairly good pictures. Never again would I assume that the bulky beast I knew and loved would have to be mounted on a sturdy tripod at ground level to produce decent images.

What saved me was the fact that, being so high over the landscape, I was able to focus the lens on infinity, which meant that I didn't need any depth of field and the widest aperture could be selected to maintain the fastest possible shutter speed. Those speeds weren't great – 1/60sec and 1/125sec at best – but because the GX617 uses a leaf shutter and there is no reflex mirror to create recoil, shooting handheld at such speeds wasn't a problem. Based on that success, I would happily use my 6x17cm panoramic camera again for aerial pictures, be it from a balloon or an aircraft.

A few years later, I was able to repeat the exercise, only this time over the stunning landscape of Cappadocia in Turkey and with a more compact Hasselblad XPan. This time I was more prepared. Expecting the worst, I hung the XPan around my neck already fitted with one lens, and stashed the other two lenses plus several rolls of film in my pocket. This enabled me to re-load and change lenses with ease, and in doing so respond to opportunities that never lasted for more than a few seconds due to us being continually on the move.

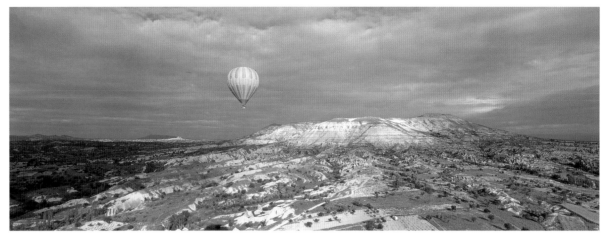

△ CAPPADOCIA, TURKEY

The sun played hide and seek during my flight over Cappadocia, but occasionally it came out and illuminated the early morning landscape. Here I included another balloon for scale.

Camera Hasselblad XPan Lens 30mm Filter 0.45 centre ND
Film Fujichrome Velvia 50

▽ CAPPADOCIA, TURKEY

It's an amazing experience to peer down to earth from a hot air balloon; everything seems so small and far away, and the silence is amazing. In this shot, long shadows from the early morning sun add a sense of depth.

Camera Hasselblad XPan Lens 45mm Film Fujichrome Velvia 50

△ NAMIB DESERT, NAMIBIA

This is one of my favourite photographs from a memorable balloon flight over the Namib Desert. On the day, the winds weren't strong enough to carry us over the dunes, but the misty dawn views towards the mountains and Sesriem Canyon more than made up for that.

Camera Fuji GX617 Lens 180mm Film Fujichrome Velvia 50

I photographed the extraordinary landscape from above, complete with its waves of volcanic tufa and the eye-catching rock formations known as 'Fairy Chimneys' characteristic of that part of the country. I took pictures of other balloons that were in the sky that morning too. Past experience had taught me that focusing on infinity and setting maximum aperture would be fine; all I had to do was concentrate on the composition of each shot, and the quality of the light.

BLACK AND WHITE PANORAMICS

My main reason for investing in a Hasselblad XPan was so that I could shoot panoramic landscapes in black and white and print them on a medium-format enlarger. I had used a 6x17cm panoramic for three or four years, and found that the black and white photographs I was taking with a Pentax 67 were regularly being cropped under the enlarger to panoramic format, so I decided to bite the bullet and invest in a panoramic camera.

For some months after, I regretted the decision. However, once I found the time to start printing those early landscapes shot with the XPan, I realized I had made a wise decision, and my love affair with the XPan still endures to this day.

I'm happy to admit that I am no master black and white printer. More often than not, the prints I end up with are nothing like what I expected, as in the case of the photograph on page 103. But that's why I enjoy printing so much – there's always a pleasant surprise around the corner if you're willing to have an open mind and take risks. After all, no one has to see your mistakes!

Colour photography tends to be my first priority, so if I work in black and white it's usually because the light was no good for colour. This may seem like a rather negative attitude, but I see the two mediums as completely different, and what suits one doesn't necessarily suit the other. I can see no point in wasting black and white film on a golden sunset, because the glory of such an event can only be captured in colour. Equally, I will not shoot colour landscapes on a dank, grey day, but I find that such conditions are perfect for black and white photography because the soft light can be very atmospheric and images can be manipulated in the darkroom to create dramatic prints.

The advantage of adopting this approach is that for me there's no such thing as bad weather or bad light: no matter where I am, and no matter what the circumstances, I can come up with something interesting. Also, when I enter the darkroom to make prints, I rarely set out with preconceived ideas about what I want to achieve. To me, a black and white negative merely provides the basic ingredients from which I can produce a great print. How-

ever, it might be years before I get round to printing that negative, so when that time comes, the memory of taking the original photograph may well have faded and I just go with the flow and see what happens.

MARRAKECH, MOROCCO

These four photographs were all taken on the same day in Marrakech. I was wandering around the old part of the city, shooting anything that caught my eye. My camera was loaded with fast film so I could cope with changing light levels, and I had left my tripod back at the hotel so that I could shoot handheld and respond to fleeting opportunities – the best way to work in cities. The panned shot of the man on the scooter was taken early in the morning – I just stood by the roadside and fired away as people passed by. The water sellers were captured in the main square of Djemaa el Fna as they plied their trade; the shopkeeper was photographed in a quiet square in the souks; and the bikes as I wandered through the kasbah – I just noticed them propped against a wall and took a quick shot.

Camera Hasselblad XPan
Lens 45mm and 90mm
Film Ilford HP5 Plus (ISO 400)

ST JOHN IN THE VALE, LAKE DISTRICT, ENGLAND

This was one of the first black and white panoramics I took with my Hasselblad XPan. I had set out to photograph Castlerigg Stone Circle, but the light was too flat, so I went for a walk to check out other scenes in the vicinity. As I arrived in this location, the sun began to break through the stormy sky and I could see the potential for an interesting panorama, using the old tree branch on the ground as foreground interest. However, as there was no direct sunlight on the landscape, I decided that it would suit black and white more than colour, and proceeded to expose a dozen or so frames. Some serious dodging and burning-in was required when I printed the negative in order to recapture the drama of the scene as it appeared to my eyes, but it was worth it. The stunning quality of the XPan lens is clear to see, with even the finest distant details clearly resolved on the original print – which was partially bleached and toned in dilute sepia.

Camera Hasselblad XPan Lens 45mm Filter Orange Film Agfapan APX100

DERWENTWATER, NEAR KESWICK, LAKE DISTRICT, ENGLAND

I usually set out with the intention of shooting landscapes in colour, but if the light and weather are against me, I tend to work in black and white instead. Dull, overcast days are useless for wideangle views in colour, but such conditions are ideally suited to black and white, and the image can always be manipulated in the darkroom to add drama. In this case, the scene was very soft and tranquil on the day, but when I came to print the image some months later, I decided to go for a much bolder effect and printed hard on grade IV so the sky was emphasized and the shadows darkened down. It's nothing like how the scene really appeared, but that's the beauty of black and white printing – you can make a photograph say what you want it to say.

Camera Hasselblad XPan **Lens** 45mm **Filter** Orange **Film** Agfapan APX25 film

Modern architecture is the perfect subject for abstract shots because it's full of bold shapes and patterns. I spotted this scene while strolling around London and knew that it would make a great upright panoramic. Shooting in black and white heightened the graphic simplicity of the scene. To take things a step further, I scanned the negative into Photoshop and closed the gap between the buildings on either side of the street so they appear to be almost touching.

Camera Hasselblad XPan **Lens** 30mm **Filter** 0.45 centre ND
Film Ilford FP4 Plus

PANORAMIC PATTERNS AND ABSTRACTS

A photograph is made up of textures, patterns, shapes and colours, and although the majority of pictures we take rely for their success on the subject matter being recognizable, it doesn't have to be this way, and the very elements that make up the photograph can instead become the main focus of attention.

This is where we leave behind reality and explore the world of abstract photography; where we look for and isolate interesting patterns, textures, shapes and colours that appeal to our visual senses. For example, a bright yellow bucket placed in front of a blue wall will make an interesting photograph not because the bucket itself has any aesthetic merit, but because the two colours, yellow and blue, contrast strongly and attract our attention.

Similarly, in the shot here of the blue wall and painted door, what appeals to us is the bold use of colour, the deep shadows and the conflicting lines of the doorway and the stripes on the door. When you look at this image you don't need to know what it's of, just what it contains.

I have long been fascinated by the idea of abstract photography and the practice of looking for photographs within a scene, rather than the scene itself being the subject. This interest has spilled over into my panoramic photography, and I love nothing more than wandering around a bustling city or colourful market, trying to look beyond the obvious and see pictures that others have missed – the patterns, shapes, colours and textures that can make bold statements in their own right, and not just as part of a bigger picture.

△ **SWAKOPMUND, NAMIBIA**

I noticed these masks while wandering around an outdoor woodcarvers' market in Swakopmund and immediately saw the potential for an interesting pattern shot. Using the XPan, I composed carefully to make sure that the masks filled the entire frame. The man selling them thought I was mad, but photographers never miss the chance to take an interesting picture.

Camera Hasselblad XPan Lens 45mm Film Fujichrome Velvia 50

◁ **MAJORELLE GARDENS, MARRAKECH, MOROCCO**

I have visited these gardens many times, and usually photograph the colourful pots and urns. On this occasion, however, the play of light and shade on the vibrant blue walls of the pavilion caught my eye, so I spent my time there shooting abstracts. I used the wide field of view of my XPan's 30mm lens to create interesting juxtapositions of colours, shapes and shadows and shot from unusual angles to add impact.

Camera Hasselblad XPan Lens 30mm Filter 0.45 centre ND
Film Fujichrome Velvia 50

PANORAMIC JOINERS

Y ou don't need a panoramic camera to produce exciting panoramic images – a pair of scissors, a pot of glue and a selection of photographic prints are all that's required, along with a little imagination. You can also use your computer to help.

This is how I made my first panoramic. I was on a school trip to Paris, aged 15, and armed with a Zenith EM SLR. Gazing over the city from the top of the Eiffel Tower, I was disappointed by how little of it I could capture in a single frame of 35mm film. I shot half a dozen pictures on colour negative film, and when the processed prints were returned from the lab, I pasted them side by side on a sheet of white card to create a dramatic cityscape. Okay, the end result was rather crude, but it was the start of my panoramic adventure – and it could be yours if you have no other means of creating panoramics at this stage.

The key is to use your imagination. Instead of seeing 'joiners' as the poor relation of photographs taken with an expensive panoramic camera, focus on the creative potential the technique offers – by constructing an image from a number of individual photographs, all kinds of interesting effects are possible.

For example, rather than just sticking a row of prints down side by side as I did, be a little more creative. The images don't have to be side by side in a perfect line, for a start – you could shoot a vertical joiner of a tall building by starting at the top and working your way down to ground level and arranging the prints in that way. The final joiner doesn't have to be precise, either. There can be spaces between each print if you like, or the prints can be arranged in more than one row, or in a random fashion – it all depends what you are photographing and what kind of effect you wish to create. You could even create

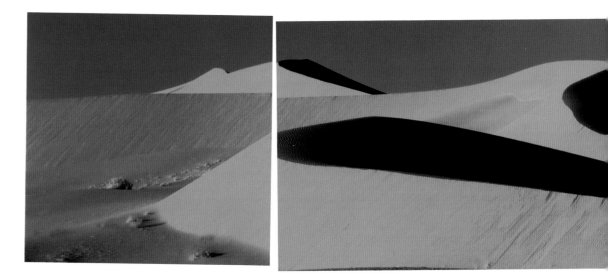

Namibia, March 2004

the final image in-camera so that one long strip of film becomes the final photograph and the individual elements within are contained in each frame.

PLANNING A PANORAMIC JOINER
Planning is important when you are creating a joiner. Having chosen a suitable subject or scene, you will need to stand back and think about how you are going to capture

it on film. Decide on the shooting sequence, how many pictures you will need to take, and how the final joiner will be presented.

For a simple panorama for which you take a series of pictures from left to right this is relatively easy, but if you're going to attempt a more ambitious project then you will need to have a solid plan. Making a sketch beforehand can help, because you can establish exactly how many

▽ **SOSSUSVLEI, NAMIB DESERT, NAMIBIA**
Panoramic photographs don't come simpler than this graphic desert image. It started life as a set of 6x4in colour enprints, which I trimmed to get rid of any overlap and then pasted to a sheet of white card with spray mount adhesive. Tilting each print slightly adds visual impact to the final artwork. Images like this look great framed and hanging on a wall.

Camera Nikon F5 **Lens** 80–200mm zoom **Film** Fujicolor Superia 100

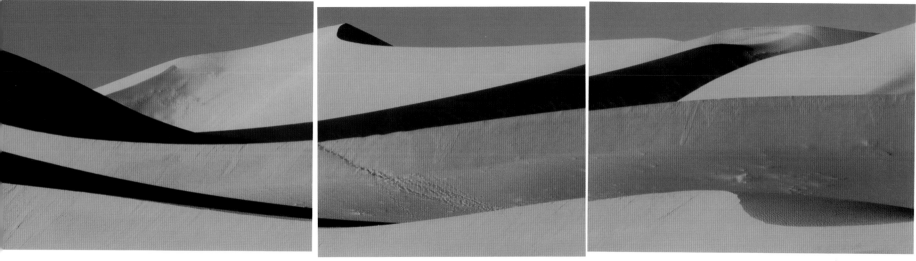

frames of film need to be exposed, and the particular order in which you expose them.

You need to plan simple things like making sure you have enough film on your camera to complete the job. If you run out, by the time you load another roll the light may have changed, for example, and consistent lighting is essential, especially if you want to create a panorama that looks convincing.

In terms of equipment for creating panoramic joiners, any type of camera can be used. A 35mm SLR is ideal because you can make use of a wide lens range, but even a simple 35mm fixed-lens compact or a single-use camera can be employed. Remember, the camera is only creating the individual pieces – rather like the pieces in a jigsaw puzzle. It's how you put those pieces together that really counts.

Don't feel that you should try to cover a vast field of view when taking pictures for a panoramic joiner. There's nothing wrong with shooting through 180 degrees or even 360 degrees with a wideangle lens if the scene suits such a approach. Equally, you could use a telephoto or telezoom lens to photograph quite a small area bit by bit. There are no rules when it comes to making joiners, so keep an open mind and experiment.

△ VENICE, ITALY

This image illustrates an alternative way of creating panoramic joiners. The process of taking the pictures to complete the final artwork is exactly the same as for other examples in this chapter, but instead of isolating each frame and joining them together, the complete strips of film were used instead. I experimented with different focal lengths on my telezoom lens to establish which setting worked best, then took two sets of photographs, starting on the left side of the building and moving to the right with each frame. Having reached the other side, I then lowered the camera position slightly and repeated the exercise, creating two strips of images that, when presented together, revealed the statues along the top of this elegant Venetian building in jigsaw-puzzle form. The end result is far more interesting and intriguing than a single image could ever be because it forces the viewer to use their imagination and piece the contents of the joiner together.

Camera Nikon F5 Lens 80–200mm zoom Film Fujichrome Velvia 50

▷ SIENA, TUSCANY, ITALY

This image came about while I was having a little fun with a Horseman 612 camera. Though the final result isn't actually a panoramic, it was created from two panoramic images, so it still qualifies as a panoramic joiner! I was admiring the cathedral through the viewfinder of the Horseman when I realized that I could capture the whole of this wall by taking two shots: one of the top half and one of the bottom. I knew that the perspective would be somewhat distorted, but decided that this would just add to the appeal of the image – it was never meant to be taken seriously anyway!

Camera Horseman SW612 Pro Lens 65mm Film Fujichrome Velvia 50

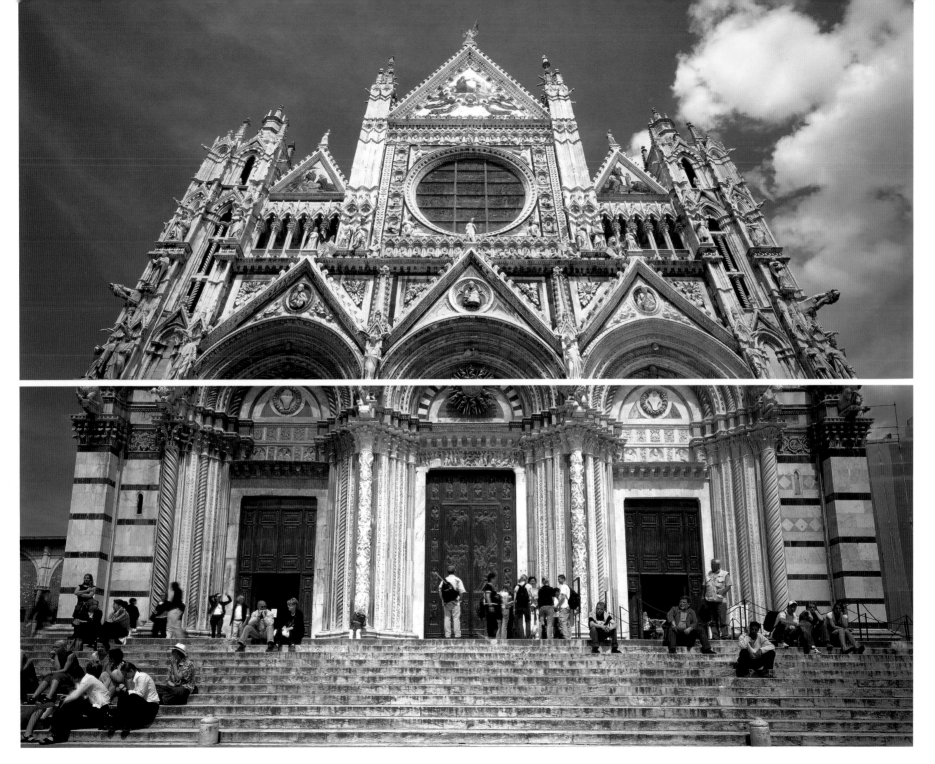

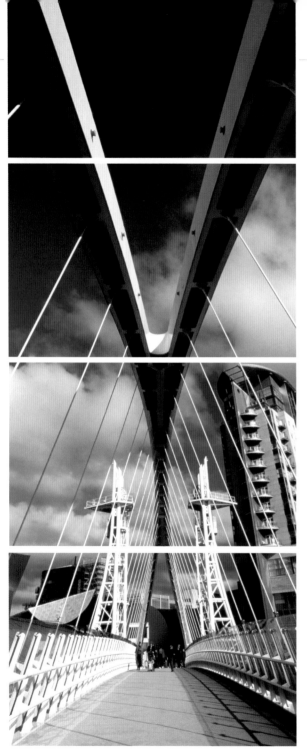

Siena

◁ **SALFORD QUAYS, MANCHESTER, ENGLAND**

I had been photographing this pedestrian suspension bridge for an hour or so, from either side of the river, when I saw the potential for a vertical panoramic. Assessing the view with my widest lens attached, I realized that I couldn't get everything in the composition that I wanted in a single frame, so I took four separate shots with a 35mm SLR and created a joiner. Not only did this satisfy my original idea, but the use of individual images to complete the final panorama added impact.

Camera Nikon F5 **Lens** 28mm
Film Fujicolor Superia 100

CONSTRUCTING THE ARTWORK

Once the pictures have been taken, all you need to do is construct the finished artwork. Glossy 6x4in enprints are fine, so you can have your film processed by any commercial lab. Consider having a second set of prints made when the film is processed. The cost is minimal, but it means that if you make a mistake and spoil a print, you will have another one to replace it.

Give yourself plenty of space in which to work. A clean tabletop is ideal, or the floor if your joiner is going to be big. If you need to cut any of the prints, a craft knife with a new blade or a rotary trimmer will give you clean, straight cuts.

Use spray mount adhesive to glue the prints in place. Not only is this type of adhesive clean and quick to use,

but you can lift a print and re-set it if necessary without making an awful mess. White card makes a crisp, neutral background for joiners, though coloured card can also work with the right subject.

Size is up to you. Start small and simple initially, perhaps working with six to ten prints. But as your confidence, experience and creativity grow, you can increase the number considerably – joiners made from 50–100 prints can look amazing.

CREATING DIGITAL JOINERS

By far the most foolproof and sophisticated way to create panoramic joiners is by using a computer and suitable software to merge images together digitally. Most of you will have a computer of some description at home or at

the office, and a growing number of you will already be exploring the wonders of digital imaging. This means that even if you can't afford to buy a purpose-made panoramic camera, there's no reason why you can't create amazing panoramic images.

Even though I'm committed to using panoramic cameras, and have very limited knowledge of digital imaging, the idea of taking the digital route is becoming more appealing simply because it offers almost endless creative scope. You can create panoramas covering any angle up to 360 degrees using a normal camera such as a 35mm SLR; you can use any lens, from super-wide to long telephoto, whereas the lens range for purpose-made panoramic cameras is limited; and elements from many different images can be blended to create

panoramas that would simply be impossible to record in a single exposure.

Best of all, the techniques that are used to stitch images together are easily mastered if you already have a basic knowledge of digital imaging, and you can produce seamless results that are at least as good as those created using panoramic cameras without having to invest heavily in specialist equipment.

EQUIPMENT AND SOFTWARE
You have two options here: either take your pictures using film then scan them, or use a digital camera. It doesn't really matter which method you choose, though a digital camera is more convenient because it means that you won't have to scan each image ready for stitching.

△ **SIENA, TUSCANY, ITALY**
I took the photographs that formed the basis of this unusual joiner a year earlier than the one above, in the same city. Shooting from a window in the tower that overlooks the Piazza del Campo, I took a series of four pictures on colour print film. Once the film had been processed, each print was cut into four slices and these were mounted on board. If nothing else, it shows that panoramic joiners offer lots of scope for creativity if you're willing to experiment.

Camera Nikon F90x **Lens** 50mm **Film** Fujicolor Superia 100

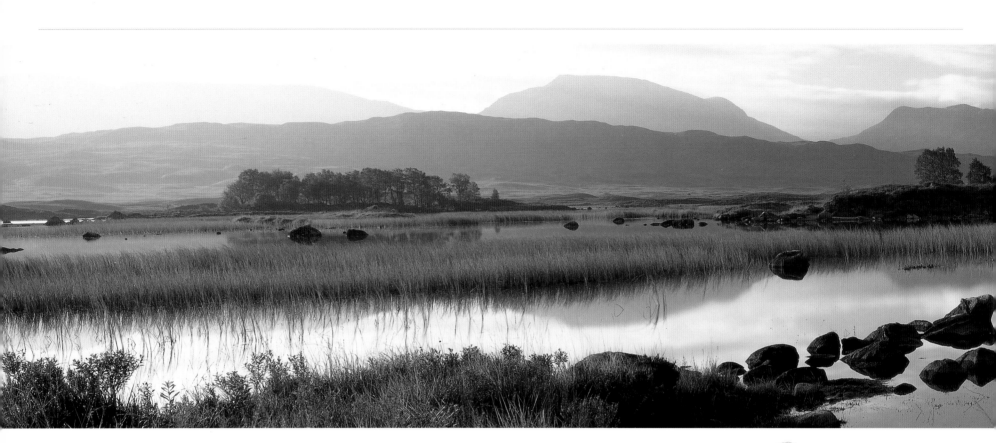

However, many processing labs now offer an additional service of scanning the images and copying them onto a CD. Doing this can save a lot of time and means that you end up with a consistent set of scans to work with, even if you don't have your own scanner – though the quality of scans does vary from lab to lab.

In terms of software, there are numerous packages available that are specifically designed to create pano-ramas: PhotoVista, Panorama Maker, Picture Publisher, PanaVue Image Assembler, and Panorama Factory are all popular examples, and demo versions can usually be downloaded from the Internet for free trials. If you have a digital camera, you may find that it came packaged with some sort of stitching software. Failing that, you can always rely on Photoshop, which just about every photographer involved in digital imaging will already have loaded onto their computer.

For the step-by-step guide to creating a digital panorama in this chapter, we used the latest version of Photoshop – CS. Earlier versions are also suitable, including Photoshop Elements, which comes bundled with many scanners and digital cameras and has a very easy-to-follow tool called Photomerge that allows you to join images quickly and seamlessly.

TAKING THE PICTURES
Planning is the key to success when it comes to creating digital panoramas, and that starts before you even press the camera's shutter.

1: LEVELLING THE CAMERA
First, you need to find a suitable viewpoint over the scene you intend to photograph so that your view is uninter-rupted. Next, you need to set up your camera so that it's

◁ Levelling bases that fit between the tripod head and legs can be purchased and help you to keep the camera level even when the tripod is set up on uneven ground.

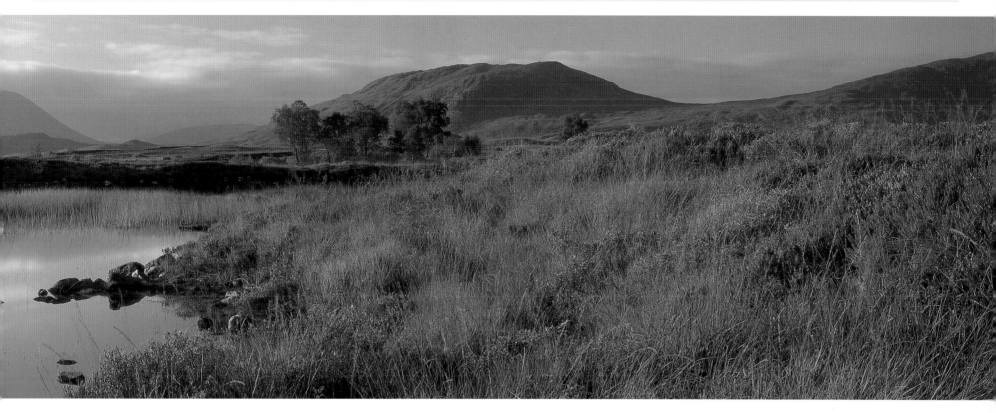

perfectly level, and remains so as you rotate it and take individual shots. It is possible to shoot sequences of pictures with the camera handheld, but there's a danger that the camera won't remain level so you may have to crop quite a lot off the top and bottom of the final panoramic joiner to level it up.

Initially, set up the tripod without the camera on it and use spirit levels to make sure the head is perfectly level in all directions. This might sound easy, but it's actually quite a tricky task. Often you will find that, even though you think the head is level, the level changes as you rotate it.

Some tripod manufacturers make special levelling bases and heads that use a ball-and-socket arrangement and a bull's-eye bubble. These allow you to level the camera even when your tripod is set up on uneven ground. The Manfrotto 554 Levelling Column works well, as does the Gitzo 1321 Levelling Base. If you intend to create digital panoramas on a regular basis, it might be a good idea to invest in a levelling base, as it will help to make your life easier. If you experience problems when levelling your camera, use a wider lens than you initially intended so that you have some room for error. If the images aren't perfectly aligned once you stitch them together, you can trim the top, bottom and sides to correct this, without losing any important subject matter.

△ **LOCH BA, RANNOCH MOOR, HIGHLANDS, SCOTLAND**
Here's a good example of the sort of results you can expect if you stitch images together digitally. I took a series of six frames, overlapping each one by at least 20 per cent, and then carefully merged them in Photoshop. The great benefit of creating joiners digitally is that you can work on the joins until they are invisible. Any mistakes made along the way can be rectified so that the final image is as convincing as one made using a single exposure on one piece of film.

Camera Nikon F5 Lens 50mm Film Fujichrome Sensia II 100

2: EXPOSURE

Exposure consistency from one frame to the next is important if the images are to be combined successfully. You can correct small differences digitally, but it's better to get it right at the taking stage. To do that, set your camera to manual exposure mode and give each frame the same exposure. If you work in an automatic mode such as aperture priority, the exposure may change each time the camera's position is altered, and this can lead to inconsistency from one frame to the next.

3: FILTERS

It's common to use a polarizing filter for landscape photography, but when shooting for digital panoramas you must take care because the wide angle you cover will almost certainly show uneven polarization across the sky. This can be corrected digitally if you have the knowledge, but it's easier to darken and saturate the whole sky digitally if it's evenly exposed, rather than trying to even out the exposure and colour saturation of one area so it matches the rest.

▽ **OIA, SANTORINI, GREEK ISLANDS**

These photographs give you an idea of how much you need to overlap each shot when you are producing a sequence of images to stitch together digitally. Notice how I have used key features in the scene, such as the windmill, as reference points for the overlapping.

Camera Nikon F90x Lens 50mm Film Fujichrome Velvia 50

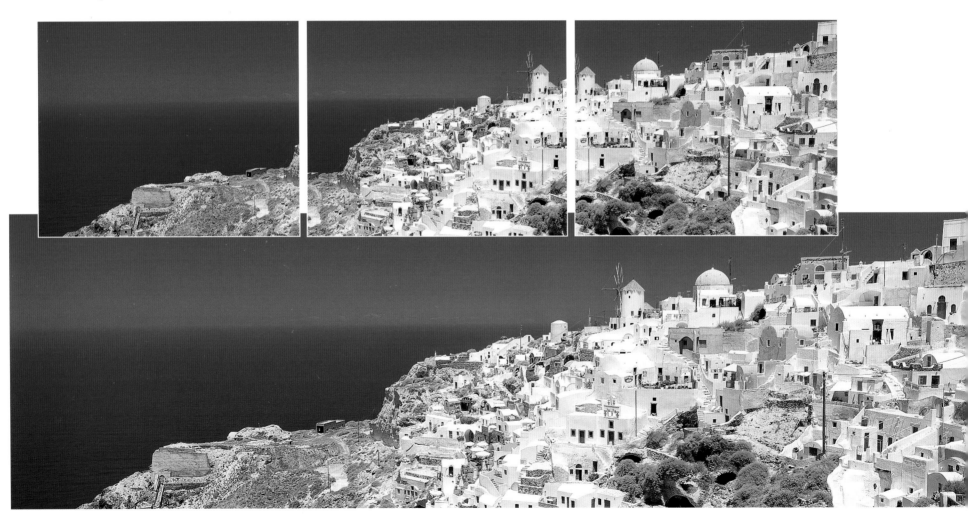

4: OVERLAPPING

When you take them, overlap each picture by at least 15 per cent, as I did for the set of prints opposite, taking note of reference points in the scene so that you can judge the overlap. This makes it easier to blend the images digitally.

5: SCANNING

Leave your processed film uncut. When cutting the film, make sure that the photographs that you wish to stitch together are all on the same strip. Use a filmstrip holder if your scanner has one. Use the same scanner settings for all of the frames so that they are scanned identically. For maximum quality, scan the frames at the maximum bit depth and resolution that your scanner will allow. Be warned that you will need lots of RAM on your computer if you do this – at least 500Mb – as the final image size will be huge (100Mb+).

6: DIGITAL CAPTURE

If you use a digital camera to take the pictures of a panorama, ideally shoot them as RAW files. This allows the option to convert the RAW files at maximum bit depth, which is 16 bit. When developing your RAW files in your preferred RAW file-converting software, make sure that the same settings are applied for all of the photographs that will make up your stitched panorama to ensure consistency.

STITCHING THE IMAGES TOGETHER
Okay, so you have a series of images loaded into your computer and ready to stitch together. Before opening these image files, it's sensible to number them from the left by renaming them so you know the order in which they need to be worked on. Once you've done that, stitching can commence.

▽ STEP 1

Open the files in Photoshop and determine their dimensions under Image > Image Size. Create a new document in RGB with a bit depth appropriate to your images, and large enough to accommodate them all once combined.

It's better to make the canvas longer and deeper than you need so that the images can be slid around easily using the move tool ▶⊹. Once the panorama is complete, you can crop it. Alternatively, click on the left-most image to be stitched and increase the canvas size, as shown below. Note how the anchor point position has been set in the dialogue box. If you use this method, the left-most image becomes incorporated into the background and its relative position cannot be changed.

▽ STEP 2

The next step is to select the move tool and drag and drop the source images in order into the new document or extended canvas that you have created, as shown below. You can now close down the source images as you no longer need them, and closing them will free up valuable memory.

▽ STEP 3

Go to the layers palette and make the layer containing the second of your images active by clicking on it. Reduce the master opacity of this layer by 50 per cent using the drop-down slider control (as shown below). By reducing the opacity of this layer, it is much easier to see the alignment points between the two images, as shown in the example for step 4, opposite. Make all the layers above this invisible by clicking off the eye icon in the left-hand box (see layer 4 in this example).

▽ STEP 4

Select the move tool and align the two images as best as you can at this stage without taking too much time over it. When you are close to alignment, you can use the arrow keys on the keyboard to nudge the upper image in the layer stack by one pixel at a time – a very handy tool for fine tuning. In the example that follows you can see the two images as well aligned as I could make them. The ghosting that you can see is probably due to some barrel or pincushion distortion in the lens that was used to take the original pictures. Fortunately, we do not have to worry too much about this, as the degree of alignment is certainly enough to allow blending of the images using layer masks.

Occasionally, you will need to use the transform tools. These can be applied to the whole or a part of a layer to achieve better alignment. Lock the position of each of

the image layers in relation to each other by activating the appropriate tool ✛ at the top of the layer palette, as you can see in step 6. This prevents inadvertently misaligning the images if the move tool is used again. Having achieved satisfactory alignment, return the master opacity of all layers back to 100 per cent before proceeding to the next step.

▽ STEP 5

Now you need to add layer masks and paint on the masks to reveal and blend with a lower overlapping image. In this example, I added layer masks to layers 3 and 4 using the add layer mask tool ◻ at the bottom of the layers palette. The default setting is to 'reveal all', i.e. to reveal (as opposed to hide) the entire layer on which the mask is created. I find it best to paint away the edge of an overlapping image to create an invisible blend

because this is where the lens that was used to create it will have recorded the lowest resolution and where light fall-off may cause problems with the blending process, particularly in areas of continuous tone. The first step is to identify a join between two overlapping images, as below.

▽ STEP 6

Add a layer mask to layer 3 and select a soft-edged brush. Make sure your foreground colour is set to black and that the layer mask is active by clicking on it. Paint onto the layer mask to reveal the layer beneath and try to make a join that is invisible. It is often easiest to make your blends coincide with an abrupt change in tone or contour, so that it is hidden – along the edge of a river or rock formation, for example, or up the side of a large building.

▽ STEP 7

Use the square bracket keys on the keyboard to interactively change the brush size as you paint. If you make a mistake, simply exchange your foreground colours so that white becomes the foreground and paint away the error. You can also vary the opacity of the brush in the layers palette from solid black (100 per cent) through variable grey to pure white (0 per cent), making it easy to blend areas where there are abrupt changes

of tone. You can also paint on the layer mask using the gradient tool ◼. This is particularly useful where there are abrupt changes of tone in a large area of what should be relatively continuous tone, such as a blue sky.

▽ STEP 8

A simple way to monitor the progress of the blending process is to open the layer mask itself and look at the areas that you have painted. This will help to guide you to look at areas that have not yet been satisfactorily blended. The layer mask channel is opened by alt-clicking (Windows) or option-clicking (Mac) the mask thumbnail in the layers palette, as shown below.

▽ STEP 9

Alternatively, you can display the rubylith mask superimposed on top of your images by alt+shift-clicking (Windows) or option+shift-clicking (Mac) the mask thumbnail, as shown below.

STEP 10

Use the zoom tool 🔍 and the pan tool ✋ to magnify and move around your blends until you are completely happy with the end results. The final step in the blending process is to crop off any untidy edges and unwanted canvas using the crop tool 🔲.

STEP 11

Having blended your stitched panorama, save it as a Photoshop PSD file, which is losslessly compressed. Then archive this file. You can then always go back and re-edit it using the steps above.

One thing that you will probably notice is that although your blends look fine on a monitor screen, when they are subjected to close scrutiny on large prints, you may find that there are blends that require further work to make them completely invisible – this is something you can go back to. It may take two or three revisits until you are completely happy with the final image, but it's worth the

effort as the results can look stunning – certainly a match for any purpose-made camera.

Having archived this stage in the process, flatten the image using the flatten command in the layers palette and edit the panorama as you would any other photograph with tonal and colour corrections, dust removal and noise/grain reduction. Finally, reduce the bit depth to 8 bit and sharpen, depending on the intended output device.

▽ **THE DADES VALLEY, MOROCCO**

Here is the final image, of The Dades Valley in Morocco. The source images for the joiner were shot digitally using a Canon EOS 1Ds.

Camera Canon EOS 1Ds Lens 70–200mm zoom

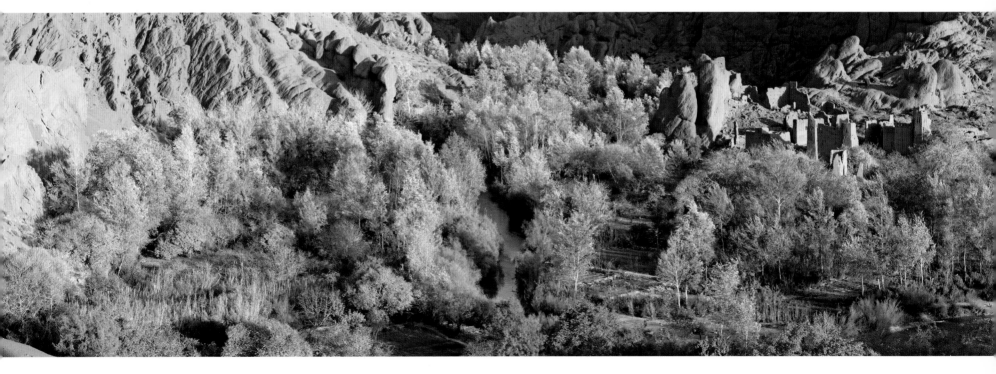

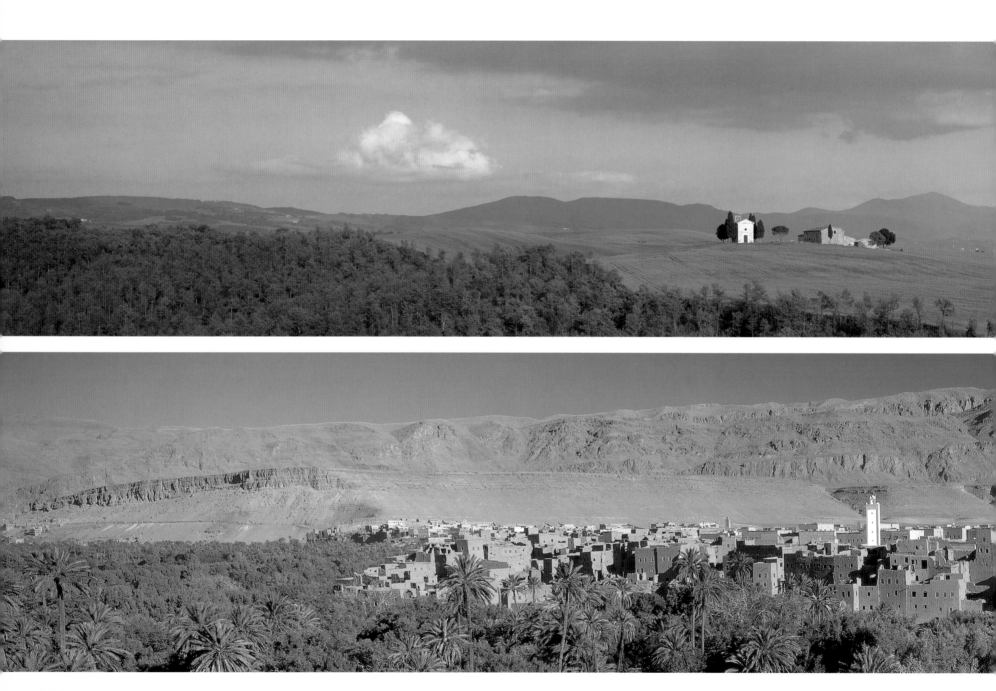

◁ CAPELLA DE VITALETA, TUSCANY, ITALY

This tiny church stands in the heart of the Tuscan countryside near San Quirico d'Orcia. As it's so far away, the majority of photographers use a long lens for their shots. I think this approach fails to show the building in its environment, so I decided to produce a panoramic joiner that did. I shot a sequence of six 35mm images that I stitched together in Photoshop. A great benefit of using this technique is that you can create images that are unique.

Camera Nikon F90x Lens 80–200mm zoom Film Fujichrome Velvia 50

▽ TINERHIR, MOROCCO

Any scene with interesting subject matter running horizontally will make an ideal digital joiner. In this case, it was the old desert town sandwiched between palm trees and mountains that caught my attention, while the white minaret standing high above the rooftops makes a natural focal point. I took a sequence of six photographs, this time on colour print film. I had the whole film scanned by the processing lab to save me the bother of scanning each frame. Joining the images was tricky in places because of the high level of detail in the buildings, but by enlarging the images to fill my computer monitor I was able to make sure they blended smoothly and that no joins were obvious.

Camera Nikon F90x Lens 80–200mm zoom Film Fujichrome Sensia II 100

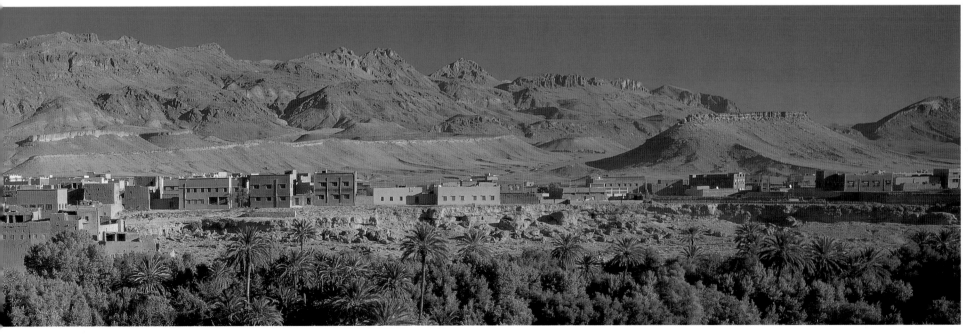

PRESENTING PANORAMICS

Okay, so you're starting to put together a collection of first-class panoramics. But what do you do next? Do you leave them to gather dust in a box or drawer somewhere, or do you show your work off to the world?

I would like to think that you would go for the latter option, because there's no point in producing works of art if you are the only person who ever sees them. Photography is a visual medium that should be shared with others. It's also helpful to get feedback from family, friends, and even complete strangers, just to reaffirm that you're doing a good job – and you can't do that unless you let them see your work.

I don't like to be constantly looking at my own work, and I know a lot of photographers who feel the same way. But I do have a few framed panoramics hanging on the walls of my home and office, and I often give them away as presents to family and friends – something that they greatly appreciate.

So, rather than regarding the taking of a photograph as the end of the process, look upon it as the beginning: think about what you can do with your work to make the effort and expense of producing it worthwhile. There are also practical considerations that you need to make once you start shooting panoramics.

FILM PROCESSING AND PRINTING

I am often asked whether it is necessary to inform the processing lab that you have exposed the film in a panoramic camera when handing it to them for processing. My answer to that is, it depends. If you shoot colour negative film, I would say yes; if you shoot colour transparency film, no. Here's why.

Automated mini-labs like those you find on every high street are unlikely to recognize the fact that you have used, say, a Hasselblad XPan camera, and there's a danger that the film may be cut as if you had shot the film in a 35mm camera, with the result that some frames will be sliced through the middle and ruined.

If you are serious enough about your photography to buy a panoramic camera, it is highly unlikely that you will send your precious films off to a high street lab anyway, but no matter which lab you use to process and print your negative film, it is important to let them know that it has been exposed in a panoramic camera, just to be on the safe side.

Some labs offer a panoramic processing and printing service, intended mainly for Hasselblad XPan users, where the film is developed and a print is made from each frame in a size of your choosing. This service is expensive though – especially if you tend to take several shots of the same subject or scene. A more cost-effective alternative is to have the film processed and a contact sheet made from it, so you can identify which frames you would like to have printed, then order the enlargements separately.

If you shoot colour transparency (slide) film, life is a bit easier because the processed film is the final product, and all the labs, in my experience, cut the films into strips by hand, so there's no danger of mistakes being made with panoramics. I never tell my processing lab that I have used a panoramic camera, and often I hand them a batch of film that has been shot in three or four different cameras and in different formats. It makes no difference to them, and I have never lost a shot through lab error.

If you are thinking about having enlargements made from your favourite panoramic negatives or prints, it is

Lucignano d'Asso, Tuscany, May 2004

well worth spending some extra money on hand prints and choosing your printer carefully – speak to other photographers to find out who they recommend if you're not sure who to use.

Prints from colour transparencies are made on special reversal papers such as Ilford Ilfochrome or Fujicolor

Crystal Archive. The results can look stunning, though more sophisticated processes are now available, such as LightJet prints, where the film original is scanned to a very high resolution and prints output onto special paper. Only a few labs offer this process. The results look stunning, but at a price.

△ **LUCIGNANO D'ASSO, TUSCANY, ITALY**
Panoramics are at their most impressive when enlarged to a decent size and neatly window-mounted behind white or off-white archival board. The quality that is possible, especially with rollfilm formats such as 6x17cm, is stunning. In the original print of the photograph reproduced here, the finest details are clearly recorded. Once they are mounted, I like to hand title and sign my prints, just to add something of a personal touch. Photographs presented in this way make ideal gifts for family and friends.

Camera Fuji GX617 Lens 300mm Filter Polarizer Film Fujichrome Velvia 50

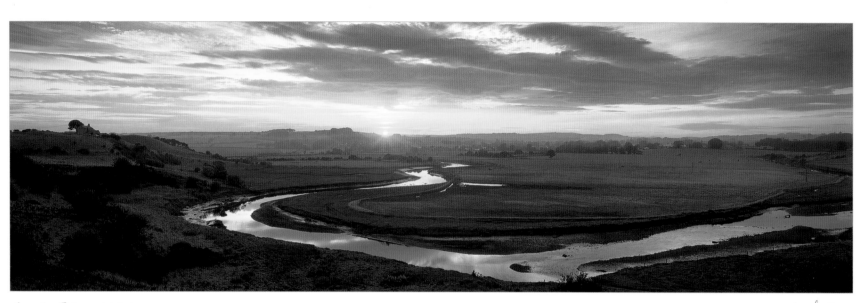

River Aln, Foxton, October, 2002

SCANNING AND PRINTING PANORAMICS

With the advent of digital technology, scanning a panoramic negative or transparency into your computer then outputting an inkjet print is relatively easy. The cost is a fraction of that of a hand print, but the quality can be just as high – and you have control to enhance and tweak the image as you like before making the final print.

My knowledge of digital imaging is fairly limited. However, I have no problems with scanning images shot using my XPan or Fuji GX617 and outputting high-quality inkjet prints. For this I use a Microtek ScanMaker 8700 A4 flatbed scanner, which allows me to scan all the film formats I work in. A dedicated film scanner that could handle formats up to 6x17cm would cost several times more than the Microtek, but would not really offer any great benefits – there is a limit to how much quality you need when you're outputting prints for the wall. If you only shoot panoramics on 35mm film, you will need a medi-

um-format film scanner that can take images up to 70mm (2¾in) long, though these models are very expensive compared to a high-quality flatbed scanner.

To print the images, I use an Epson Stylus Photo 1290. This is capable of outputting prints up to 32x47cm (13x19in/A3+) on sheets, though it will also handle rolls of paper up to 32cm (13in) wide, allowing me to generate panoramic prints that measure a whopping 32x62cm (13x37in) from a 6x17cm original – or bigger if I cropped the image along the length to increase the aspect ratio.

My computer is an Apple Mac G4 with 1Gb of RAM. I use Photoshop 7.0 as my editing software, plus Silverfast V scanning software.

When I scan a negative or transparency, I usually set the scanner to a resolution of 300ppi (pixels per inch) and an output size bigger than what I expect to need – usually something in the region of 30cm (12in) high times whatever width the scanner automatically sets

△ **RIVER ALN, FOXTON, NORTHUMBERLAND, ENGLAND**

Although I have little experience of digital imaging – and what I do know has been learned through trial and error and making lots of mistakes – I do enjoy scanning panoramics and outputting inkjet prints. The quality possible today with a moderately priced scanner and printer is amazing.

Camera Fuji GX617 Lens 180mm Filters 0.9 ND hard grad and 81B warm-up Film Fujichrome Velvia 50

based on the format of the original. An alternative scanning technique is to select the highest resolution that the scanner is capable of and scan at 100 per cent of the image size – although with 6x17cm this generates a huge file, in excess of 100Mb. To output prints, I set the printer resolution to 300dpi (dots per inch), though anything over 200dpi will be sufficient.

PRINTING BLACK AND WHITE PANORAMICS

Although the vast majority of the panoramics that I shoot are taken on colour film, I enjoy working in black and white and get a great deal of satisfaction from making hand prints in my darkroom. In fact, the initial reason why I invested in a Hasselblad XPan was so that I could shoot black and white panoramics and print them on a medium-format enlarger.

To print the 24x65mm images from the XPan, I use a Durst M670k colour enlarger fitted with a Rodenstock 80mm lens. There are no purpose-made panoramic masks for the negative carrier, but these are easily fashioned from pieces of black card. I made a set that is slightly bigger than the image area of an XPan negative so I can print full-frame and use the film rebates to create a black border around the printed image.

If you want to print 6x12cm negatives, you will need a 5x4in enlarger and a 150mm lens. If you scour the

◁ Some professional labs offer special package deals for users of 35mm panoramic cameras such as the Hasselblad XPan.

secondhand market, it's possible to find old 5x4in enlargers for sale at surprisingly low prices, and providing you fit a decent-quality lens, even the most primitive model can produce great results. The biggest problem with large-format enlargers is that they are physically very large and take up a lot of space.

There are many commercial labs around that will make high-quality hand prints to your instructions from black and white negatives, but for me the most enjoyable aspect of black and white photography is the printing, so I would much rather do the job myself. If you do your own printing, you can make subtle changes to the image, employ creative techniques such as lith printing, and experiment with toning; most of my prints are partially bleached and sepia-toned to add subtle warmth.

Prague, October 2003

◁ **OLD TOWN SQUARE, PRAGUE, CZECH REPUBLIC**
The weather was appalling for most of this trip to Prague, so I ended up shooting more black and white panoramics than colour. I find that dull days are ideal for black and white: the soft light and low contrast allows me to record maximum detail on the negative, then decide how much of it I want to reveal once I'm in the darkroom.

Camera Hasselblad XPan
Lens 30mm Filter 0.45 centre
ND Film Ilford HP5 Plus

MOUNTING AND STORING PANORAMIC FILM

The unusual shape and size of panoramic images can make storage a bit of a problem, though it's an easy one to overcome. If you mainly shoot negatives, whether they are colour or black and white, you can place the cut strips of film in archival sleeves, and these can either be stored in ringbinder folders or, as your collection grows over time, in filing cabinets.

For colour transparencies, I mount each frame in individual black card masks, which I purchase from a company in England called Javarette (see page 142). The masks for XPan-size transparencies measure 150x100mm (5x4in) while the masks for 6x12cm and 6x17cm measure 210x100mm (8x4in). Each mask slips into its own archival polyester sleeve with a clear front and frosted back.

These masks not only protect the transparencies, but help to show the images off at their best when they are placed on a lightbox. There's also space on each mask for address and caption labels, which are vital when photographs are sent away for publication.

To store the individual transparencies, I use one of two systems. Images shot on 35mm film and mounted in 150x100mm (5x4in) masks are held four to a sheet and the sheets are stored in filing cabinets. Panoramics

△ Black card masks and clear sleeves provide the most effective means of protecting and presenting panoramic transparencies. Here, 6x17cm, 6x12cm and 24x65mm XPan images are shown.

shot on rollfilm (6x12cm and 6x17cm) are stored in small steel filing cabinets and categorized according to location – one drawer holds panoramics from Morocco, another from Italy and so on. Where I have many pictures from a specific region, such as Northumberland in England, a drawer is assigned for that region alone.

PRINT STORAGE AND PRESENTATION

Making enlargements of your favourite panoramics is a worthwhile pursuit, but only if you do something with those prints. Hiding them away in tatty old boxes serves no purpose, other than to use up yet more of your time and money.

The starting point for me is to window-mount selected prints using archival board. I prefer window mounting to surface mounting because it looks more effective, and I use white archival board to create a crisp, neutral border that shows off the image to great effect.

You can pay a professional framer to mount your prints, but you will save money in the longer term if you do the job yourself. For me, it also adds to the enjoyment and satisfaction – I took the photograph, made the print, and cut the mount.

Mounting board is readily available from artists' supply stores or specialist photographic retailers such as Silverprint, and there are numerous cutting devices available so you can prepare your own bevel-edged mounts.

I favour the Fletcher Mat Mate (available from Priory Framing). It's not the cheapest cutter available, but it allows me to produce high-quality mounts quickly and easily. It even comes with an instructional video that shows

△ The easiest and cheapest way to store panoramic negatives is in glassine sheets. They can then be placed in ringbinder folders or filing cabinets.

△ I store my mounted 6x17cm panoramic transparencies in shallow steel drawers. Each drawer can store more than 200 images.

△ Panoramic prints look stunning when window-mounted behind white card and hand titled and signed. I then store my mounted prints in archival polyester sleeves for protection.

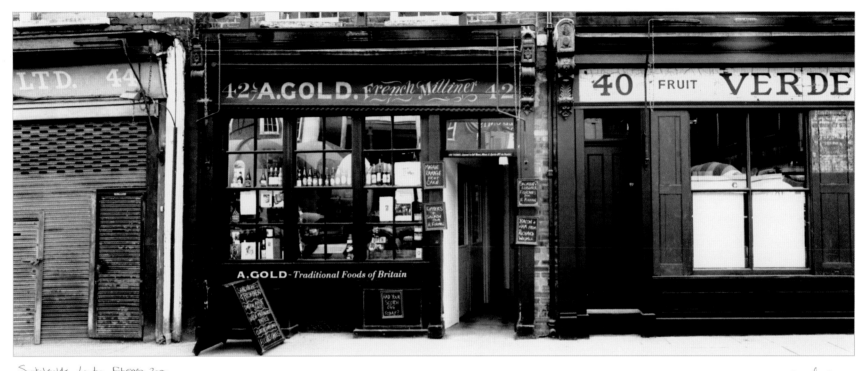

Spitalfields, London, February 2004

you how the device works. It can be used not only to cut single and double mounts, but circular mounts as well if you're feeling particularly adventurous. I can also recommend the Mountmaster, which I used successfully for a number of years, and the Longridge Duo Plus cutter.

For general use, I tend to make prints of around 12x30cm (5x15in) and window-mount them behind 40x50cm (16x20in) board. The mounted print is then slipped inside a 40x50cm (16x20in) clear archival sleeve, and the sleeved prints are stored in black clamshell-type portfolio boxes, which are constructed from archival materials. I purchase the sleeves and boxes from Silverprint in London. They're not cheap, but the overall effect is very polished and professional, and I like to show off my best work as well as I can. I get a great deal of enjoyment from opening up one of the boxes every now and then and looking through the prints, which all remain archivally safe and pristine.

△ **SPITALFIELDS, LONDON, ENGLAND**

I photographed this row of old shops in one of the most historic parts of London. Despite being surrounded by high-tech development, they have been well preserved and offer a glimpse of what the city was like two or three centuries ago. To add to the nostalgic feel, the print was bleached and sepia-toned before being window-mounted.

Camera Hasselblad XPan **Lens** 45mm **Film** Ilford HP5 Plus

▽ **RIVER ALN, ALNWICK, NORTHUMBERLAND**

When I'm choosing which of my panoramic prints to frame and hang on my wall, I tend to give preference to local scenes; not only are they more topical, but family and friends visiting my home tend to find them more interesting because they can relate to the where the photos were taken. I also choose images that will suit the decor of my home, which is mostly in muted colours and tones. This is an important consideration when hanging photographs: garish colours often look out of place in family rooms and are perhaps too personal, whereas softer images will complement the overall feel of the room.

Camera Fuji GX617 **Lens** 90mm **Filters** 0.3 centre ND and 81C warm-up **Film** Fujichrome Velvia 50

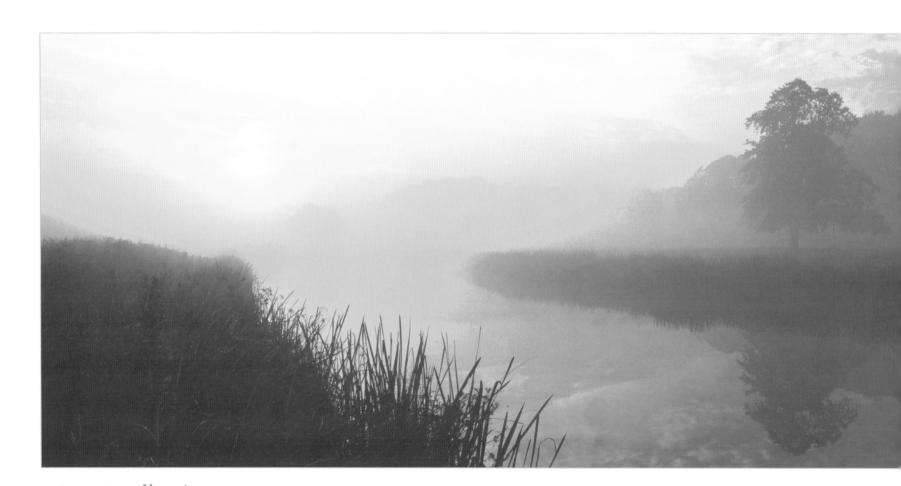

River Aln, Alnwick, October 2003

FRAMING PANORAMICS

Another reason for sticking to a standard-sized mount is that if I'm particularly fond of a print I can always frame it, and it's much easier to do this if the mount I have already cut can go straight into a frame, rather than having to cut another one.

I tend to buy ready-made frames, and I always go for plain designs in natural materials such as oak. Elaborate frames take attention away from the photograph itself, and for me that defeats the object – I want people to look at the photograph, not the frame!

That's not to say you shouldn't be more adventurous. I know of photographers who make huge prints from their panoramics – 40x120cm (16x48in) or bigger – and have frames specially made to accommodate them. This can get very expensive, but a special photograph deserves special treatment. Just make sure you have the wall space to show it off!

PROJECTING PANORAMICS

Perhaps the best way to view panoramic transparencies is in a darkened room, on a large white screen. Alas, due to their size, even those shot on 35mm film in Hasselblad XPan, Noblex and Horizon cameras require a medium-format projector capable of handling images as wide as 70mm (2¾in). Not only are such projectors quite rare, they are also very expensive.

△ I mainly hang framed prints in my office so that when I'm chained to a computer (writing books!) I can be reminded of memorable shoots, and daydream of getting back outdoors with a camera.

I am fortunate to have a rather antiquated contraption that was made many years ago as a one-off by a garden-shed boffin. It doesn't look particularly attractive, and it's big, bulky and noisy, but it does allow me to project panoramics shot on my Hasselblad XPan. If you want to invest in a projector that will do the same, speak to some of the bigger photo retailers such as Robert White, or panoramic specialists such as The Widescreen Centre (see page 142).

Beyond 35mm panoramics, projection becomes impractical. There are 5x4in projectors available that will handle 6x12cm images, but they are even harder to find than medium-format models, while projectors capable of handling 6x17cm originals would have to be specially designed and made.

The cheapest alternative is to make duplicates from the original on 35mm film, so they can be projected using an affordable 35mm model. I have always thought of this route as defeating the object though – what's the point of shooting 6x17cm panoramics, only to copy them onto 35mm film so that the projected image is tiny, only around 12x36mm (½x1½in)?

A more effective and versatile option is to scan your panoramics – which also gives you the option of digitally enhancing them at the same time – then project them via a laptop computer and digital projector. The cost of digital projectors is coming down all the time. They are also much smaller and lighter than conventional projectors, and you can put together customized audio-visual presentations using panoramics that were shot in different formats.

This is something that I am investigating at the moment as it would allow me to show both 35mm and rollfilm panoramics in the same presentation, as well as images that were shot on other film formats.

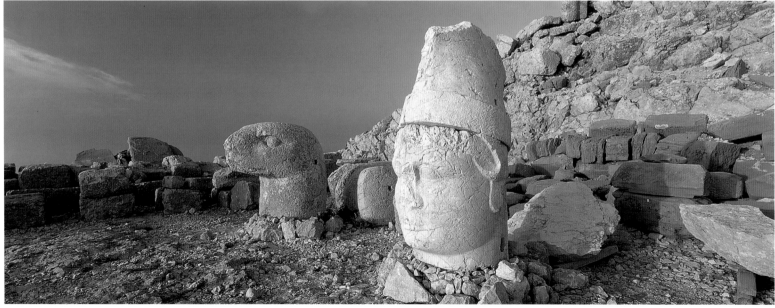

MOUNT NEMRUT, TURKEY
Sometimes, the impact of a photograph can be increased by presenting it as part of a set rather than in isolation. This can be done by framing and hanging the prints as a group, or in the case of audio-visual presentations via a digital projector, showing groups of images on the screen at the same time. These photographs were taken during a morning shoot on Mount Nemrut in Turkey. The summit is home to many carved stone heads that were erected

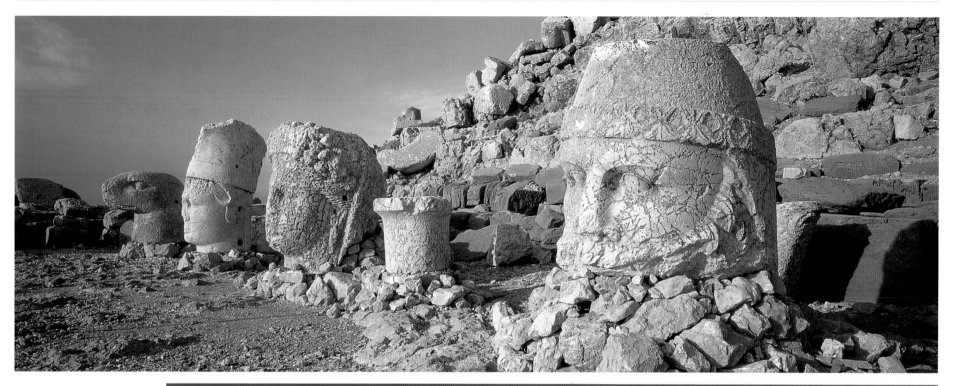

centuries ago by Nemrut Dagi, an ancient local king. It took a 50km (30-mile) drive from my hotel, mostly on a winding mountain road, then a strenuous 20-minute walk to reach the summit, but the magnificent sight of the heads bathed in early morning sunlight made the 3.30am start more than worth it.

Camera Hasselblad XPan
Lens 30mm, 45mm and 90mm
Filters 0.45 centre ND (for 30mm lens) and polarizer Film Fuji-chrome Velvia 50

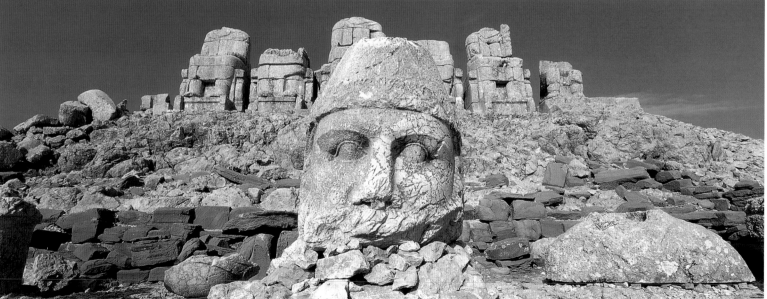

SELLING PANORAMICS

Although I started shooting panoramics for creative satisfaction rather than commercial gain, it's heartening to see that in the last few years, interest in them has increased considerably and I am making a healthy return on my initial investment in expensive equipment.

I supply a variety of picture libraries with stock images, and it's the panoramics that they are most excited about these days, simply because they, and most of the people in the industries that they serve, are constantly looking for ways of pushing back the boundaries of creativity and coming up with fresh material.

The unusual letterbox format is now being used in all areas of publishing because it gives designers the chance to flex their creative muscles and come up with something a little different. As well as books and magazines, panoramics are being used for postcards and calendars, posters and prints, bookmarks, advertising campaigns, mailshots, websites, and so on.

Because panoramic images are considered to be somewhat specialized and more expensive to produce, they also tend to command higher fees than photographs of the same scene in a 'normal' format would. When you then consider that panoramic photographers are in a minority, it soon becomes clear that if you can identify the right markets for your work, either directly or through picture libraries, the financial rewards can be pretty considerable. I'd go as far as saying that my best-selling and biggest-earning photographs at the moment are my panoramic landscape photographs (see page 132).

To give you an idea of the returns possible, and the variety of ways in which panoramics can be used, here are some examples of sales I have made recently.

△ **PANORAMIC CALENDAR**
Here's the cover and some internal pages from the calendar. The reproduction quality is very high and the size was carefully chosen so the end result is big enough to admire, but not so big that's it's unwieldy and expensive.

Camera Fuji GX617 Lens 90mm and 180mm Filters Polarizer, warm-ups and ND grads Film Fujichrome Velvia 50

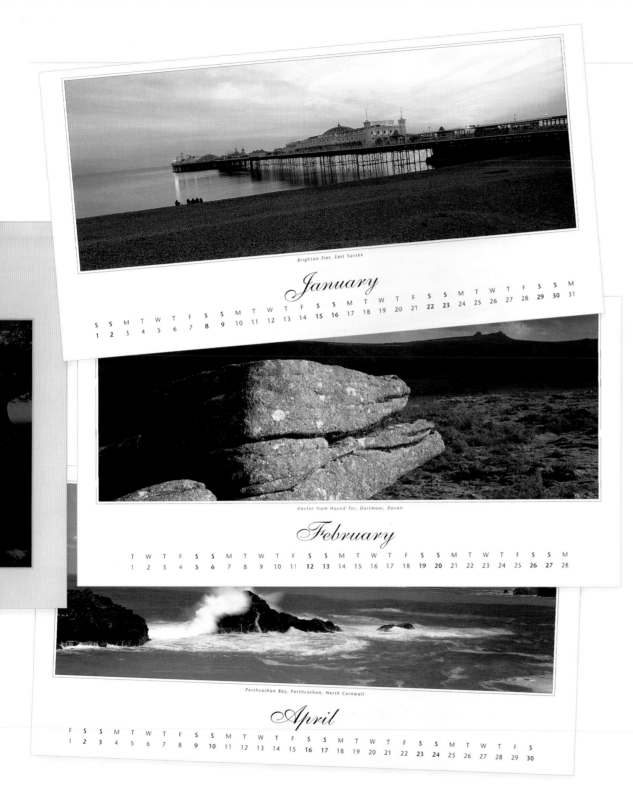

Brighton Pier, East Sussex

January

Havtor from Hound Tor, Dartmoor, Devon

February

Porthcothan Bay, Porthcothan, North Cornwall

April

CASE STUDY 1: ENGLISH PANORAMAS

Project: Retail calendar
Fee: £1,000 (US$1,660)

People who buy calendars want something that they can hang on their wall and admire. They'll be looking at each page for a month, so the images must be inspiring.

This is where panoramics score highly. Just about every household in the developed world has a camera, but only a tiny minority have one capable of taking panoramics. To the average person, therefore, panoramic photographs are exotic and unusual. This means that they're more likely to want to look at them than the usual square or rectangular photographs they see everywhere.

For this reason, panoramic calendars are becoming more popular, and although many calendar publishers are stuck in a time warp and worried about trying anything too creative, those who do are reaping the benefits.

This project came about when I was approached by the publisher to supply images for a calendar featuring English landscapes. As well as sending off a parcel of 6x7cm medium-format transparencies, I also included 20–30 6x17cm panoramics with a note asking if they had considered publishing a panoramic calendar.

The response was positive, and after brief discussions it was decided to produce some dummy pages and see how the idea was accepted at a forthcoming trade fair. My collection of English panoramas isn't huge, as I tend to concentrate on specific areas such as the coast of north Northumberland. However, I came up with a wide enough geographic spread and the project went ahead.

This calendar is an experiment. I accepted a lower fee than would normally be negotiated for such a project, but I was willing to take a gamble with the publishers, on the understanding that if it's a success, the fee will be reviewed in subsequent years.

A worldwide panoramic calendar has also been mentioned, which would be even more exciting, so I am keeping my fingers crossed that sales of the first edition exceed expectations.

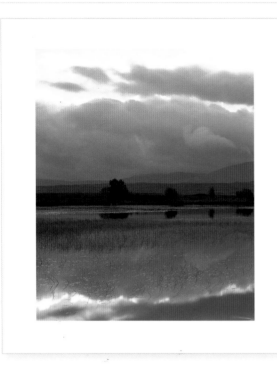

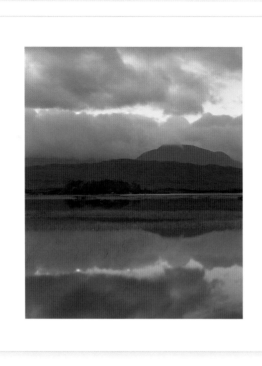

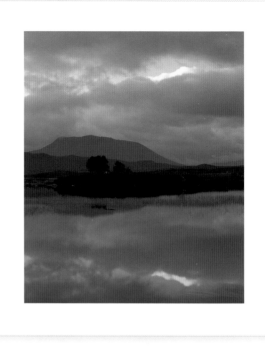

CASE STUDY 2: **LOCH BA, RANNOCH MOOR, SCOTLAND**

Project: Retail poster
Fee: £5,000 (US$8,300) and rising

If you want to make sales, it's important to find new markets for your work. I'm always checking calendars, posters and prints to see if they've been published by a company I've never dealt with before. That's how this sale came about. I was browsing in the print and frame section of a location department store and took a note of the publisher of some prints I'd seen.

A week or two later, I posted a submission of images to this publisher to see if there was anything that would be suitable for their range. Soon after that, I received a telephone call to say that the images had been reviewed and a selection had been scanned for the artists' database to be considered for future use. This kind of response often means that you will never hear from

them again, but to my surprise, some time later I received an email asking for clearance to reproduce the image shown here for a poster.

Several months after that, another email came asking for permission to include this image in a presentation to the same group of department stores – the panoramic would be presented as a triptych; in other words, three separate prints that would be framed and mounted side by side. I wasn't sure how popular this would be, but gave the go-ahead.

After much deliberation, it was selected for the stores' range. In the first three months of sale, over 25,000 copies of the triptych were sold around the world, earning £5,000 (US$8,300) in royalties. It was strange to walk into a branch of the store and not only see my panoramic on sale, but people actually picking it up and buying it! Eventually, this image has become one of my biggest earners. I have since sold more panoramic images to the same clients so the returns from them should be of a similar amount – hopefully more.

△ **LOCH BA, RANNOCH MOOR, HIGHLANDS, SCOTLAND**
The weather wasn't quite what I expected when I drove up onto Rannoch Moor for sunrise, but the steely blues and greys in the sky, which were reflected in the calm waters of the loch, looked attractive, so I decided to take some pictures anyway. It's ironic that a picture I considered to be a consolation prize for getting up early ended up being one of my best sellers!

Camera Fuji GX617 Lens 90mm Filters 0.3 centre ND and 0.45 ND hard grad Film Fujichrome Velvia 50

CASE STUDY 3: **TUSCANY, ITALY**

Project: Retail poster
Fee: £700 (US$1,160) and rising

It was the last day of a location shoot in Tuscany and I had just run out of colour transparency film. The light was still good, so I was annoyed with myself for not being more disciplined earlier in the week so that my film stocks lasted to the very end. Luckily, I still had a couple of 120 rolls of Konica 750 infrared film in my backpack, and as the light was ideal for infrared photography I decided to shoot them.

Some months later, while printing images for my previous book on black and white photography, I made an enlargement of this scene on 16x12in Ilford Multigrade FB paper, cropping it to a panoramic as I preferred the composition. It ended up being in my first submission to this particular publisher, and was the first image to be selected for publication as a poster in their own range. It has since been released as a stretched canvas, and though sales haven't been that great so far, I can't complain – the photograph was only taken as a last resort because I had run out of Velvia, but so far it's the best-selling and best-earning shot from that trip.

▽ **NEAR PIENZA, TUSCANY, ITALY**

This scene is one of the most photographed in the whole of Tuscany, but using infrared film was different enough to make it stand out and be selected for poster publication. It's still selling, all over the world.

Camera Pentax 67 Lens 45mm
Filters Deep red and polarizer
Film Konica 750 infrared

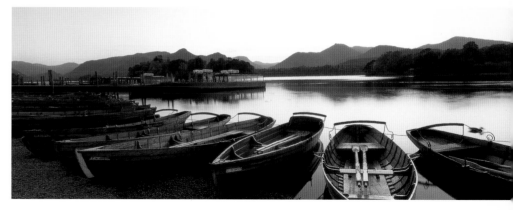

△ **DERWENTWATER, LAKE DISTRICT, ENGLAND**

These two images have been selected for publication as posters. When printed, they will be sold worldwide and each will generate a five-figure sum in royalties. It's no surprise that both panoramics are of the same scene, from the same viewpoint: calm water and boats and jetties photographed at dawn or dusk seem to sell better to the poster market than any other landscape subject. Note that both were also taken using my XPan – proof that 35mm panoramics can be big sellers.

Camera Hasselblad XPan Lens 30mm (colour shot) and 45mm
Filters 0.45 centre ND and 81C warm-up (colour shot)
Film Fujichrome Velvia 50 (colour shot) and Agfapan APX25

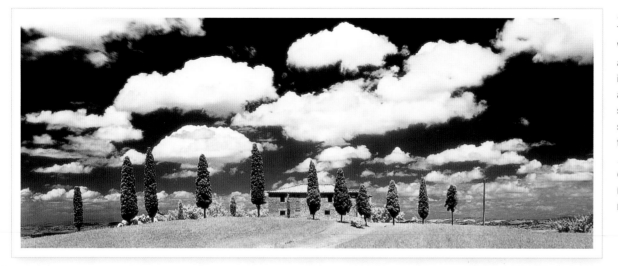

CASE STUDY 4: **NORTHUMBERLAND COAST**

Project: Magazine article
Fee: None

Living in a small village on the coast of north Northumberland, I am lucky enough to have access to some of the most stunning coastal scenery in Britain: places such as Bamburgh Castle, Dunstanburgh Castle, Embleton Bay, Alnwick Castle and Holy Island are all a short drive away, while Alnmouth, where I live, is home to a stunning windswept beach and tranquil estuary. I therefore tend to take more panoramics in this area than anywhere else, and my collection of local images grows bigger every month.

One of the best showcases for photographers in the northeast of England is a glossy magazine called *Living North*, so I decided to submit some of my own work for consideration. I knew that there would be no fee, but I was keen to show my work to a wider audience, and knew that other sales might result from people seeing my images in the magazine. Tourism is big business in the area and photographs of local scenes are used to attract visitors.

The five-page article they ran is shown here. I was really pleased with it, and within a couple of weeks of the magazine being published I was contacted by the Northumbria Tourist Board, asking me to submit panoramics for use in their upcoming Northumbria Visitor's Guide.

WIDE OPEN SPACES

The inspirational beauty of the Northumbrian coastline and countryside inspired professional photographer Lee Frost to relocate to the North East. David Crow learns about the beauty of turning your hobby into a very successful and fulfilling career.

Submitting panoramics to magazines

Every county or region in the UK has its own magazine dealing with the local lifestyle and issues, and many other countries have a similar arrangement, so why not submit some of your own panoramics of local scenes and subjects and see if there is any interest in publishing them. As I discovered, fees tend not to be paid because the publishers regard publication as free advertising for the photographer. I don't entirely agree with their viewpoint, but seeing your work in print can be a great thrill, and you never know what it might lead to.

The great thing about submitting panoramic photographs to such publications is that they will offer a new and refreshing angle on popular scenes, so the chance of your work being published should be increased substantially. The key to success is editing your submission so only the best images are put forward. It is better to send six really top-class panoramics than 24 that are okay but not great. Weak images dilute the impact of strong ones, and as it's rare for a magazine to publish more than half a dozen shots, there's no need for you to send mountains of them in the first place. Enclose a covering letter with the photographs, explaining who you are and why you're submitting them. Give the magazine a couple of weeks to respond rather than chasing them a few days later. There are no guarantees of success, but panoramics always make people sit up and take notice – even magazine editors who look at photographs every day of the week.

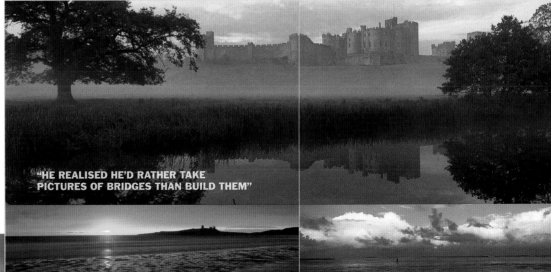

◁▽ NORTHUMBERLAND COAST, ENGLAND

The most spectacular locations on the north Northumberland coast were selected for publication: Dunstanburgh Castle, Aln Estuary at sunset, Berwick-upon-Tweed, Alnwick Castle, Embleton Bay and more. Capturing these scenes in panoramic format gave them a new lease of life.

Camera Fuji GX617 **Lens** 90mm and 180mm **Filters** Polarizer, warm-ups and ND grads **Film** Fujichrome Velvia 50

"HE REALISED HE'D RATHER TAKE PICTURES OF BRIDGES THAN BUILD THEM"

HE HAS TRAVELLED THE WORLD TAKING PHOTOGRAPHS THAT GRACE THE PORTFOLIOS OF MANY IMAGE LIBRARIES

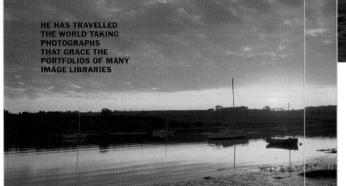

cameras, and he talks in admiring terms about the technical quality of the results they achieve as well as their progress as image takers. For now though, Lee Frost is more than content to stick with his traditional equipment. State-of-the-art it may be, but it is still essentially a piece of film, inside a dark little box with a lens on the front. I prefer to think that secretly he loves the craft of it, the process of it all, the tactile nature of the flimsy celluloid roll, the satisfying little clicks and pops the camera body makes while he's loading and unloading the film cassettes. But maybe that's the romance of some of his pictures getting to me.

If there's a 'magic circle' for landscape photography then Lee certainly isn't a member – in fact he's much more likely to be an 'anti-member', the Penn and Teller of the photographic magic circle – exposing the myths and taking pleasure in doing so. There is no magic to getting a beautiful landscape image

– the mystery is supplied by nature: the right light and the environment. To capture it, you simply need to be technically competent, committed to the occasional early morning and patient. Even if that means returning again and again to the same spot until all the elements are in place – click.

He puts this philosophy into practice regularly with his workshops and holidays. He has travelled the world taking photographs that grace the portfolio of many image libraries, on posters, CD covers and travel brochures, but now he takes guests along too. Enthusiastic amateurs mainly. Many have been on a number of trips and are now considered friends. Morocco, Tuscany and Venice are just some of the exotic destinations for these events. Closer to home, the Northumberland coast and its castles, the North Yorkshire Coast and the Scottish Highlands have provided the subject matter for this intimate groups of photographers.

Don't be fooled by the term holiday though, the most recent trip was in April: two weeks in Namibia, South West Africa, where there were many early mornings, lots of miles trudged and the world's oldest desert to contend with. Whatever the hardships, the chances of capturing some spectacular pictures were good as Lee's fellow travellers found themselves among the highest and most dramatic sand dunes the planet has to offer, in the Quivertree Forest at dusk, among Bushmen on the edge of the Kalahari, or the little deserted mining town that is slowly being gobbled up by the shifting sands of the Namib Desert.

I wondered if all this 'off the beaten track' travel ever presented any danger. After a moment's thought the only thing that he could recall is being "Stood on the edge of a cliff with a force 10 gale blowing, waiting to get a shot, and it wasn't until later that I thought about any danger … there's little danger apart from the isolation of being alone somewhere really really remote." At this

point in his career, Lee has the perfect combination for a happy and fulfilling lifestyle. No longer needing to be constantly globe trotting as a busy freelancer, he can pick and choose his trips to accommodate his family and his writing commitments.

I've always admired people that can identify a moment, carpe diem as they say, people that can separate the wheat from the chaff. Instinct I guess. Lee Frost has an instinct for the right moment to make his move, be it geographically or on the camera shutter. The results speak for themselves.

Right, I'm off to eBay to see if I can get a second hand Hasselblad.

Lee Frost
E-mail: mail@leefrost.demon.co.uk
Web: www.photoadventures.co.uk

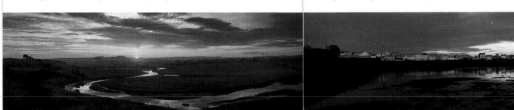

DON'T YOU JUST LOVE IT when you're listening to someone who's genuinely passionate about a subject? When their enthusiasm carries you along at such a speed you get a bit giddy. Lee Frost is a man with this ability. He is a fortunate man. His career has been centred on his personal passions, walking, the great outdoors and his love of photography – a skill that is self taught.

Originally from Yorkshire, Lee first picked up a camera in his teens and immediately fell in love with the whole process. At age 16 his family moved down to Devon. While studying a degree in Civil Engineering, at what was then Plymouth Polytechnic, he had one of those moments, one where you understand you're about to make a life-changing decision. He realised he'd rather take pictures of bridges than build them.

The breaks came thick and fast. In 1988 he entered and won a competition for the now defunct SLR Photography magazine. The prize was a week on location abroad with a professional photographer. Perhaps a little less glamorous than it may first appear, as the shoot was actually an endless list of hotel and

resort shots for a holiday brochure, but the experience was an invaluable one nonetheless and the contacts he made were even more significant.

SLR Photography later employed Lee as a features writer. They too, it seems, were charmed by his enthusiasm and asked him to help launch the new magazine Photo Answers, he then became assistant editor on Practical Photography before being plunged into the uncertain world of freelance photography in 1992. He later returned to Photo Answers as editor. Lee believes it was easier back then to make a living as a freelancer, before the mighty Getty Images and similar image library giants swallowed the more flexible, independent, ones.

He first became aware of the North East 8 years ago when commissioned to take the pictures for a book, "Northumbria", the foreword written by Eric Robson. Sadly this book is out of print now, although there are still some copies about if you look hard enough – Lee noticed one recently in WH Smiths in Alnwick, just in case you were interested! Over a period of several months, Lee and his wife discovered

many glorious locations where he captured the magic of the landscape on transparency. Slowly, it was the Northumbrian coast that charmed them, and two years ago they upped sticks from Peterborough and brought their two small children to Alnmouth.

In addition to the many magazines he has scribed for and edited, Lee is much published as a photographic author in his own right. He has a dozen or so books to his name already, with more in the pipeline. Some are best sellers; "Teach Yourself Photography", "A-Z of Creative Photography" and "Taking Pictures for Profit" are just a few. The latter helps the reader decipher the difference between great pictures and great pictures that you can make a living from.

All his books have a practical edge to them. He is benevolent of the understanding he has discovered over 20 years. There's a certain joy he takes by passing on his experience and seeing others hone their skills and develop. His books are becoming more personal too, his current project being specifically about "panoramic" landscapes – those horizontally long, cinematic,

images – a format that Lee has come to find irresistible. On the downside these broad pictures have a ferocious appetite for film stock, each roll is greedily consumed by only 4 exposures and Lee will openly admit, even he doesn't get it right all the time – some pictures do go straight in the bin, leaving him wondering what on earth possessed him to get up at 4:30am and wait for the sun and mist on that specific shot. Surely the progress in digital photographic techniques could reduce his processing lab bill?

Lee isn't precious or stuffy about using film. For an equivalent digital camera, to match or improve the high technical specification he works to, the cost would simply be too prohibitive (we're talking a 5 figure sum here, for camera body alone) and with something that expensive, would you really want to drag it around a desert for 2 or 3 weeks, waiting for the perfect lighting conditions? I imagine concern for rising insurance premiums might distract you from the moment!

Some of his guests, on the workshops and photographic holidays he organises, do use high quality 35mm digital

135

CASE STUDY 5: **SANTORINI, GREEK ISLANDS**

Project: Retail posters
Fee: £600 (US$1,000)

In June 2003, I took a group of photographers on location to the beautiful Greek Islands of Santorini and Mykonos. I had visited both islands before and knew that they were both stunning, especially Santorini, so before the trip commenced, I spent some time thinking about how I could come up with different images on this trip. One step that I took was to hire a 30mm lens for my Hasselblad XPan, as I felt that the extreme wideangle view might prove to be useful. I also decided that I would experiment with shooting upright panoramics and capture slices of island scene. The cobbled streets, whitewashed houses and deep blue sky of the Greek Islands were ideal for this graphic approach to panoramic photography, and

I was very pleased with many of the results I achieved – largely because they were so striking and different. (See pages 62 and 63 for further examples of this type of panoramic image.)

The question was, how would these unusual images be received commercially? Fortunately, I got my answer just a few weeks after returning from the trip; one of the picture libraries that I regularly supply contacted me to say that an Italian publisher had selected four of my panoramics from Santorini – two portrait format and two landscape – to be reproduced as posters.

All four images had been shot with the 30mm XPan lens I had hired, which prompted me to go out and buy my own immediately. The fact that two of the four were upright panoramics also reassured me that there is a market for alternative panoramic images, and I now make an effort to shoot in the portrait format whenever I encounter a scene that suits it.

(See pages 62 and 63 for further examples of this type of panoramic image.)

Which format sells?

It's a given in the photographic industry that the bigger the film format, the more likely it is to sell. Does that still apply when it comes to panoramics? A 6x17cm original placed on a lightbox next to a 24x65mm XPan image shot on 35mm film is going to look superior. However, the quality of a 35mm panoramic is high enough for it to stand significant reproduction, so don't feel that you must invest in a rollfilm panoramic camera to make sales – a Hasselblad XPan is more than capable, and its versatility allows you to shoot a wider range of subjects than the likes of the Fuji GX617. It's also much smaller and can be used alongside another camera system, whether 35mm or medium-format.

The images reproduced in this chapter were mainly taken with a Fuji GX617, simply because that is my first-choice panoramic camera. However, my 35mm pans do sell. Examples include the Greek Island shots here, and the two photographs of the lake scene on page 133.

▷ **SANTORINI, GREEK ISLANDS**

Just weeks after returning from my trip to the Greek Islands, these four images were chosen by an Italian publisher for use as retail posters.

Camera Hasselblad XPan
Lens 30mm Filters 0.45 centre ND and polarizer Film Fujichrome Velvia 50

LEE FROST • GREECE

CASE STUDY 6: **COTTAGE IN LANDSCAPE**

Project: Picture library sales
Fee: £575 (US$950) to date

This photograph was taken during early experiments with a 5x4in large-format camera fitted with a Horseman 6x12cm rollfilm back. The cottage was just two miles from my home at the time, so one day I decided to drive up to it and ask permission to take some pictures. The tiny, unoccupied cottage was on a farm and obscured by large grain silos, but the owners kept it in a good state of repair, and on a clear, sunny morning it looked stunning against a backdrop of blue sky and green fields. I couldn't have picked a better morning, and spent an hour or so taking pictures in both 5x4in and 6x12cm.

It was a very straightforward scene to capture. I used a little rising front on the camera to correct converging verticals, plus a polarizer to deepen the blue sky and make the whitewashed walls of the cottage really stand out. The scene composed itself really – when positioned anywhere but the dead centre of the frame, the cottage looked odd and awkward.

Some weeks later, I sent the shots away to my picture library and they retained a selection. In the five years since then it has sold three times: for the cover of the property section of a newspaper, for a calendar, and for use on a display panel in a large shopping mall.

▽ **CANARY COTTAGE, NEAR THORNEY, CAMBRIDGESHIRE, ENGLAND**

Quirky scenes like this can be good sellers through picture libraries. It's not often you see a tiny thatched cottage in the middle of a field, and the image could have many different uses.

Camera Walker Titan 5x4in **Lens** 65mm **Filter** Polarizer
Film Fujichrome Velvia 50

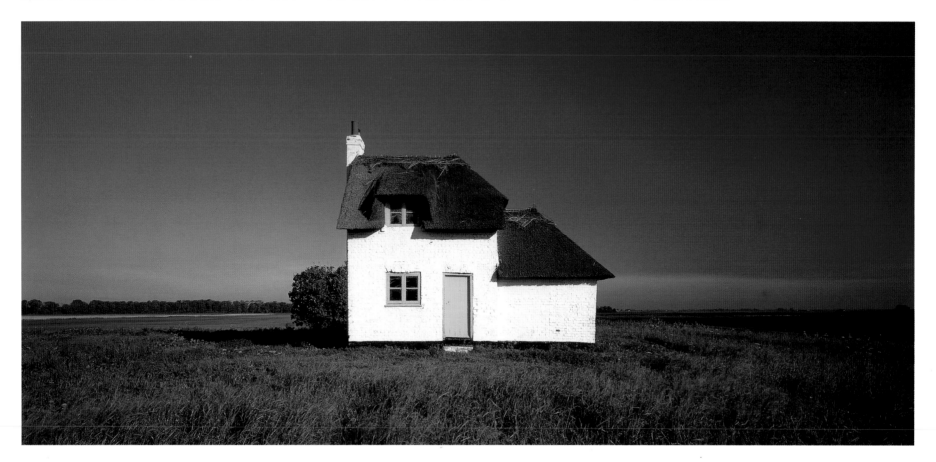

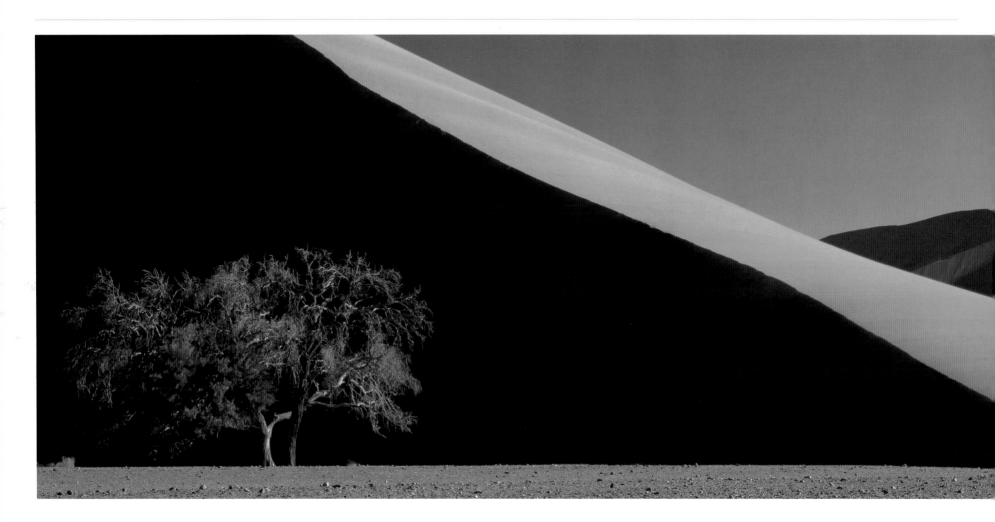

DUNE 45, NAMIB DESERT, NAMIBIA

When I arrived at this dune late one afternoon, I was prevented from shooting the view I had in mind because the ridge was covered in footprints, left by people who had climbed it that morning. Rather than just give up, I decided to look around for a different angle. That's when I discovered this view, with the side of the dune in shadow but the single tree and a thin strip of orange sand in full sun. I was attracted to the graphic interplay of shapes and colours, and realized that this was a better shot than the one I had intended taking – which just goes to show that you should always look beyond the obvious.

Camera Fuji GX617 **Lens** 180mm **Filter** Polarizer **Film** Fujichrome Velvia 50

ISTANBUL, TURKEY

This is the Ayasofya mosque at sunrise, shot from the roof terrace of the hotel I was staying in. We were taking an early flight that morning and my tripod was packed away in a suitcase. Fortunately, there was a low wall around the terrace where, with the help of lens caps and other bits and pieces acting as levellers and wedges, I was able to set up my camera and keep it still during a two-second exposure. Shots of famous views like this tend to sell well because they summarize the atmosphere of a location in a single image and immediately identify the place.

Camera Fuji GX617 Lens 180mm Film Fujichrome Velvia 50

USEFUL CONTACTS

The Internet makes it easy to research panoramic cameras and buy equipment online from dealers not only in your own country, but anywhere in the world. Auction websites such as eBay also make it possible to track down specialized items of equipment or pick up bargains.

The world of panoramic photography is still a small one, but if you explore search engines such as Yahoo.com, it's surprising how many links you will find for manufacturers of equipment and computer software, retailers, organizations and groups and individual photographers, all of which can provide you with a valuable source of advice and inspiration.

To get you started, here are some of the most popular names to watch out for, along with their web addresses so you can check out what they have to offer online. Happy surfing!

PANORAMIC CAMERA MANUFACTURERS

Art Panorama, see www.robertwhite.co.uk
Eyescan, see www.kst-dresden.de
Fotoman, see www.fotomancamera.com
Fuji Film USA www.fujifilm.com
Fuji Photo Film UK Ltd www.fujifilm.co.uk
Gilde www.gilde-kamera.de
Globuscope www.everent.com/globus
Hasselblad Xpan www.xpan.com
Horseman www.horsemanusa.com
Hulcherama www.hulchercamera.com
Linhof www.linhof.de
Lookaround http://panoramacamera.us
Lotus www.lotusviewcamera.at
Mottweiler www.mottweilerstudio.com

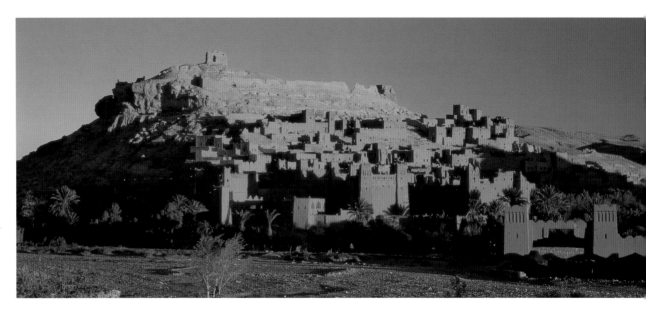

△ **AIT BENHADDOU, MOROCCO**
This kasbah near Ouarzazate is one of the most spectacular in North Africa. It has featured in numerous Hollywood epics including *Jesus of Nazareth* and *Gladiator* and is also a UNESCO World Heritage Site. I have visited the village several times, but it never fails to impress me, especially at first light, when the rising sun makes the fortified houses glow orange.

Camera Hasselblad XPan **Lens** 90mm **Filters** Polarizer and 81B warm-up **Film** Fuji Velvia 50

▷ **SAHARA DESERT, MOROCCO**
One of the camel guides who accompanies us in the Sahara is this man, Ali. He's a veteran of several of my Moroccan Photo Adventures and has become a keen and able model over the years. On this occasion, I asked him to lead three of his camels into position so we could photograph them against the vivid orange dune and deep blue sky.

Camera Hasselblad XPan **Lens** 90mm **Filter** Polarizer **Film** Fuji Velvia 50

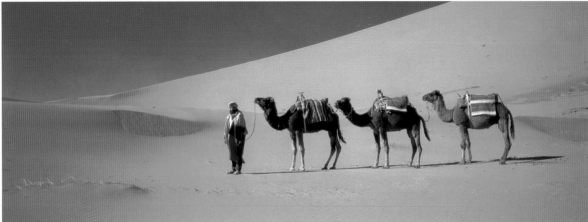

△ **TIZI 'N TICHKA PASS, MOROCCO**

The drive from Marrakech south to Ait Benhaddou (see page 140) involves crossing this spectacular mountain pass. It's strange to see snow-capped mountains, then a day or two later be riding camels into the Sahara Desert! All along the winding road up and through the pass are stalls and small shops selling fossils – though none command such an amazing position as this one, near the summit.

Camera Hasselblad XPan Lens 90mm Filter Polarizer Film Fuji Velvia 50

Noblex www.kamera-werk-dresden.de
Panoscan www.panoscan.com/
Spheron Panocam www.spheron.com
Seitz Roundshot www.roundshot.ch
Walker www.walkercameras.com
Widepan (panflex), see www.widescreen-centre.co.uk

LARGE-FORMAT CAMERA MANUFACTURERS
Canham www.canhamcameras.com
Ebony www.ebonycamera.com
Gandolfi www.gandolficameras.com
Horseman www.horsemanusa.com
Linhof www.linhof.de/english
Lotus www.lotusviewcamera.at
Silvestri www.bromwellmarketing.com/silvestri.htm
Sinar www.sinar.ch
Walker www.walkercameras.com
Wista www.wista.co.jp/e_wista/english.htm

PANORAMIC EQUIPMENT RETAILERS
Adorama www.adorama.com
Advantica www.advantica.com
B&H Photo Video www.bhphotovideo.com
Calumet Photographic www.calumetphoto.com
Linhof & Studio Ltd www.linhofstudio.com
Robert White www.robertwhite.co.uk

Teamwork www.teamworkphoto.com
The View Camera Store Inc www.viewcamerastore.com
Walker www.walkercameras.com
Widescreen Centre www.widescreen-centre.co.uk

FILTERS
B+W www.schneiderkreuznach.com
Cokin www.cokin.fr
Heliopan www.heliopan.de
Hitech www.formatt.co.uk
Lee Filters www.leefilters.com
Singh Ray www.singhray.com
Tiffen www.tiffen.com

ACCESSORIES
Canham (6x17cm back) www.canhamcameras.com
Gitzo (tripods and heads) www.gitzo.com
Horseman (rollfilm backs,) see www.robertwhite.co.uk
Mamiya (panoramic insert) www.mamiya.co.uk
Manfrotto (tripods and heads) www.manfrotto.com

DIGITAL STITCHING
ACD www.acdsystems.com
Adobe Photoshop www.adobe.com
Adobe Photoshop Elements www.adobe.com
Panavue Image Assembler www.panavue.com

Panorama maker www.arcsoft.com
Panoweaver www.easypano.com
Photo Vista www.roxio.com
Picture Publisher www.micrografx.com
Pixaround.com www.pixaround.com
Pixtra www.pixtra.com
Realviz stitcher www.realviz.com
Ulead Cool 360 www.ulead.com

MOUNTS, MASKS AND FRAMES
Franklin Photo Products (USA) www.franklinphoto.com
GePe www.gepe.com
Javarette (UK) www.photosleeves.com
Longridge www.longridge.co.uk
Mountmaster Products www.mountmaster.co.uk
Priory Frames (0044) 1502 714 324
Secol (UK) www.secol.co.uk
Slidepacks (UK) www.slidepacks.com

PANORAMIC ORGANIZATIONS
The International Association of Panoramic
Photographers www.panoramicassociation.org
Panoguide www.panoguide.com
Panoramic Network www.panoramic.net
Panoramic Photography Club www.groups.yahoo.com/group/
panoramicphotography

◁ **MARRAKECH, MOROCCO**
Marrakech is one of my favourite cities. The colour, noises,
smells, and constant hustle and bustle is intoxicating, and when-
ever I visit I always come away with something new. This shot
shows the view over part of the Djemaa el Fna, the old square in
the city that comes to life each evening with food sellers and
entertainers. The sun was about to set, and the last rays of
golden light were catching the buildings and stalls. I used an
eight-second exposure so that people walking through the scene
would blur while those gathered around the storytellers and
entertainers would come out relatively sharp.

Camera Hasselblad XPan Lens 90mm Filters Polarizer and 81C
warm-up Film Fuji Velvia 50

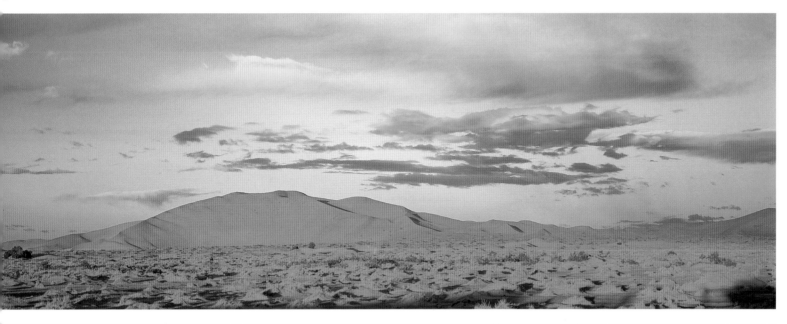

◁ **SAHARA DESERT, MOROCCO**

Every November I take a group of photographers on a 12-day trip to Morocco. It's an amazing trip that includes camel trekking across this dune sea, the Erg Chebbi, and sleeping under the stars for two nights. This view greeted me when I woke at dawn one morning and looked back towards the dunes. The light lasted only a moment before the sun disappeared behind cloud.

Camera Hasselblad XPan
Lens 90mm **Filter** Polarizer
Film Fuji Velvia 50

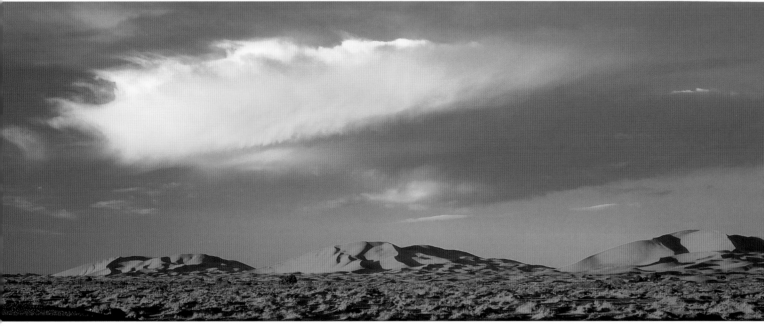

◁ **SAHARA DESERT, MOROCCO**

This photograph was taken just seconds after the previous one. The Hasselblad XPan is ideal in situations where the light is changing constantly and you need to work fast. With 21 frames on a roll of film, you can take a range of shots. Had I been working with my Fuji GX617, which gives only four shots, I would have missed opportunities while changing film.

Camera Hasselblad XPan
Lens 90mm **Filter** Polarizer
Film Fuji Velvia 50

INDEX